# The Art Institute of Chicago

## Twentieth-Century Painting and Sculpture

The Art Institute of Chicago

Distributed by Hudson Hills Press, Inc.

# The Art Institute of Chicago

## Twentieth-Century Painting and Sculpture

Selected by

**James N. Wood, Director**

and

**Teri J. Edelstein, Deputy Director**

## Contributors

Margherita Andreotti: 24, 30, 39, 45, 52, 63, 74, 77, 83, 91, 112

Neal Benezra: 156

Jill Bishins: 119

Courtney Donnell: 66–67

Audrey Fosse: 60, 131, 145, 148

Gloria Groom: 41

Madeleine Grynsztejn: 115, 130, 153

Dennis Nawrocki: 21, 32–33, 49, 61–62, 65, 68, 70–71, 78–79, 82, 85, 88–90, 92, 94–95, 97, 102, 104–11, 113–14, 116, 118, 120–22, 124–27, 129, 132, 134–37, 140–44, 146–49, 151–52, 154–55

Julee Pearson: 31

Daniel Schulman: 11–13, 15, 17–20, 26, 34–36, 38, 47, 54–55, 57, 72, 80–81, 86, 96, 123

Staff of the Department of Twentieth-Century Painting and Sculpture: 14, 16, 22–23, 25, 27, 37, 40, 42–44, 46, 48, 50–51, 53, 56, 58; 64, 69, 76, 84, 93, 98, 100–101, 103

Sue Taylor: 28–29, 73, 117, 128, 133, 138–39, 150

Executive Director of Publications, The Art Institute of Chicago: Susan F. Rossen

Edited by Sarah H. Kennedy, assisted by Sarah E. Guernsey and Kate Irvin

Production by Daniel Frank, assisted by Sarah E. Guernsey

Designed and typeset by Katy Homans, Seattle, Washington

Printed and bound by Arnoldo Mondadori, Verona, Italy

Color separations by Professional Graphics, Rockford, Illinois

All photographs are by the Department of Imaging and Technical Services, Alan B. Newman, Executive Director, with the following exceptions: © Leo Castelli Gallery, New York: 141 (photograph slightly altered); © Philippe Cazeau-Jacques de la Béraudière Gallery, Paris: 41; © Estate of Robert Smithson, courtesy of John Weber Gallery, New York: 130; © Whitney Museum of American Art, Jerry L. Thompson: 123 (photograph slightly altered).

Cover:
Edward Hopper, *Nighthawks*, 1942 (see p. 85)

Frontispiece:
Franz Kline, *Painting* (detail), 1952 (see p. 102)

Entries based on the following works appeared in slightly different versions in *The Art Institute of Chicago Museum Studies* 20, no. 2 (1994): 24, 30, 45, 63, 74, 77, 83.

Distributed in the United States by Hudson Hills Press, Inc., Suite 1308, 230 Fifth Avenue, New York, NY 10001–7704

Editor and Publisher: Paul Anbinder

Distribution in the United States, its territories and possessions, Canada, Mexico, and Central and South America through National Book Network. Distribution in the United Kingdom, Eire, and Europe through Art Books International Ltd. Exclusive representation in Asia, Australia, and New Zealand through EM International.

First Edition

### Library of Congress cataloging-in-publication data

Wood, James N.
 The Art Institute of Chicago : twentieth-century painting and sculpture / selected by James N. Wood and Teri J. Edelstein.
  p.  cm.
  Includes index.
  ISBN 0-86559-096-6
  1. Art, Modern—20th century—Catalogs. 2. Art—Illinois—Chicago—Catalogs. 3. Art Institute of Chicago—Catalogs.
  I. Edelstein. T. J.  II. Title.
  N6487.C52A788  1996
  709'.4'007477311—dc20
                                96-14289
                                CIP

## Permissions

The Art Institute of Chicago wishes to thank the following for permission to reproduce works in this volume:

Carl Andre / licensed by VAGA, New York: 132; © 1996 Artists Rights Society (ARS), New York / ADAGP, Paris: 17–18, 23, 25, 28, 39, 44, 48, 55, 61, 68, 71, 78, 80, 83, 87, 94–95, 125; © 1996 Artists Rights Society (ARS), New York / ADAGP / SPADEM, Paris: 27, 53; © 1996 Artists Rights Society (ARS), New York / SPADEM / ADAGP, Paris: 45, 56, 69, 81; © 1996 Artists Rights Society (ARS), New York / SPADEM, Paris: 14, 58–59, 63; © 1996 Artists Rights Society (ARS), New York / VEGAP, Madrid: 21, 31; © 1996 Artists Rights Society (ARS), New York / VG Bild-Kunst, Bonn: 70, 79, 138; © 1996 Artists Rights Society (ARS) / SPADEM, Paris: 11; Francis Bacon Estate: 106; Georg Baselitz: 136; Vija Celmins: 155; Foundation of Giorgio de Chirico / licensed by VAGA, New York: 30; The Joseph and Robert Cornell Memorial Foundation: 104–105;

The Estate of Robert Delaunay: 26; The Estate of Paul Delvaux / licensed by VAGA, New York: 77; © 1996 Demart Pro Arte, Geneva / Artists Rights Society (ARS), New York: 75; The Estate of Richard Diebenkorn, c/o Acquavella Contemporary Art, New York: 134; Helen Frankenthaler: 135; Lucian Freud: 143; Leon Golub and Ronald Feldman Fine Arts, New York: 152; The Estate of Philip Guston: 142; Alan Bowness, Hepworth Estate: 112; © 1996 C. Herscovici, Brussels / Artists Rights Society (ARS), New York: 76; The Estate of Eva Hesse: 128; David Hockney: 127; © 1996 Robert Irwin / Artists Rights Society (ARS), New York: 126; On Kawara and Sperone Westwater, New York: 140; Anselm Kiefer, courtesy of Marian Goodman Gallery, New York: 150; Jacob Lawrence: 96; © 1996 Sol LeWitt / Artists Rights Society (ARS), New York: 133; Roy Lichtenstein: ii–iii, 117; Kerry James Marshall, courtesy of Koplin Gallery, Los Angeles: 154; Agnes Martin, c/o Pace Wildenstein, New York: 131; © 1996 Succession H. Matisse, Paris / Artists Rights Society (ARS), New York: 16, 37, 40, 50; Mondrian Estate/Holtzman Trust, Essex, Connecticut: 49; The Henry Moore Foundation: 113; Elizabeth Murray,

c/o Pace Wildenstein, New York: 144; © 1996 Bruce Nauman / Artists Rights Society (ARS), New York: 141; The Estate of Louise Nevelson, c/o Pace Wildenstein, New York: 123; © 1996 Barnett Newman Foundation / Artists Rights Society (ARS), New York: 100; Clemente Orozco and Family: 65; Ed Paschke: 149; © 1996 Estate of Pablo Picasso / Artists Rights Society (ARS), New York: 12, 19–20, 35, 51, 57, 72, 111; Sigmar Polke: 151; Pollock-Krasner Foundation / Artists Rights Society (ARS), New York: 93; Martin Puryear: 145; Gerhard Richter, courtesy of Marian Goodman Gallery, New York: 137; The Estate of Diego Rivera, Instituto Nacional de Bellas Artes, Mexico City: 34; James Rosenquist: 116; Robert Ryman: 156–57; © 1996 Richard Serra / Artists Rights Society (ARS), New York: 129; Cindy Sherman and Metro Pictures: 147; Kiki Smith, c/o Pace Wildenstein, New York: 153; Estate of Robert Smithson, John Weber Gallery, New York: 130; © 1996 Frank Stella / Artists Rights Society (ARS), New York: 122; The Fundación Olga y Rufino Tamayo, Mexico City: 82; Günther Uecker: 121; Bill Viola: 148; © 1996 Andy Warhol Foundation for the Visual Arts / ARS, New York: 139.

# Contents

# Acknowledgments

In bringing *The Art Institute of Chicago: Twentieth-Century Painting and Sculpture* to completion, we have been generously and enthusiastically supported by a number of individuals at The Art Institute of Chicago. We are particularly grateful to have had the counsel of Charles F. Stuckey, former Frances and Thomas Dittmer Curator, and Daniel Schulman, Assistant Curator, Department of Twentieth-Century Painting and Sculpture, in selecting the works to be included.

We also wish to thank the authors who produced the lively, informative texts that accompany the illustrations: Margherita Andreotti, Neal Benezra, Jill Bishins, Courtney Donnell, Audrey Fosse, Gloria Groom, Madeleine Grynsztejn, Dennis Nawrocki, Julee Pearson, Daniel Schulman, and Sue Taylor.

The task of organizing, editing, and preparing the text for this book belonged to Sarah H. Kennedy, who was ably assisted by Susan F. Rossen, Sarah E. Guernsey, and Kate Irvin. Daniel Frank, Associate Director of Publications, and Sarah E. Guernsey contributed their expertise to its production. The elegant design is by Katy Homans of Seattle, Washington, and the superb photographs were produced by the Art Institute's Department of Imaging and Technical Services.

We are particularly grateful to Mr. Nawrocki, who wrote the lion's share of the entries. He would like to thank Jean Peyrat, Librarian, and Mary Ryckman, Librarian Assistant, Center for Creative Studies-College of Art and Design, Detroit, for their unfailing and rapid response to all of his research requests. He would also like to acknowledge Ginny Neel and Elizabeth Murray for reviewing entries on Alice Neel's *Ginny with the Yellow Hat* and Murray's *Back to Earth*, respectively; and to Courtney G. Donnell, Associate Curator, and Nicholas A. Barron, Kate Heston, and Richard Holland, Department of Twentieth-Century Painting and Sculpture, for their ongoing support.

**James N. Wood,** Director
**Teri J. Edelstein,** Deputy Director

# Introduction

The twentieth century can be said to have begun for many Chicagoans with the arrival of the World's Columbian Exposition in 1893. To a degree perhaps hard to grasp today, in a world made small by television and computers, the exposition was an epochal event for Chicago, irrevocably altering many of its citizens and institutions. The Art Institute, for example, had arranged to help finance a Beaux-Arts-style building on Michigan Avenue to house some of the fair's functions; and, when the exposition closed, that structure became, and remains today, the museum's home. Thus, after fifteen years without satisfactory quarters, the Art Institute acquired appropriate gallery space and the impetus to begin assembling a serious collection.

The role modern works would play in that collection was influenced by two art exhibitions mounted at the World's Columbian Exposition. One was a showcase for American art created since the last great American world's fair, the 1876 Centennial Exposition in Philadelphia. This collection reflected the predominant American taste for realism: genre scenes, historical narratives, landscapes. The other, more adventurous exhibition featured nineteenth-century European masterpieces gathered from American collections by Sarah Tyson Hallowell, an art agent and friend of Mary Cassatt, who, beginning in the 1870s, had introduced Chicagoans Potter and Bertha Palmer and other prominent mainly East Coast collectors to Impressionist painting.

The exhibitions at the World's Columbian Exposition changed the way Chicagoans thought about art. People already associated with the Art Institute were stirred to collect art seriously or to do so more adventurously. The prominent businessman Martin A. Ryerson, for example, who had helped acquire the museum's first Old Master paintings, began collecting the work of Claude Monet, including such late, quasi-abstract canvases as *Water Lilies* (see p. 11). Attorney Arthur Jerome Eddy was inspired to purchase and write about the art of his time and had his portrait done by James Abbott McNeill Whistler and a bust by Auguste Rodin. Frederic Clay Bartlett, the son of an Art Institute trustee, was

moved to devote his life to art, first studying painting in Europe and then setting up a studio in Chicago in the Fine Arts Building.

Despite its popular image as a place of crass commercialism, Chicago was an important center for the arts in the early years of this century. Daniel Burnham, Louis Sullivan, and Frank Lloyd Wright, along with many others, were reinventing the art and practice of architecture. The city boasted an active theater community and was the cradle of the American motion picture industry before it relocated to Hollywood. Writers Sherwood Anderson and Theodore Dreiser called Chicago home. And after 1912, Harriet Monroe's *Poetry* magazine helped define modernism in literature.

That audacious spirit was rarely evident at the Art Institute, however. Little modern European art was exhibited or collected. Beginning in 1888, the museum sponsored an annual exhibition of works by living American artists, but it often featured the kind of genteel art shown at the 1893 exposition of American art. To be sure, significant works appeared in the American Exhibition and entered the collection, notably Henry Ossawa Tanner's *Two Disciples at the Tomb* (see p. 13), judged the best work in the 1906 show. It was with some justice, however, that in 1912 Harriet Monroe could say, "Our paintings are too mild."

No one would make that claim a year later, when the International Exhibition of Modern Art came to the Art Institute. This groundbreaking exhibition, featuring works by Marcel Duchamp, Francis Picabia, and Pablo Picasso, among many others, had originated in New York, where, unable to find a host museum or gallery, it was held in a National Guard armory, thus earning its more familiar sobriquet, the Armory Show. Art Institute Trustee Arthur Aldis successfully lobbied to bring the exhibition to the museum, but the response was mixed. While 188,000 people visited the show during its twenty-four-day run,

most came to mock the new art, which the press vehemently derided. Even Art Institute director William M. R. French worried that the museum was mistaken in exhibiting "the strange works." Despite the tumult, the Armory Show left its mark on the Art Institute. Arthur Jerome Eddy bought extensively from the exhibition, and in 1931 many of his purchases and other modern masterpieces from the collection entered the museum, including Constantin Brancusi's *Sleeping Muse* (see p. 23) and Vasily Kandinsky's *Painting with Green Center* (see p. 28).

After the furor over the Armory Show, the Art Institute shied away from controversy for a time. Interest in experimental art continued unabated, however, outside the museum, notably at the Arts Club of Chicago, founded in 1916. Led by Rue Winterbotham Carpenter, the Arts Club organized exhibitions featuring works by Charles Sheeler and Charles Demuth, among others. Beginning in 1922 and continuing for the next five years, the club maintained an exhibition room at the Art Institute that emphasized contemporary art. Even after the Arts Club found its own gallery space, connections between the two institutions remained strong. In 1990 Brancusi's magnificent *Golden Bird* (see p. 48), which the Arts Club had purchased in 1927, was acquired by the Art Institute.

Another Arts Club connection resulted in one of the most far-reaching and influential gifts in the museum's history. Undoubtedly influenced by his daughter's activities in the Arts Club, Chicago industrialist Joseph Winterbotham donated $50,000 to the museum in 1921. Winterbotham specified that interest from this money should be used "for the purchase of works of art painted by European artists of foreign subjects" and that the number of objects in the collection should never exceed thirty-five. The museum, he added, could replace any work with another, better one, thus ensuring that the Winterbotham Collection would experience "continuous improvement" over time. Among the works in the collection are Balthus's *Solitaire*

(see p. 83), de Chirico's *Philosopher's Conquest* (see p. 30), Dalí's *Inventions of the Monsters* (see p. 75), Delaunay's *Champ de Mars: The Red Tower* (see p. 26), Delvaux's *Awakening of the Forest* (see p. 77), Dufy's *Open Window, Nice* (see p. 63), Feininger's *Carnival in Arcueil* (see p. 24), Léger's *Railway Crossing* (Preliminary Version) (see p. 45), Magritte's *Time Transfixed* (see p. 76), Matisse's *Geranium* (see p. 16), and a painted screen by Tanguy (see pp. 58–59).

One of the people drafted by Art Institute officials to help with the initial purchases for the Winterbotham Collection was Frederic Clay Bartlett. Through the influence of his second wife, Helen Louise Birch, a writer affiliated with *Poetry* magazine, Bartlett had begun collecting avant-garde European artists. When his wife died in 1925, Bartlett proposed donating and installing the Helen Birch Bartlett Memorial Collection at the Art Institute. According to some reports, museum director Robert B. Harshe had to beg reluctant trustees to accept Bartlett's gift of modern art. They did, and in 1926—three years before the founding of The Museum of Modern Art in New York—the Art Institute became the first American museum to devote a gallery to the permanent display of Post-Impressionist and other modern art, including Amedeo Modigliani's *Jacques and Berthe Lipchitz* (see p. 38), Picasso's *Old Guitarist* (see p. 12), and, of course, Georges Seurat's masterpiece *Sunday Afternoon on the Island of La Grande Jatte*.

Chicago once again became the focus of world attention in 1933 and 1934, when it hosted the Century of Progress Exposition. The Art Institute organized two exhibitions for the fair that drew extensively on the museum's growing collections. These exhibitions were arranged in the galleries along chronological and geographic lines; when the fair ended, the Art Institute's works (previously hung according to donor) retained this organization. Thus, after more than fifty years, the Art Institute signaled that, important as those donors were, the museum's collection now had an identity beyond that of acquiring private holdings.

The acceptance of landmark gifts such as the Winterbotham and the Helen Birch Bartlett Memorial collections did not imply a wide-scale acceptance of avant-garde art at the Art Institute. Tensions flared anew in 1935 on the occasion of the 46th American Exhibition. Josephine Logan, wife of museum trustee Frank Logan, condemned works in the show (some of which addressed the effects of the Depression) as morbid and vulgar and called for the display of more "uplifting" art. The Logans funded the American Exhibition's major prize and were influential leaders within the museum and in the city at large, so Mrs. Logan's effort to stamp out the "trash" of "mad" modern artists—known as the Sanity in Art movement—had considerable impact.

Still, contemporary art had its supporters at the Art Institute. In 1938 Daniel Catton Rich was named director. His commitment to the art of the day was steadfast. Rich found a kindred spirit in 1943, when he hired Katharine Kuh to join the museum's staff. Kuh had battled the proponents of Sanity in Art as the owner of the first commercial gallery in Chicago to show avant-garde art and counted among her friends such pivotal figures as László Moholy-Nagy and Mies van der Rohe.

Together Kuh and Rich continued their advocacy of modern art through exhibitions, education, and acquisitions. In 1945 they tranformed the American Exhibition into an invitational show selected by museum staff. Two years later they made Surrealist and abstract art the theme of the exhibition. These efforts had their price: the Chicago press decried the "fantastic" and "nightmarish" creations of "a score of foreign isms." The uproar refused to die down, and in the process Rich became a spokesperson for modern art. In the politicized atmosphere of the early Cold War years, such public stands made Rich a target for attack, and in 1949 he was accused of "encouraging communists" through

his controversial exhibitions. When in 1951 Willem de Kooning's *Excavation* (see p. 99) received first purchase prize in the American Exhibition, Kuh and Rich were again subject to assaults in the press.

Despite the air of hostility that surrounded some of their activities, Rich and Kuh were supported by trustees and collectors who were increasingly sympathetic to new art. As early as 1940, a group of collectors, inspired by the success of the Winterbotham Fund, organized as the Society for Contemporary American Art. The group held annual exhibitions and purchased for the museum one significant work from each show. The society, which later expanded its mission to include recent European art, has been responsible for bringing a number of landmark works to the Art Institute's collection, including Leon Golub's *Interrogation II* (see p. 152), a slate sculpture by Isamu Noguchi (see p. 91), Jackson Pollock's *Greyed Rainbow* (see p. 103), and Charles Sheeler's *Artist Looks at Nature* (see p. 90).

During their tenures, Rich and Kuh helped secure many of the museum's most notable twentieth-century works, including Matisse's landmark work *Bathers by a River* (see p. 40), as well as paintings by Bacon, Beckmann, Blume, Chagall, Mondrian, Picabia, Rivera, and Rothko. Bequests from the first generation of adventurous Art Institute collectors, such as Charles M. and Mary F. S. Worcester and Kate L. Brewster, further enriched the collection. In 1949 Georgia O'Keeffe, a former student at the School of the Art Institute, gave the museum a remarkable selection of works from the collection of her husband, the photographer and dealer Alfred Stieglitz, including Arthur Dove's *Monkey Fur* (see p. 54), Marsden Hartley's *Movements* (see p. 36), and O'Keeffe's own *Blue and Green Music* (see p. 46). In 1954 Kuh's groundbreaking role in collecting and exhibiting modern art was formalized when she became the Art Institute's first curator of modern painting and sculpture.

By 1960 both Rich and Kuh had left the museum for other endeavors. John Maxon succeeded Rich as director, and A. James Speyer was named Kuh's successor in 1961. Speyer, who had been trained as an architect by Mies van der Rohe and had written for *Art News*, did not face the public-relations battles that Kuh had, thanks to a new generation of Chicago collectors and trustees who needed little convincing of the value of contemporary art. The Speyer years, which saw remarkable growth in the collection, were a time of solidifying strengths and filling gaps. A 1964 bequest from Grant J. Pick helped in the acquisition of such important works as Picasso's *Nude Under a Pine Tree* (see p. 111). The Chicago painter Ivan Albright, another alumnus of the Art Institute School, gave a group of his unforgettable pictures in 1977. In 1982 Lindy and Edwin Bergman donated a remarkable collection of thirty-seven constructions by Joseph Cornell. Other acquisitions made during Speyer's tenure include works by Beuys, Braque, Hockney, Kiefer, Lichtenstein, Martin, Murray, Nauman, Nevelson, Puryear, Rauschenberg, Richter, and Kiki Smith.

By 1980, when my tenure as director began, the Art Institute had amassed one of the most notable collections of twentieth-century art of any museum of its type. Thanks to strengths in other areas of the collection, the museum was able to present a comprehensive view of Western art from the fifteenth century in Europe to the present. The manner in which these works were arrayed in the museum, however, often belied these riches. The time seemed ripe for a rethinking of how we presented our holdings, just as Robert Harshe had done fifty years earlier. A period of renovation and expansion, begun in the mid-1980s and presently near conclusion, means that, for the first time, the museum will be able to offer a comprehensive installation of the twentieth-century collection. A. James Speyer did not live to see this process completed, and, in 1987, the new head of the Department of Twentieth-Century Painting and Sculpture, Charles F. Stuckey, took over where his predecessor had left off—both in reinstalling the galleries and in bringing new works into the

collection. He acquired, for example, several important works by noted African-American artists, including Jacob Lawrence's *Wedding* (see p. 96), Kerry James Marshall's *Many Mansions* (p. 154), Horace Pippin's *Cabin in the Cotton* (see p. 84), and Martin Puryear's *Sanctuary* (see p. 145).

Stuckey's highly original plans for the reinstallation erased the sometimes arbitrary and artificial lines of nationality that had kept related works in separate rooms. When galleries devoted to art dating from 1900 to 1950 were opened in 1991, works by American artists were integrated with those by Europeans to more accurately reflect the influences that have flowed so freely between artists in different countries and continents during this century. Further, by installing works in various mediums—books, drawings, photographs, prints—alongside paintings and sculptures, we believe that the richness and variety of the art of our century comes to life in ways rarely experienced before. Even as these changes have been carried out, the Art Institute has remained committed to collecting works by the most significant artists of our time, including Freud, Paschke, Sherman, Kiki Smith, and Viola.

By letting history be our guide, we have been able to tell a cohesive, comprehensive story about the art of the twentieth century. That these modern masterpieces found a home in the Art Institute is due in large part to the vision, courage, and determination of many remarkable people: artists, collectors, trustees, directors, curators, and members of the public. We hope this book is not merely a expression of pride in what we have accomplished, but a means to stimulate the drive to create, collect, and experience art in the future. With only a few years remaining in the twentieth century, clearly a name change is in store for the area of the museum charged with collecting and exhibiting contemporary art. What will not change is the Art Institute's commitment to acquiring and presenting the finest and most challenging art of the day.

**James N. Wood**, Director

# Claude Monet

## *Water Lilies, 1906*

Oil on canvas; 87.6 x 92.7 cm

After traveling throughout France and abroad in the 1880s and 1890s, perfecting his method of working in series to render the varied nuances of light and atmosphere on the landscape, Claude Monet settled down on the property he had purchased in 1890 at Giverny, forty miles northwest of Paris along the Seine. During the last three decades of his life, which extended well into the twentieth century, he labored with single-minded intensity on a project that extended Impressionism to its limits—his water lily paintings.

At Giverny the artist indulged in his passion for gardening, creating a water lily pond that he continually refined from 1893 to 1902, thereby assuming control over the landscape motif that would serve him for the rest of his life. His earliest paintings of the subject date from 1897, as does his first mention of a decorative project that ultimately led to the installation of large, panoramic murals of his water garden, in 1927, at the Orangerie in Paris. To prepare for these murals, Monet painted hundreds of versions of the lily pond, in a variety of formats and sizes, destroying countless numbers during periods of doubt and frustration.

Featured in Monet's 1909 exhibition of forty-eight water lily paintings, subtitled "Water Landscapes" (*paysages d'eau*), the Art Institute's 1906 canvas poses the ultimate Impressionist challenge of superimposing two landscape views of sky and water on a single, continuous plane. Rendered with pink, peach, purple, and red daubs of paint, the groups of lily pads sparkle like jewels in a twilight sky and appear to drift across the surface of the canvas like clouds. In this and his other water lily paintings, Monet achieved an amazing equilibrium between illusion, reality, and abstraction, fostering in the viewer a state of meditation and reverie.

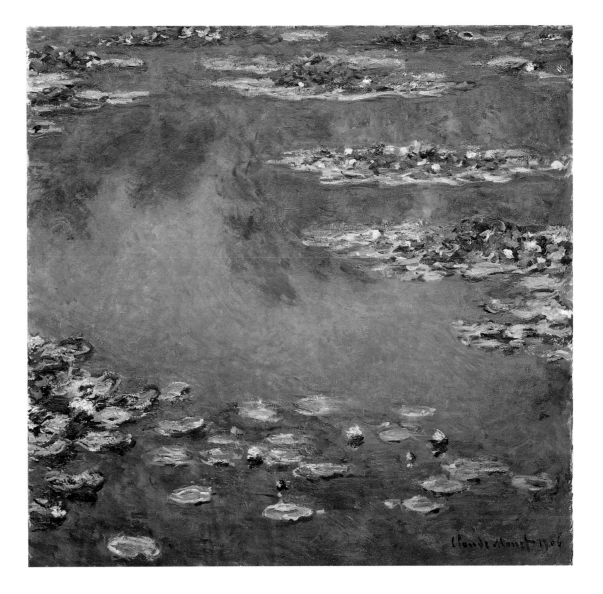

# Pablo Picasso

## The Old Guitarist, 1903

Oil on panel; 122.9 x 82.6 cm

The first child and only son of doting parents, Pablo Picasso was born in the Andalusian port city of Málaga in Spain. In 1891 his family moved to the Atlantic coast town of La Coruña, and then, in 1895, to Barcelona, where Picasso's father, an artist and painting professor, obtained teaching posts. After a brief period of study at the Real Academia in Madrid, Picasso gravitated back to Barcelona, then the cultural capital of Spain, and to Paris, which he visited three times from 1900 to 1903, before settling there permanently in 1904.

Stimulated by modern-art movements in both cities, Picasso abandoned the academic and moralizing set pieces of his early career. After a brief flirtation with the high-key palette of Post-Impressionism, he began to picture the seamy, modern subjects of such artists as Théophile Steinlen, Henri de Toulouse-Lautrec, and Vincent van Gogh. In his succeeding Blue Period works (1902–1904), epitomized by *The Old Guitarist*, Picasso elevated his social outcasts from a realistic to a timeless mode. Rooted in the Symbolist movement, his paintings of bohemians and beggars, rendered predominantly in blue, are emblems of tragic love and loss.

*The Old Guitarist* was painted during Picasso's final months in Spain. Gaunt, haggard, and blind, the old musician appears physically drained and exhausted. Yet his exaggerated pose conveys an otherworldly quality that recalls the spirituality of the martyred saints of El Greco, the mystical, sixteenth-century painter whom the Spanish vanguard had recently rediscovered. Cradled by the musician's angular body and spidery fingers is a guitar, which figures significantly in Picasso's oeuvre as an emblem for Spain and, with its gently curved contours, as a metaphor for the female body.

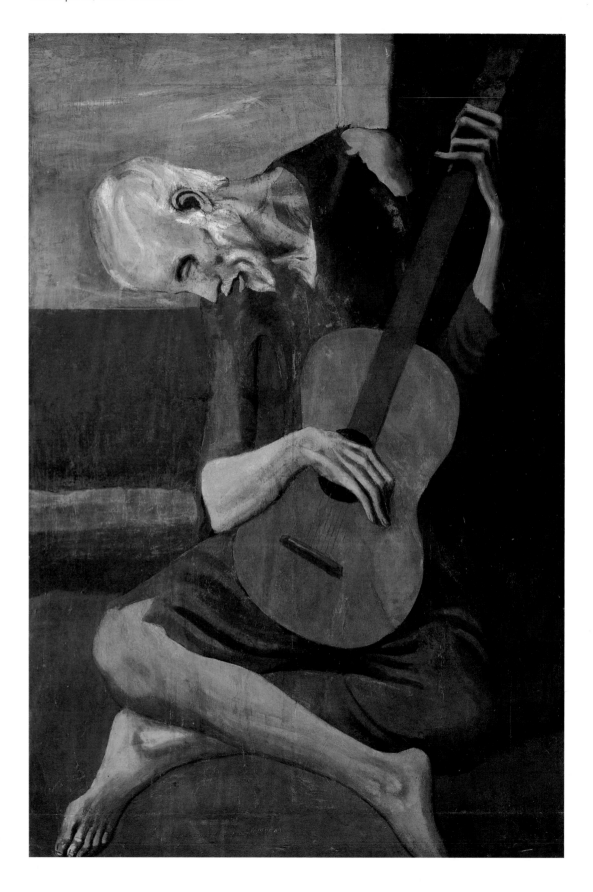

# Henry Ossawa Tanner

## The Two Disciples at the Tomb, c. 1906

Oil on canvas; 129.5 x 105.7 cm

The first African-American painter to achieve an international reputation, Henry Ossawa Tanner spent most of his career in France, where race posed less of an impediment to acceptance than in the United States. Recognized primarily for his religious paintings, Tanner resisted pleas from prominent black intellectuals that he use his position as the preeminent African-American painter of his day to help overturn the racial stereotypes pervading contemporary paintings. His commitment to biblical subjects, with their universal themes of human equality and redemption, was inspired by the example of his father, a leading figure in the African Methodist Episcopalian Church, who implanted in his son a strong sense of religious devotion.

After training at the Pennsylvania Academy of the Fine Arts, in Philadelphia, under America's leading Realist painter, Thomas Eakins, Tanner moved to France in the early 1890s. Working in a naturalist-academic style, he exhibited every year at the Paris Salon from 1894 to 1914, from which the French nation purchased two of his works for its museum of modern art, the Musée du Luxembourg, Paris. By the time *The Two Disciples* received the prize for best painting at the Art Institute's Nineteenth Annual American Exhibition and was subsequently purchased by the museum (1906), Tanner had reached the height of his renown.

Illustrating a scene in the Gospel of Saint John, the painting depicts Peter's and John's discovery of the empty tomb of Christ on Easter morning. The strong light that lifts the faces of the figures out of the murky atmosphere of the tomb endows the scene with dramatic intensity. At the same time, the understated and thoroughly individualized reactions of the two disciples, as seen in their introspective expressions and restrained gestures, capture the essential mystery of the event.

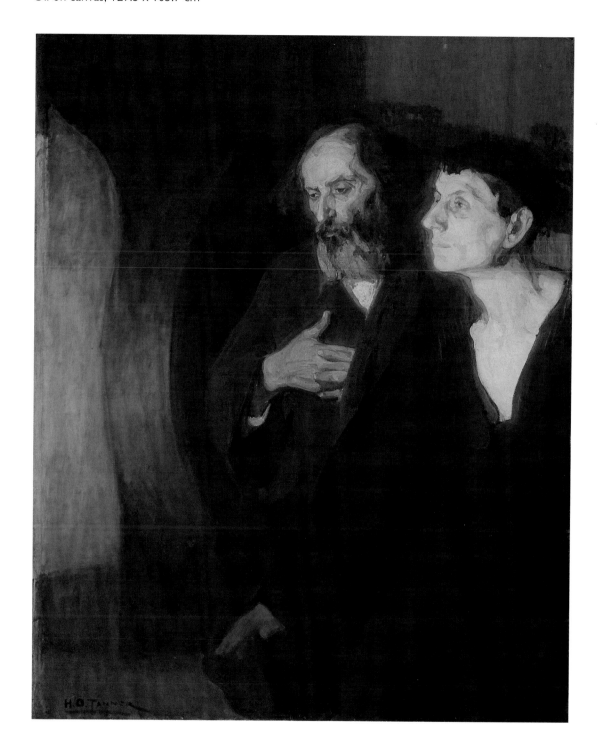

# Edouard Vuillard

## *Still Life, Hydrangeas, 1905*

Oil on cardboard; 73.7 x 64.5 cm

Edouard Vuillard was a member of the Nabis (Hebrew for prophets), a group of artists who sought to express mood with richly orchestrated harmonies of color and form. Vuillard had established by 1900 a unique decorative style that would deeply influence painters such as Henri Matisse. Comprising a complex interweaving of patterned wallpapers, rugs, and fabrics, his elaborate interiors all but overwhelm the figures and individual furnishings of the rooms. By the time Matisse and his Fauve colleagues (see pp. 16–17) were brashly transforming Nabi rhythms into more abstract compositions of brilliant color and impassioned brushwork, Vuillard was working more conventionally. He portrayed the intimate world of the pre-World War I French upper-middle class with the kind of sophisticated observations and sensuous details that find their verbal counterpart in the writing of Marcel Proust.

Painted on the warm-hued cardboard surface that Vuillard favored from the outset of his career, *Still Life, Hydrangeas* displays a masterful and subdued response to the unrestrained use of color in contemporary French painting at the time. A traditional floral still life rendered in shades of white and green, the composition can also be understood as a poetic meditation on time and space. Illusionary and two-dimensional, and thus akin to painted images, the mirror encourages the viewer to consider how two-dimensional versus three-dimensional forms are perceived differently by reflecting the back of a statue shown from the front. Like the classical figurines on the mantelpiece, the presence of a reproduction of the famous Venus de Milo serves to contrast the enduring beauty of the ancient past with the immediate—and transitory—loveliness of the fragile, white hydrangea blossoms.

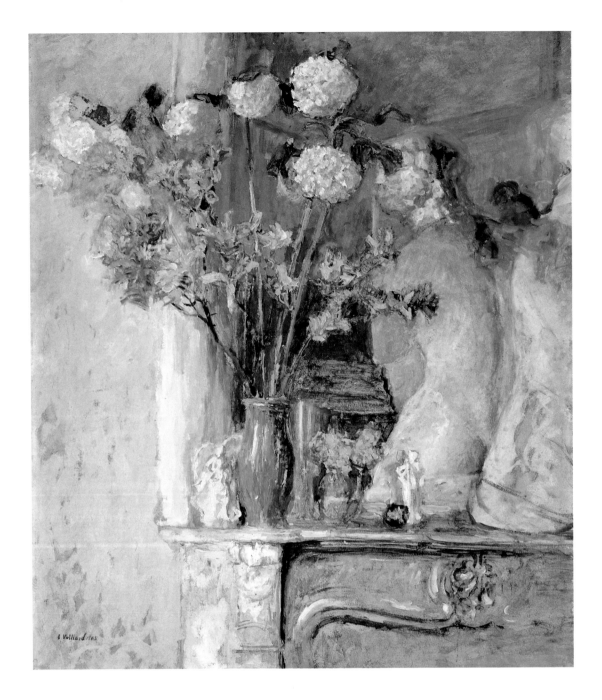

# John Singer Sargent

## *The Fountain, Villa Torlonia, Frascati, Italy,* 1907

Oil on canvas; 71.4 x 56.5 cm

Born in Florence to a wealthy expatriate couple from Philadelphia, John Singer Sargent led an elegant, itinerant life, moving effortlessly throughout Europe and the United States, which he first visited in 1876 to claim his citizenship. Trained in Paris in the late 1870s by the portrait painter Charles Emile Auguste Carolus-Duran, Sargent developed a virtuoso technique through emulating the dazzling brushwork of the Spanish Baroque master Diego Velázquez and the nineteenth-century painter Edouard Manet. His prodigious talents, particularly as a portraitist, attracted a glittering international clientele from both the private and public spheres.

An intimate portrayal of two figures savoring a spectacular landscape, *The Fountain* originated from one of Sargent's frequent summertime excursions, which provided respite from formal portrait commissions. The magic of the locale, a seventeenth-century Italian villa, is conveyed through the freshness of color and the juxtaposition of two white-clad figures with sublime surroundings. The couple pictured is Wilfred and Jane Emmett de Glehn, artists and long-time friends of Sargent's. Perched on the edge of a plinth, Jane occupies the center of the composition. She evaluates her subject, while her husband leans languidly against the balustrade, passively drinking in the atmosphere around him. Between them, almost a third party, is a jet of water that shoots into the air from a point just behind Wilfred's logy head. Created by dragging a dry brush across the canvas, the spray contrasts vividly with the liquid ribbons of paint constituting the figures' light-drenched clothing. The scene is a tour de force of painterly bravura and clever counterpoint, which act in concert to disarm and transport the viewer into the painting.

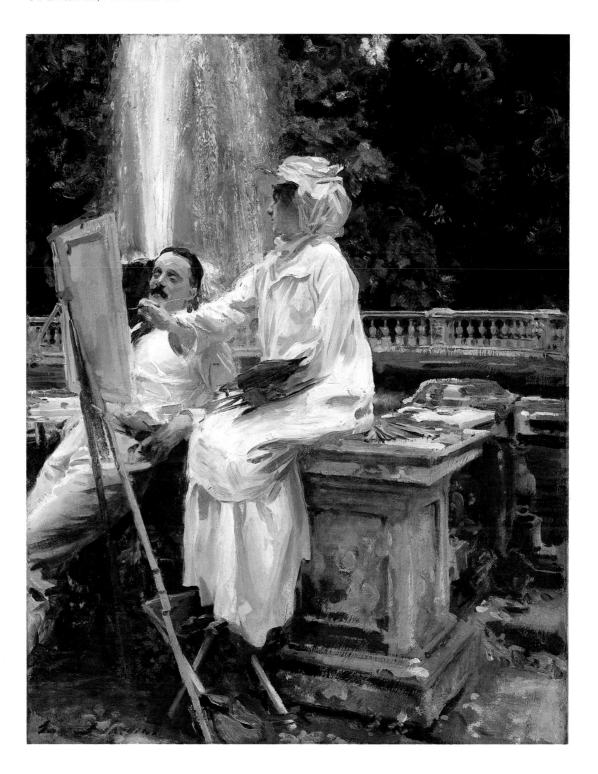

**Henri Matisse**

*The Geranium,* 1906

Oil on canvas; 101.3 x 82.6 cm

The first of many still lifes in which Matisse incorporated figurative sculptures, *The Geranium* is a variation on a traditional theme: Arcadian scenes of naked figures. Like Paul Cézanne, his favorite painter, Matisse was determined in this work to fuse traditional and avant-garde styles. This still life is a masterpiece of Matisse's Fauve period, when he and a group of fellow artists rejuvenated painting with their use of explosive colors and rapid, unrefined brushwork, leading a critic to dub them "wild beasts" (*fauves*).

Ostensibly a simple still life of flowers, vegetables, and a jug arrayed on a table, *The Geranium* resembles a landscape painting that is charged with atmospheric drama: The scumbled, blue background evokes a breezy summer sky and the green shadows of the tabletop, a lawn. The inclusion of two plaster female figures made by Matisse, which are delineated with just a few brush strokes, further upset the viewer's expectations about scale and setting in part by transforming the potted geranium into a blossoming tree. Later, the artist had these figures cast in bronze, one of which, *Woman Leaning on Her Hands,* the Art Institute also owns.

Perhaps the most remarkable element in this composition is the staked plant. With no visible sideshoots, the leaves appear to float through space like green confetti and, thus, can be discerned solely from their shape, color, and size. By covering their edges with blue, the artist further suggested the sense that space is physically in front of as well as behind the leaves. Through Matisse's animated treatment of color and form, everyday objects possess a poetic exuberance, enchanting all who come to behold them.

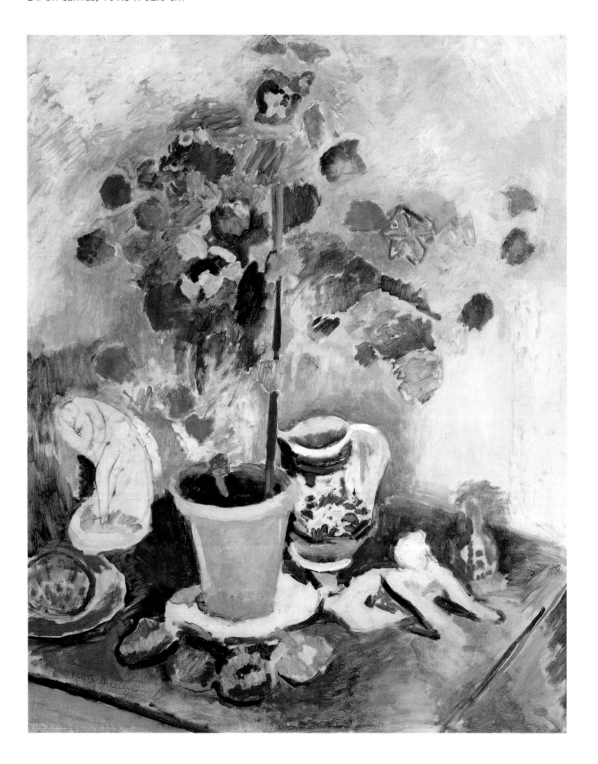

Oil on canvas; 60.3 x 72.7 cm

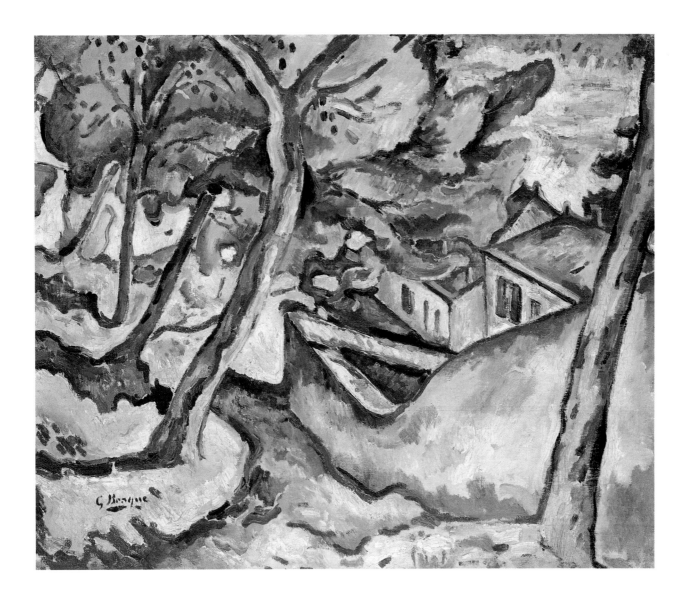

Born into a family engaged for two generations in decorative and house painting, Georges Braque once remarked that his decision to become a painter was no more premeditated than his choosing to breathe. Following an apprenticeship in his father's firm and study at an art academy in Le Havre, the busy port town in Normandy where he spent most of his youth, Braque went in 1902 to Paris to continue his studies and to set up a studio. He was working in an Impressionist style when exposed to Fauvism at the 1905 Salon d'Automne, where Henri Matisse and André Derain first showed their vibrantly colored works.

*Landscape at La Ciotat,* an example of Braque's mature Fauvist style, was probably painted during a visit in the winter of 1906–1907 to the towns of L'Estaque and La Ciotat in the south of France. A kind of turbulent heat emanates from the rooftops, walls, and paths in Braque's combination of highly saturated, molten reds, oranges, and yellows, and of minor complementary notes of blue, green, lavender, and mauve. Though its source is difficult to locate, the intense light seems to have pooled even in areas of shadow.

L'Estaque was important for Braque, both for the clarity of its Mediterranean light, and as a place commonly associated with the work of Paul Cézanne, who worked there and whose death, in 1906, triggered a flurry of memorial exhibitions. Cézanne's paintings, which pose a delicate balance between an intuitive response to nature and an abstract pictorial structure, became, through Braque's and Pablo Picasso's interpretations of the work of the Post-Impressionist master, a touchstone for Cubism and much of early twentieth-century art.

Oil on canvas; 81.1 x 80.5 cm

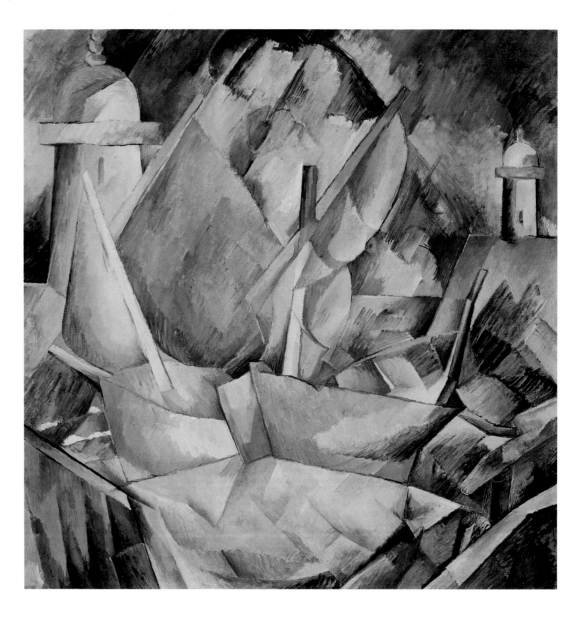

Although Georges Braque came late to Fauvism, he was among the first of the loose-knit group to abandon this exuberant style. The artist's study of Paul Cézanne's eccentric treatment of pictorial space, already evident in his Fauve works, intensified and led to his pioneering of a mode that, as early as 1908, came to be called Cubism. Beginning in 1909, and until he was mobilized to serve in World War I in 1914, Braque worked in tandem with Pablo Picasso, laying the foundations of the most influential art movement of the twentieth century. While neither artist ever abandoned references to the visual world, the freedom with which they broke down and reformulated imagery changed the way future artists would render form.

*Little Harbor in Normandy,* painted from memory in the fall of 1909 in Paris, is the first fully realized example of Braque's early Cubist style. In comparison to the superheated, molten warmth of the canvases he painted in the south of France (see p. 17), Braque's scene of the Channel coast harbor is subjected to severe geometries and a sober palette, reduced in range and intensity to shades of pale green, blue, ocher, and rose. The nearly identical lighthouses at left and right convey an overpowering sense of spatial recession, while the boats sandwiched between them seem compressed to such a degree that they threaten to spill out of the picture below. Adding to the rigid tension between surface pattern and the illusion of depth is the repetitive and striated modeling of form. The perfectly square format of the picture—unusual in traditional landscape views—reveals Braque's and Picasso's concerns with the shape of their canvases, and contributes to the impression that Braque was presenting an independent construct of the mind, rather than a naturalistic view of the world.

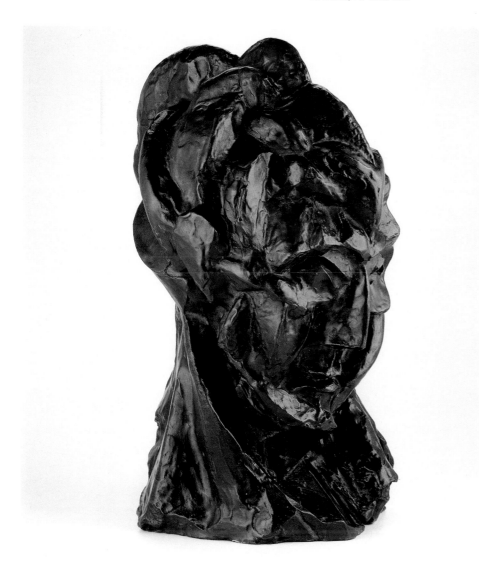

**Fernande Olivier, 1909**
Oil on canvas; 60.6 x 51.3 cm

Pablo Picasso modeled *Head of Fernande Olivier* in Paris during the autumn of 1909. A landmark in the history of modern sculpture, it followed upon a remarkable series of paintings, one of which belongs to the Art Institute (inset), that the artist had made of his long-time companion Fernande Olivier the previous summer at Horta de Ebro. In this Catalonian village, Picasso discovered a stark landscape well suited to the kind of formal reduction and purity that he and Georges Braque admired in the art of Paul Cézanne. Picasso's Horta canvases represent an important early step in the development of Cubism, which would ultimately lead the artist to shatter the closed form of objects in both painting and sculpture. This phase has been called Analytical Cubism, for its appearance of breaking down the elements of the material world and reordering the structural components of form.

The faceting technique through which the planes and contours of Olivier's head are simplified and accentuated in the museum's painting of Olivier lends a powerful sculptural solidity to the image, which Picasso felt compelled to examine in three dimensions. *Head of Fernande Olivier* is so deeply grooved and furrowed that its volumes seem as if carved from a hard substance, rather than originally modeled in soft clay. While remaining within the limits of traditional three-dimensional sculpture, this work poses a severe challenge to the tradition of the closed contour. Eventually, Picasso would irrevocably disrupt illusionistic conventions in both painting and sculpture. While there are at least sixteen extant examples of this bronze, the Art Institute's is the rare, early cast that its owner, the American photographer and dealer Alfred Stieglitz, lent to the 1913 Armory Show. Named after the building in New York where it was held, this controversial exhibition, which also traveled to Chicago and Boston, introduced North American audiences to avant-garde European art.

## *Daniel-Henry Kahnweiler, 1910*

Oil on canvas; 101.1 x 73.3 cm

The subject of Pablo Picasso's masterful Analytical Cubist portrait is Daniel-Henry Kahnweiler (1884–1979), the German-born publisher, art dealer, and writer, who was known as the impresario of Cubism because of his dedication to the work of Georges Braque, Juan Gris, Fernand Léger, and Picasso. Kahnweiler opened an art gallery in Paris in 1907 and, in 1908, began representing Picasso, with whom he remained close friends until the artist's death in 1973.

The composition presents us with a traditional genre, rendered in an entirely novel and provocative manner. Picasso's sitter is atomized into a network of shimmering, semitransparent planes that merge with the atmosphere and objects surrounding him. Contours and surfaces that ordinarily appear continuous are ruptured, and the comforting distinctions between matter and void become elusive. Yet, we can easily discern that this painting is a portrait of an individual, since Picasso provided us with several crisp and well-placed clues: the hands resting one over the other at the bottom of the frame; the double loop of a watch chain; and the head, with its crescent-shaped mouth (or moustache), nose, eyes, and forehead with a shock of hair.

At the left is a sculpture resembling a figure from New Caledonia that Picasso displayed in his studio, and below this can be discerned a still life on a small table. The revolutionary nature of Cubism becomes evident when the work is turned upside-down, making it unreadable as a portrait. Its clues or signs, which now reveal themselves as arbitrary forms, are only identifiable when viewed within the context of a recognized system.

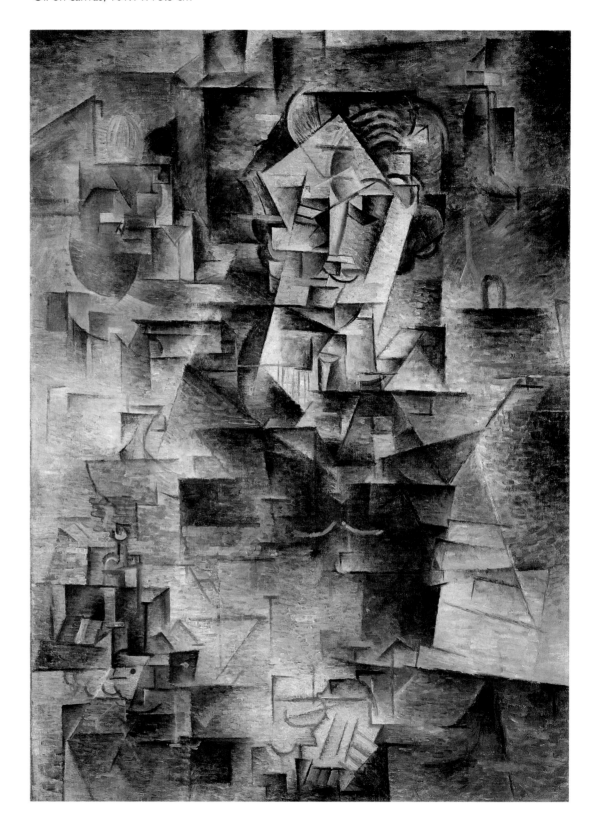

# Juan Gris

## *Portrait of Pablo Picasso, 1912*

Oil on canvas; 92.7 x 87.6 cm

Born and raised in Madrid, José Victoriano Gonzalez changed his name to Juan Gris upon emigrating in 1906 to Paris, where he lived until his early death, in 1927. There, he eventually joined the circle of avant-garde writers and painters that had gathered around his compatriot Pablo Picasso. When his portrait of Picasso appeared at the Salon des Indépendents in the spring of 1912, Gris emerged as a major figure in Cubist painting. Paying homage to his slightly older mentor (by six years), Gris produced a luminous portrait that draws upon the Analytical Cubist style, but is distinguished by its more systematic geometry and crystalline light. Here, Picasso, palette in hand, is portrayed as a figure of considerable girth, whose breadth is further enlarged by the double-breasted, military-style coat he wears. At the peak of this craggy, almost mountainous torso is the seemingly mobile, delicately segmented face of Picasso.

The fastidiously misaligned eyes, nose, and mouth suggest something of the agile expression and keen intelligence of this inventive artist. Seated in a chair whose back adds additional bulk to the image of the body, he is lit by diagonal rays entering from behind, which are countered by the opposing diagonals of the torso. The insistence of the painting's armature of grids (horizontal, vertical, and diagonal) is relieved by the deft application of dots and dashes of blue, gray, and tan pigments, which combine to achieve the cool luminosity that envelops figure and surroundings. Recently mounted in a copy of its original, simply designed frame, Gris's *Portrait of Pablo Picasso* clairvoyantly presents the then thirty-one-year-old Picasso as the *éminence grise* he became in later life.

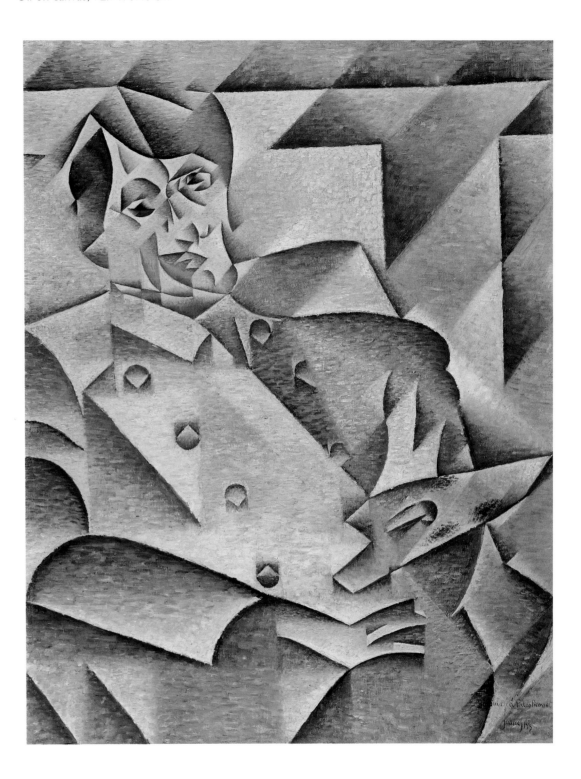

## Raymond Duchamp-Villon

## *Baudelaire, 1911*

Terracotta; 45 x 21 x 21 cm (with base)

Raymond Duchamp-Villon's *Baudelaire* is a product of the intense dialogue that took place in the early years of this century among such artists as Pablo Picasso and Constantin Brancusi about how the human figure should be sculpted. Viewed from its back side, this work is perhaps the most extreme example of simplification by any of the extraordinary sculptors living at this time. Only remotely resembling Charles Baudelaire (1821–1867), the great Romantic poet and critic who helped define the parameters of late-nineteenth-century art, the figure's blank eyes suggest the writer's visionary imagination, and the enlarged cranium, his enormous intellectual capacity. Misproportioned, expressionless, and hairless, the head is at once embryonic, funereal, and automatonlike. Indeed, *Baudelaire* anticipates the mannequin types that Duchamp-Villon began to produce a few years later, forms that would come to obsess Giorgio de Chirico and the Surrealists.

To explore the visual properties of various traditional materials, Duchamp-Villon rendered a full-scale version of the head in plaster, bronze, and terracotta, the latter of which appeared in the 1913 Armory Show (see p. 19). Following the lead of Auguste Rodin, then France's leading sculptor, Duchamp-Villon opted to leave the casting seams in these works visible, such as that between the front and back of the head, thereby imbuing the images with a monstrous quality. While at first presenting his pieces without bases, Duchamp-Villon began to attach simple rectangular supports to several of his most important sculptures around 1914, in response, perhaps, to the work of artists such as his brother Marcel Duchamp and Brancusi, who believed that sculptors should design bases that present works to their best advantage. This is the only version of *Baudelaire* that incorporates a base.

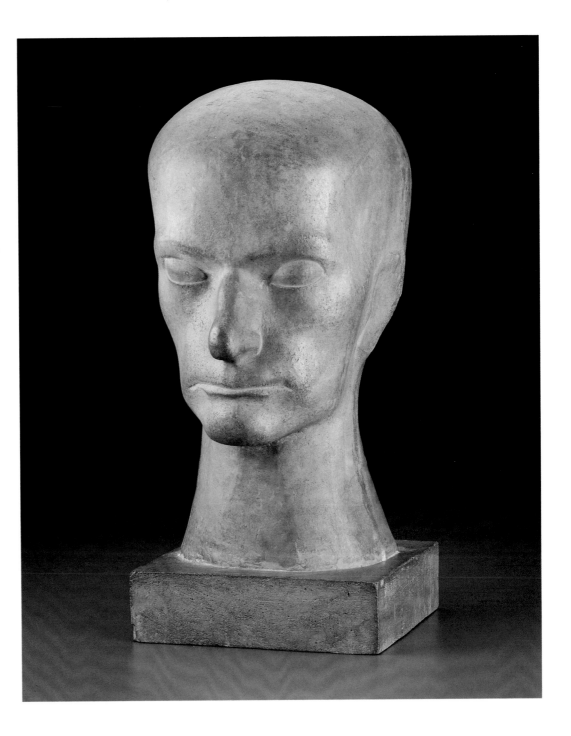

Bronze; 16.1 x 27.7 x 19.3 cm

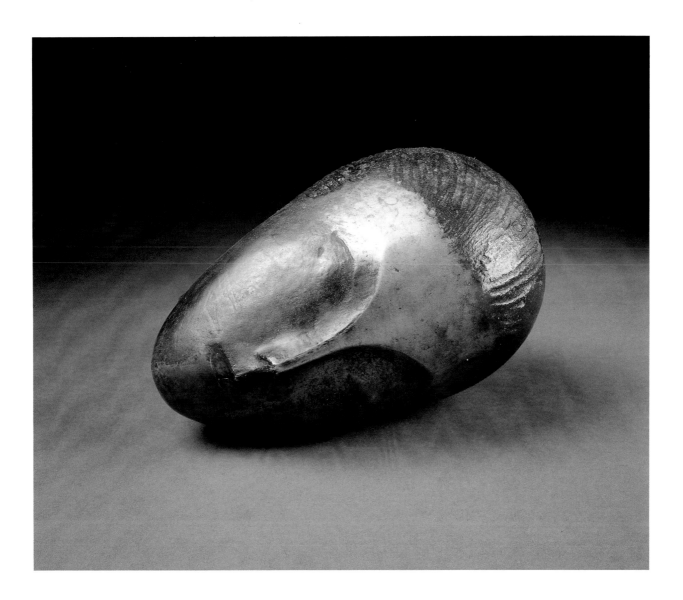

Upon arriving in Paris from his native Romania in 1904, Constantin Brancusi quickly grasped some of the concerns of avant-garde sculptors assembled there: the reduction of figurative imagery to body fragments, the simplification of complex anatomical structures into generalized curves, and the experimentation with new relationships between a sculpture and its base. Introduced by Auguste Rodin, in whose studio Brancusi briefly worked, and by the Italian sculptor Medardo Rosso in the 1880s, these ideas ushered in an era when interest in form prevailed over imitation of nature.

By 1906 Brancusi sculpted his first sleeping head, a motif he would often explore over the following two years. He placed the sculpted heads on their sides, as if the absence of a base had caused them to topple over. Possibly as early as 1909, Brancusi created the tapered, egg-shaped marble sculpture *Sleeping Muse,* of which he eventually made an edition of five in bronze. While influenced by classical sculpture and the disembodied head of Saint John the Baptist depicted in religious art, Brancusi's masterpiece of simplification primarily grew out of the ideas then circulating in Paris. Unlike its precedents, Brancusi's serene form evokes not death, but birth. With its faintly indicated features, most

noticeably the ridge of the nose, the head looks as if it were still taking shape within a protective embryo. This symbolic interpretation of *Sleeping Muse* is supported by titles Brancusi gave to later variations on this theme, such as *The Newborn* and *The Beginning of the World.*

The marble version of *Sleeping Muse* appeared in the 1913 Armory Show (see p. 19), which was brought to the Art Institute in part through the efforts of the pioneering Chicago art collector Arthur Jerome Eddy. The first of seven sculptures by Brancusi to enter the Art Institute, *Sleeping Muse* was one of twenty-three objects that Eddy donated to the museum in 1931.

## Lyonel Feininger

### *Carnival in Arcueil, 1911*

Oil on canvas; 104.8 x 95.9 cm

This is one of about fifty early works by Lyonel Feininger that had been left behind when the artist was forced to leave Nazi Germany in 1937 for the United States. Unknown and inaccessible in East Germany for over forty years, all but three pictures were finally returned to the artist's heirs in 1984.

This painting reveals an artist of remarkable maturity and vision, despite the fact that Feininger had not turned seriously to painting until 1907, following a career as a cartoonist. The setting is the town of Arcueil, south of Paris, where the artist spent several months a year from 1906 to 1912. Feininger's preoccupation with architecture, which continued throughout his career, is apparent here not only in the inclusion of the town's majestic viaduct but also in the brilliantly colored block of houses in the middle ground. It may have been reinforced at this time by his interest in Robert Delaunay's work, in which architectural subjects likewise play a primary role (see p. 26).

Feininger's early admiration for the art of Vincent van Gogh is evident in the heavily impastoed surface and in the use of highly saturated colors, especially yellow, which, in the row of houses, is beautifully modulated by touches of pink, green, and orange. Also reminiscent of van Gogh's work are the animated, billowing contours of the rooftops, which in turn echo the sweeping movement of the clouds. Against this dramatic backdrop, Feininger deployed a motley crew of grotesque and vaguely sinister characters, some of whom recall his earlier cartoons. With their vividly colored costumes, these figures create a striking counterpoint to the dominant yellow of the background. But the ultimate impression is one of dissonance between the grandeur of the town's architecture and the bombastic revelry of its inhabitants.

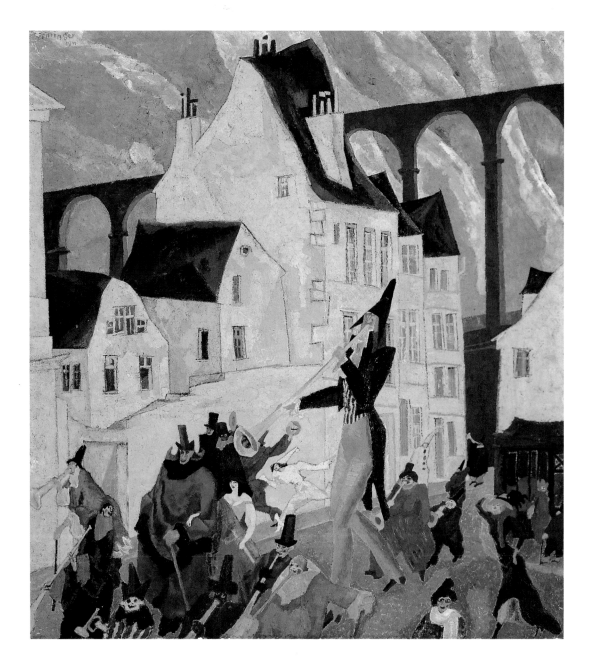

## Marc Chagall
### *Birth, 1911/12*
Oil on canvas; 113.4 x 195.3 cm

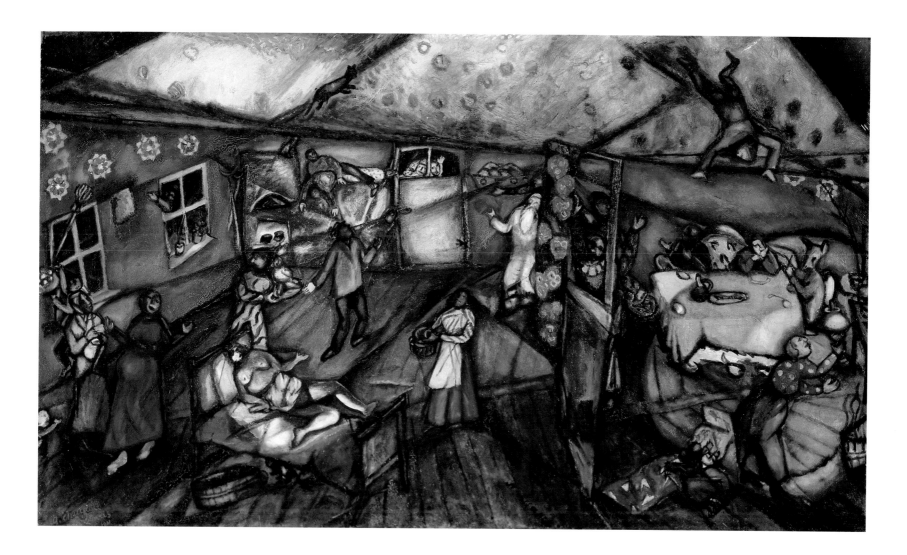

In his autobiography, the Russian-born Jewish artist Marc Chagall related that on the night he entered the world, nearly stillborn, a fire was raging in his town, Vitebsk. He further noted that, as the eldest of eight children, he witnessed birth often. Executed in 1910, his earliest treatment of the theme of birth recalls Russian folk art in its lack of concern for proportion or scale.

After studying art in his native city, Chagall went to St. Petersburg and first encountered modernist concepts. In 1910 the artist moved to Paris, where he was inspired to produce a number of extraordinary compositions in which he married avant-garde ideas with the traditions so dear to him of Russian-Jewish life. This fusion can be seen in this painting, a recollection of the birth, around 1892, of Chagall's brother David. The lack of interest in proportion and traditional perspective and the fantastic, mystical figures evoke Russian folk art, while the bold rendering of forms and striking floral patterns exhibit the artist's debt, respectively, to Georges Rouault and Henri Matisse.

The topsy-turvy scene in *Birth* seems part home, part circus. Against a starry sky, an acrobat jumps for joy, while below him, hybrid creatures that resemble sideshow performers relax at a table. Center stage belongs to the newborn child and his mother, who are illuminated and warmed by the red glow of an oven. Curious neighbors peering in through windows form an eager audience, and family members provide a rich supporting cast.

The title of the Art Institute's painting seems prophetic because, with this work, Chagall's unique vision, at once naive and sophisticated, was born. Full of poetry, energy, visionary quality, and joyousness, this style captured the world of memories and dreams as no art had done before.

**Robert Delaunay**

*Champ de Mars: The Red Tower, 1911/23*

Oil on canvas; 160.7 x 128.6 cm

Conveying images of progressive science with brightly colored forms that express a dynamic spirituality, Robert Delaunay evolved an energetic offshoot of Cubism that came to be known as Orphism. This work belongs to a series of canvases he produced from 1909 to 1911 representing one of the great icons of modernity, the Eiffel Tower. Known as the "Colossal" when it was erected for the 1889 World's Fair, the wrought-iron tower rose to a height of three hundred meters, becoming the tallest structure in the world until it was eclipsed by New York City's Chrysler Building in 1930. The tower was criticized at the outset by a cultural elite that could not accept such a pure example of engineering skill divorced from a utilitarian purpose. Sensitive to charges of the tower's uselessness, its designer, Gustave Eiffel, turned the structure into a laboratory, where he conducted experiments on aerodynamics and radio transmission.

Until Delaunay approached the subject in 1909, painters were no less equivocal about the monument, rarely choosing to represent it in their pictures. For an artist such as Delaunay, who was consumed with the vitality of the modern city and the possibilities of technology, the tower was the perfect vehicle for the celebration of modern themes. In the Art Institute version, the dark-red colossus seems to shudder like a rocket before lift-off, threatening to destabilize the old-fashioned apartment buildings flanking it. The prismatic handling of surface and space, derived from Cubism, is perfectly suited to the architectural nature of the subject: a mesh of skeletal components and spatial voids. The conjoining of various viewpoints contributes to the sensation of the monument's overwhelming size and scale, and its ubiquity, as both a physical and symbolic presence.

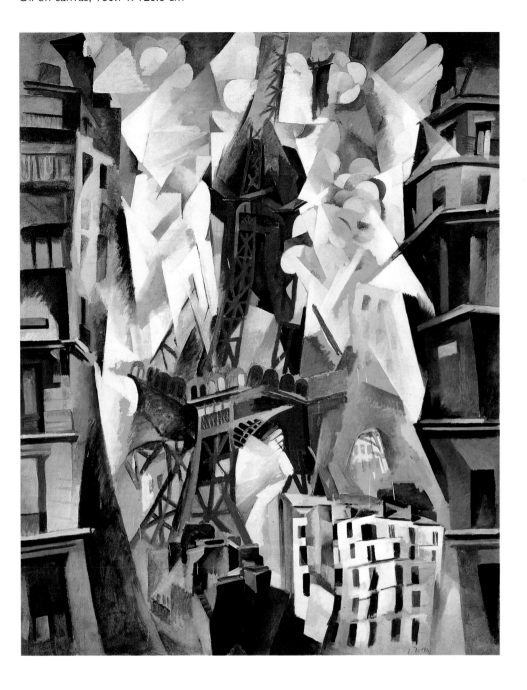

## Francis Picabia

### *Edtaonisl (Clergyman),* 1913

Oil on canvas; 300.4 x 300.7 cm

Despite achieving considerable success in what had become the fashionable Impressionist style, Picabia changed direction dramatically upon meeting the artist Marcel Duchamp in 1911. At the time, Duchamp was combining Cubist elements with pseudodiagrams in humorous, oddly titled paintings. Stimulated by Duchamp's example, Picabia helped pioneer a visual language that is generally associated with Orphism (see p. 26).

Picabia's transatlantic crossing in 1913 to attend the New York opening of the historic Armory Show (see p. 19), where he was among the most advanced modernists featured, inspired this monumental work, as well as a series of abstract watercolors, two of which the Art Institute owns. According to the artist, this painting relates to his observations of two fellow passengers—an exotic Polish dancer named Stasia Napierskowska and a Dominican priest who could not resist the temptation of watching her rehearse with her troupe. While the tumultuous shapes suggest fragments of bodies and costumes, and nautical architecture, the pinpointing of specific images is less relevant than the work's effective expression of constant, rocking motion, evoking dance and the sensation of a ship moving through rolling seas.

Picabia concocted the inscription *Edtaonisl* by alternating the letters of the French words *étoile* (star) and *danse* (dance), a process analogous to his shattering and recombining of the composition's forms. He subtitled the work *Clergyman,* linking the spiritual with the sensual in order, perhaps, to underscore the priest's pleasure from the dancer's performance. The onset of World War I prompted the artist to return to New York, where he became a major polemicist for the Dada movement (see p. 43) and helped develop a totally new style incorporating caricature, machine parts, and word play.

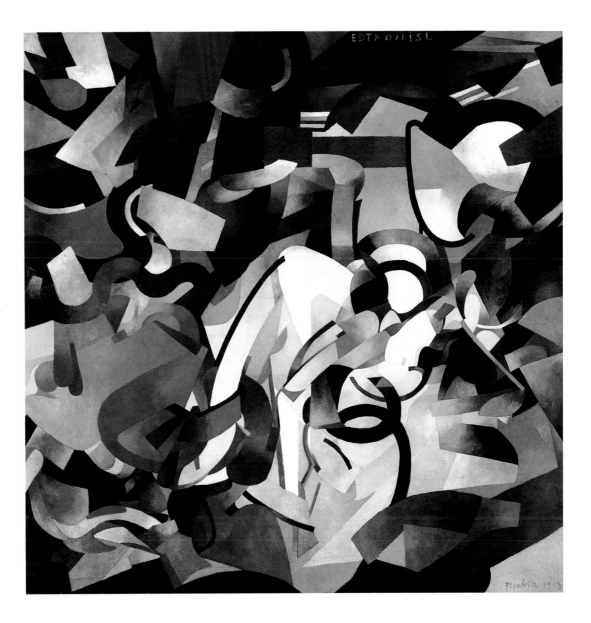

# Vasily Kandinsky

## *Painting with Green Center,* 1913

Oil on canvas; 108.9 x 118.4 cm

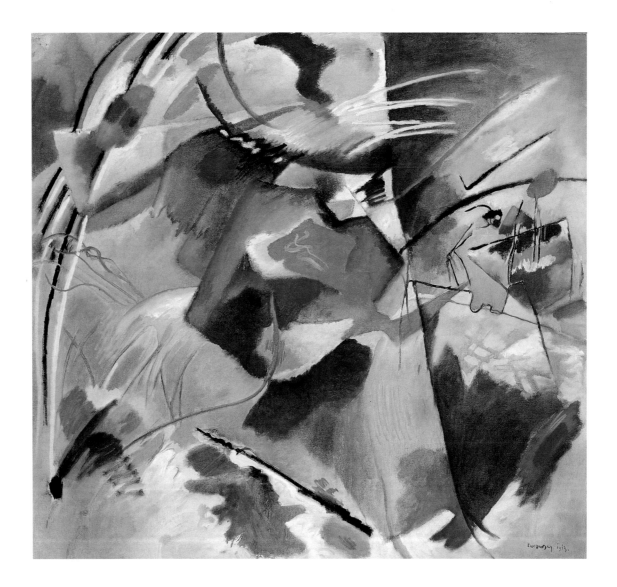

A leading proponent of abstract painting, Vasily Kandinsky was perhaps the most influential artist-theorist of the twentieth century, publishing, in 1911, his seminal text *Concerning the Spiritual in Art.* In this work, Kandinsky argued that the artist performs the role of a visionary in society, and he called for art to move beyond the imitation of natural appearances. The resulting abstract compositions, Kandinsky thought, would "cause vibrations in the soul."

While *Painting with Green Center* relates to the artist's ideas, Kandinsky doubted whether his contemporaries were prepared to accept completely abstract compositions. Therefore, he asserted the need, for the time being, to anchor his compositions with symbolic images in order to help move viewers almost subliminally toward pure abstraction. From 1910 to 1914, in quasi-abstract pictures with titles such as *Last Judgment* and *Resurrection,* Kandinsky envisioned the destruction of a materialistic civilization and the dawn of a new spiritual age that would embrace abstraction.

The symbol for Kandinsky of the benevolent forces that would prevail in the struggle between good and evil was a knight on horseback. This metaphor in fact gave the circle of German Expressionist artists (see p. 29) over which he predominated in Munich its name: the Blaue Reiter (Blue Rider). In *Painting* a knight is represented by his lance, a black vector (bottom center), which points toward Kandinsky's symbol for materialism, a dragon, reduced to a brown zigzag (lower left). Another of Kandinsky's apocalyptic images is a trumpet announcing the end of the world, which in the Art Institute canvas appears as a pale green, pink, and gray triangle at the upper left-hand corner. On the right, a schematic city with two spindly towers trembles on a hilltop suggested by an arcing black line. Eventually, the artist eliminated such motifs to devote himself to total abstraction.

# Franz Marc

## *The Bewitched Mill,* 1913

Oil on canvas; 130.2 x 69.2 cm

Among the German Expressionists—artists who, in the first decade of the century, began to use strong coloration and exaggerated forms to express emotional content—Franz Marc was unique for his empathic interest in the life of animals. "Is there a more mysterious idea for an artist," he wrote, "than to imagine how nature is reflected in the eyes of an animal?—How does a horse see the world?" Beginning in 1905, Marc devoted himself almost entirely to animal painting, a genre that allowed him to express his pantheistic vision of nature.

Similar to his friend and fellow member of the Blaue Reiter (see p. 28) Vasily Kandinsky, Marc rejected verisimilitude as the goal of painting, believing that form and color should serve abstract or symbolic ends. He developed a personal color system in which blue signals the male principle and spirituality; yellow, the female principle and passivity or gentleness; and red, materiality, which Marc believed should be opposed by other hues. The compressed space, prismatic shapes, and dynamic movement of the figures in *The Bewitched Mill* reveal the influence of Cubism (see p. 18) and Orphism (see p. 26). Resembling origami animals, four birds, a small horse, and a roe merge with a cascading stream that turns a rustic waterwheel.

Marc painted the idyllic scene following his return to Bavaria from a sojourn in the southern Tirol with his fiancée, Maria Franck. The Italian town of Merano, with its mountain peaks, towers, and suspension bridges, enchanted the artist. The work's title refers to the "magical" harmony he sensed there between human industry, represented by the houses and mill on the left, and the lyrical region of trees and animals on the right. Indeed, *The Bewitched Mill* imagines a union of organic and inorganic realms, purified and powered by a watery grace from above.

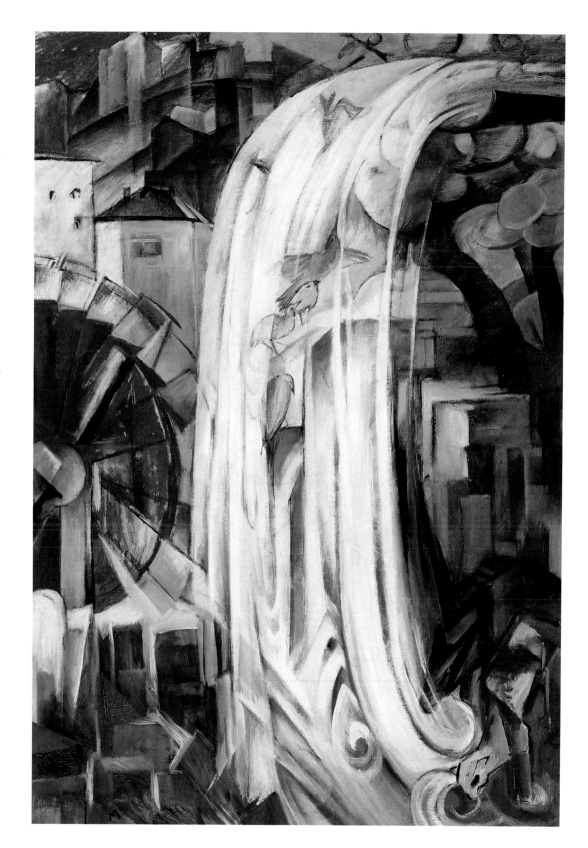

**Giorgio de Chirico**

*The Philosopher's Conquest, 1914*

Oil on canvas; 125.1 x 99.1 cm

This painting dates from Giorgio de Chirico's greatest and most influential period, the years 1911 to 1917. He was one of the first artists to concentrate on evoking a psychic rather than a material reality through incongruous juxtapositions of objects, thus foreshadowing the central goal and one of the principal techniques of Surrealism (see p. 55).

In this painting, de Chirico deployed a repertoire of images that he was to combine and recombine in many other works: the vast, empty spaces; the mysterious archways; the long, eerie shadows; the train, clock, and factory chimneys. An aching melancholy pervades the scene. The warmth and bustle of human activity seem to have receded from this place of stillness and silence. Only distant or menacing traces of human activity remain: the train and ship far in the background, dwarfed by the factory chimneys; the shadows of two unseen figures; the cannon jutting out of the left edge of the picture, with its two cannon balls provocatively stacked above it; and, in the foreground, two huge, spiky artichokes, which discourage the viewer's approach, keeping the spell of the scene behind them unbroken.

While individual objects are rendered realistically, there is no bravura in de Chirico's approach to painting. The forms are depicted in a flat, simplified, almost crude manner, and are either starkly silhouetted, as is the train and clock, or heavily outlined in black, with an intentional lack of sophistication. The painting's shifting, skewed perspective perhaps reflects the influence of Cubism (see p. 18). The artist's skill clearly lies not in a traditional display of realism, but in the strength of his compositions and in the telling choice and placement of objects.

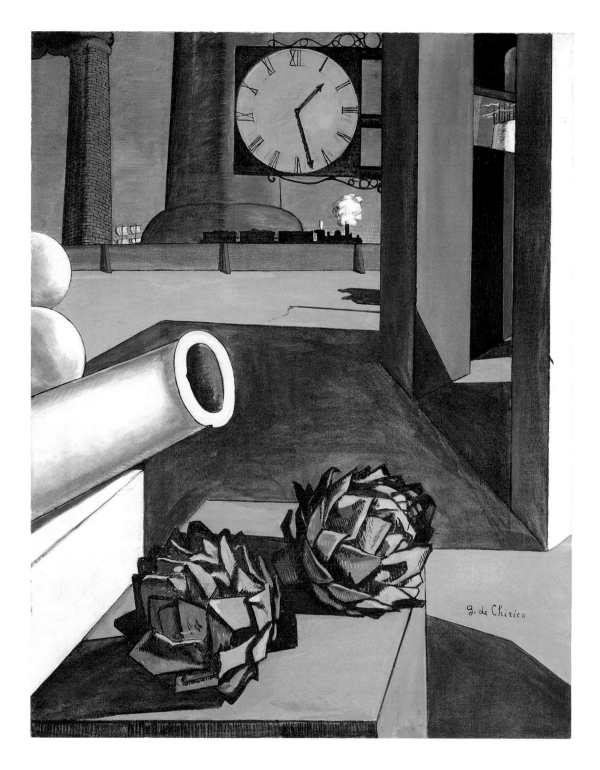

# Juan Gris

## The Checkerboard, 1915

Oil on canvas; 92.1 x 73 cm

Hailed as "the perfect painter" by the avant-garde writer Gertrude Stein, Gris worked in an Analytic Cubist style (see p. 19) until he came under the influence of the collages his friends Georges Braque and Pablo Picasso began to make in 1912, which led all three artists to develop the second, Synthetic phase of Cubism. The introduction into their work of fragments of real objects inspired the creation of images that are more analogous to visual reality and emblematic of it than Analytical Cubist works. As Gris stated, "Cézanne turns a bottle into a cylinder, but I begin with a cylinder and . . . make a bottle."

The flattened composition, overlapping planar forms, and rhythmic patterns of *The Checkerboard* reinforce the two-dimensional nature of the picture's surface, while the use of trompe-l'oeil effects, deeply saturated colors, strong light and dark contrasts, and precise definition of forms gives the still life an extraordinary physical reality and clarity. The tension between two and three dimensions is reinforced by the complex arrangement of silhouettes and shadows, which conflates distinct objects—bottle, newspaper, table—and fragments others that would otherwise be continuous, such as the checkerboard. Checkerboards figure frequently in Gris's work; their gridlike appearance and evocation of a popular game apparently allude to the sophisticated artistry and artificiality that Gris believed underlie the making of art.

Gris differed from Braque and Picasso in his more deliberate working manner. Whereas Picasso playfully added one element to another, Gris began with an overall compositional scheme or framework from which his forms developed. Despite this more methodical approach, the artist, who illustrated poetry books and occasionally wrote poetry himself, maintained that his paintings were above all evocations of his emotional response to his subjects.

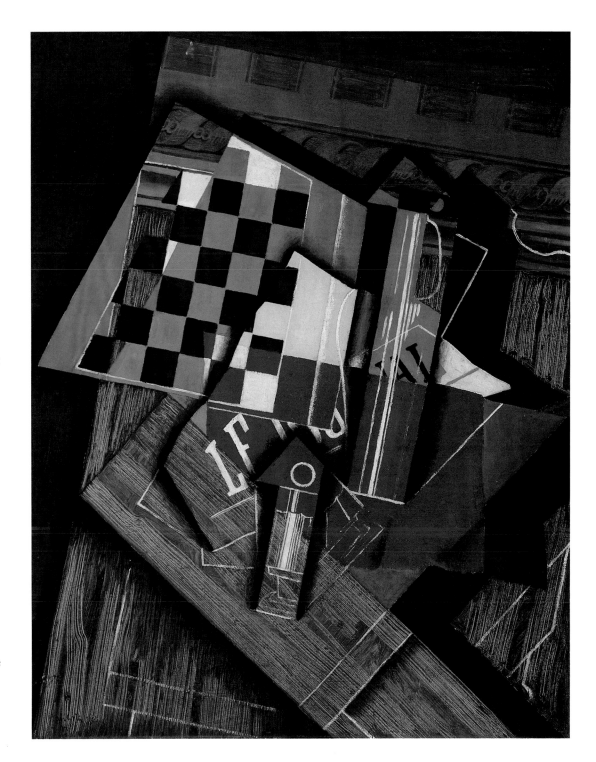

Bronze; 185.4 x 71.1 cm

"I think you are going to be happy with . . . the large figure," Gaston Lachaise wrote in 1915 to Isabel Dutaud Nagle, the model for *Standing Woman*. He added, "I want to create a miracle with it . . . as great as you." Lachaise immigrated to the United States in 1906 in part to be near Mrs. Nagle, a Bostonian matron he had met in France around 1901 and whom he was finally able to marry in 1917. While Lachaise conceived *Standing Woman* around 1912 and exhibited it in a plaster version in 1915, he did not cast the figure in bronze until 1927. Of the twelve extant statues of *Standing Woman*, the Art Institute's example is one of only four that were cast during the sculptor's lifetime.

Dubbed "Elevation" at its first showing, the figure stands on tiptoe, scarcely touching the slight rise of ground on which she is poised. The earthlike quality of her base suggests that she is outdoors, communing with nature; her closed eyes and enigmatic gesture (one hand opens toward the viewer, the other reaches up to her cheek) indicate that this experience fills her with rapture. The figure's gracefully arched feet and long, slender legs support a voluptuous torso that recalls the exaggerated contours of ancient goddess images. Like these figures, she features a disproportionately small head and nipped-in waist, which accentuate the volume of her swelling hips and breasts. The smooth, reflective surface and subdued, lustrous patina of brown and black also serve to enhance her allure. While definitely reflecting the looks and bearing of its model, *Standing Woman* represents Lachaise's first full-scale expression of the idealized female form that would come to dominate his art.

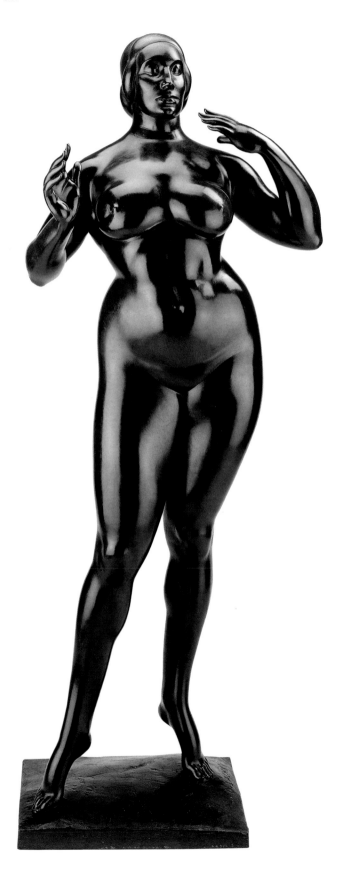

# George Bellows

## *Love of Winter,* 1914

Oil on canvas; 81.4 x 101.6 cm

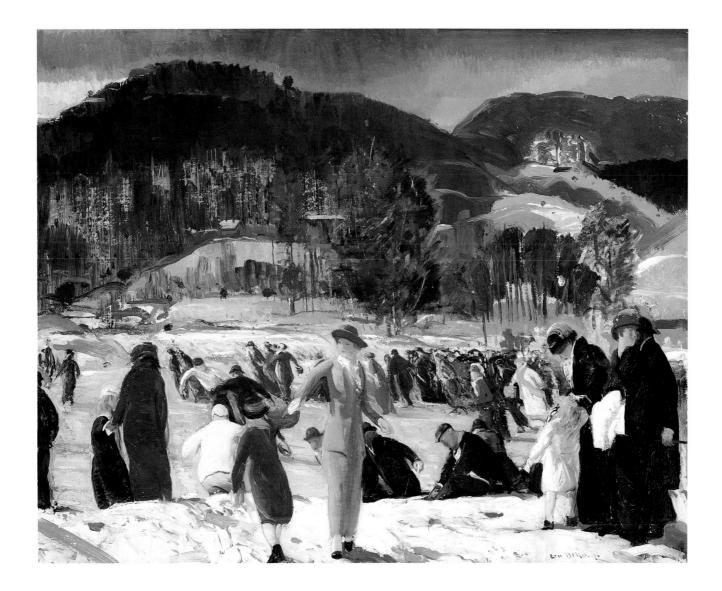

In a letter dated January 15, 1914, George Bellows lamented to a friend, "There has been none of my favorite snow. I must paint the snow at least once a year." Receiving his much-wished-for snowfall just one month later, the painter executed this vigorous scene of skaters and onlookers assembled in New York City's Central Park.

Here, Bellows skillfully counterpointed the background of the composition, an expanse of blue-gray hills and trees, with the boldly colored and vigorously rendered figures in the fore- and middle grounds. A pendant to *Love of Winter,*

titled *A Day in June* (The Detroit Institute of Arts), exhibits a similar composition. At the center of the Chicago canvas is a mother and child (perhaps the artist's wife, Emma, and daughter Anne), who, with the nearby women and children, function to offset the horizontal line of swiftly moving skaters behind them. Painted in contrasting colors and moving in opposite directions (the child turns abruptly back toward the skaters), the two figures add a note of dissonance to the otherwise harmonious scene.

A student of the influential teacher and painter Robert Henri, Bellows produced his first view of Central Park in 1905 and, in 1907, his first work

on the subject for which he is best known: the boxing match. With Henri and six other painters, he participated in a now-famous 1908 exhibition featuring realistic works often focused on gritty aspects of New York City street life. For this reason, some members of this group, which was dubbed "The Eight," later became known as the "Ashcan painters." While *Love of Winter* is a definitely picturesque urban scene, it does feature the kind of lively action that Henri and his peers favored.

## Diego Rivera

### Portrait of Marevna Vorobëv-Stebelska, c. 1915

Oil on canvas; 146.1 x 115.6 cm

The twentieth century's foremost mural artist, Diego Rivera had a brief, but sparkling, career as a Cubist painter from 1914 to 1918. After years of rigorous art training at the Academia de San Carlos in Mexico City, he traveled throughout Europe from 1907 to 1910. In 1912 Rivera settled in Paris, where he befriended other emigré avant-garde artists, such as Amedeo Modigliani and Piet Mondrian. During World War I, Rivera became a leading member of a group of Cubist painters that included Albert Gleizes, Juan Gris, and Jean Metzinger.

The subject of Rivera's portrait is his lover at the time, Marevna Vorobëv-Stebelska (1892–1984), a Russian emigré painter and writer. Photographs of the sitter, which show her distinctive bobbed hair, blond bangs, and prominent nose, reveal Rivera's gifts of observation here. Seated in an overstuffed armchair, she turns away from the book she holds in her lap, as if momentarily—perhaps angrily—distracted. Vorobëv-Stebelska is stylishly dressed in a gold-brocade bodice (the design borrowed from a wallpaper pattern), white sleeves, and a dress whose shape hints at a pair of crossed legs. To her right appears a green, *faux-marbre* form that may be a fireplace, and, behind her, a schematically rendered window and shutters. In this Synthetic Cubist composition (see p. 31), Rivera used color to suggest spatial recession, making the planes meant to be closer to the viewer brighter than those at further remove. The painting's somber and rich color harmonies recall the palette of Gris.

Following World War I and the Russian Revolution, Rivera, like many other artists in Paris, rejected Cubism as frivolous and, thus, inappropriate for the new age. In 1921 the painter returned to Mexico, where he began to produce work for which he is acclaimed today: paintings, graphics, and, above all, murals depicting Mexican political and cultural life.

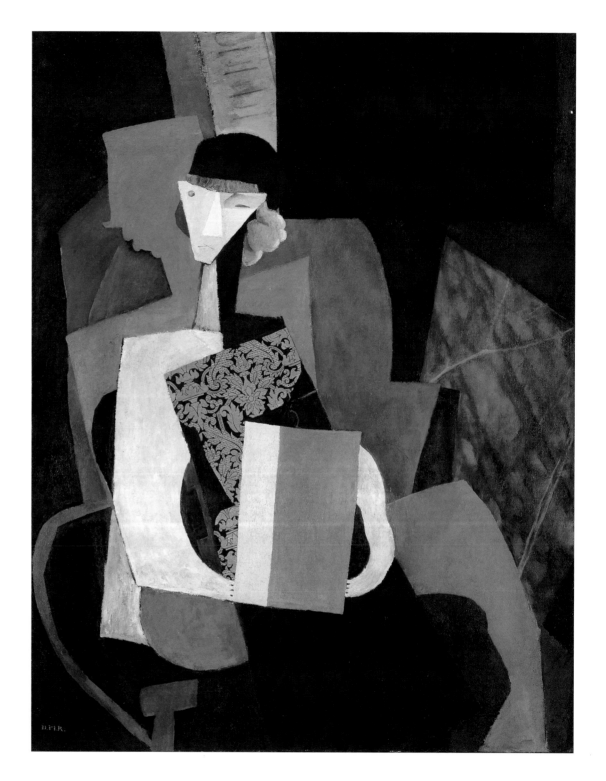

# Pablo Picasso

## Untitled (Man with Mustache, Buttoned Vest, and Pipe, Seated in an Armchair), 1915

Oil and sand on canvas; 130.2 x 89.5 cm

In contrast to the elusive forms and shimmering surface of Picasso's portrait of Daniel-Henry Kahnweiler (see p. 20), the seated personage in *Untitled* is brightly silhouetted against a darkened ground and is composed of elements that read with the harsh clarity of painted stage flats or playing cards. A brilliant example of Synthetic Cubism (see p. 31), Picasso's image of a man with a pipe exhibits multiple modes of representation and a riotous vocabulary of forms.

Allusions to playing cards, which are a persistent motif in Picasso's oeuvre, abound in this work. The insistent frontality and flatness of the smiling man in the bowler hat resembles that of a face card, and the seemingly endless visual puns stir associations with cards (games, sleight of hand, magic, and fortune-telling). Fakery of all kinds is indicated by the trompe-l'oeil decorative borders at the left, which rhyme with everything from the curves of the man's mustache and of his fingers, to the shape of his pipe and the scrolls of his chair. Also included are three different types of *faux-marbre* and large areas of stipple patterns that suggest visual static and refer mockingly to the act of painting itself.

Despite the spirited display of pictorial games, the painting has a slightly sinister cast. The smile can be read as a grimace; and the one downcast, or inward-looking eye, is paired with another that is button-shaped, blank, and perpetually open. Picasso executed this painting at a moment when he found himself isolated in wartime Paris, while the poet Guillaume Apollinaire and painters Georges Braque and André Derain, as well other close associates, were serving at the Front. Its foreboding aspects anticipated the Dada and Surrealist works that emerged after the war.

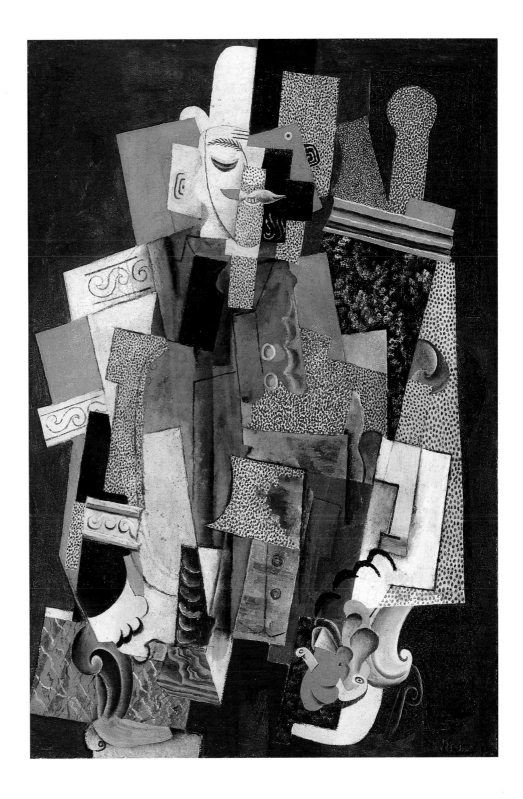

## Movements, c. 1915

Oil on canvas; 119.7 x 120 cm

In 1893 Marsden Hartley left his native town of Lewiston, Maine, for Cleveland, where he attended art school and then secured a scholarship to study painting in New York. The artist invested his early landscape paintings with an almost supernatural intensity, inspired by his interest in the transcendentalist philosophy of Ralph Waldo Emerson and in Eastern religion and mysticism. In 1909 Hartley became acquainted with the photographer and dealer Alfred Stieglitz, who immediately gave him a one-person show at his "291" gallery and raised funds to send him to Europe in 1912.

Although exposed to an extensive collection of French modernist art at the Paris salon of Americans Gertrude and Leo Stein, where he was a frequent guest, Hartley was drawn to German art. He was particularly impressed by the anti-materialist, spiritually based works of Vasily Kandinsky and Franz Marc, whom he met during two extended sojourns, between 1913 and 1915, in Germany. There, Hartley created works that combine the rigorous geometries of Cubism with the lyric, mystical abstraction of the Blaue Reiter group (see p. 28).

In late 1914, Hartley initiated a series of abstractions featuring flags, medals, and fragments of uniforms in memory of a beloved friend, a German officer who had died in combat. The culmination of his war-motif paintings, the undated *Movements* can be attributed to the end of his stay. Vigorously brushed and boldly colored, the heavily outlined zigzags, chevrons, and arcs in this totally abstract work swerve around the central motif of an engorged red disk. Another circular form, this one white and yellow, seems to hover above the apex of a black triangle. With its turbulent energy and imagery at once suggesting coiled snakes and zones of heaven and hell (the title of one of Hartley's Berlin paintings), *Movements* sparks associations that are both erotic and apocalyptic.

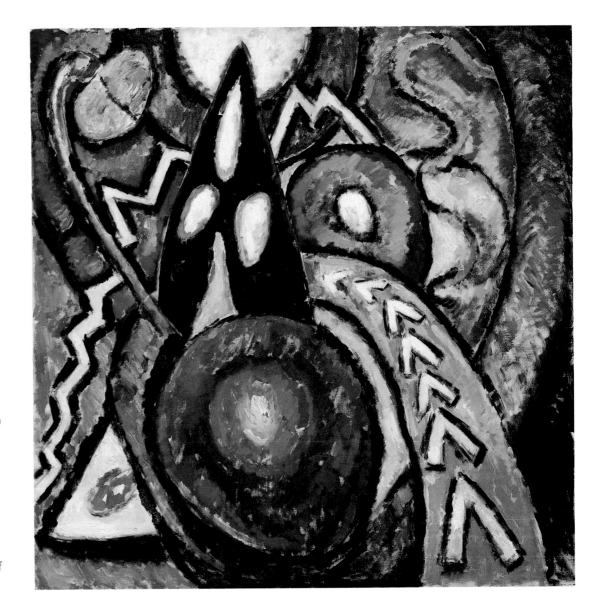

# Henri Matisse

## Apples, 1916

Oil on canvas; 116.8 x 89.4 cm

In this extraordinary still life, Henri Matisse captured the simple geometry of a group of apples by placing them in a round basket that rests upon a circular table, observed from above. Beginning in 1906, the artist created two distinct versions of each of a half-dozen major paintings, including *Apples*. Unlike the table in the apparently earlier version of this painting (The Chrysler Museum, Norfolk), only one of the table's legs is visible here, and barely so; it divides the black background on the left side of the canvas from the intensely lit background on its right. The tabletop and the basket's circular bands, extended onto the table by their shadows, seem to float in space, creating the illusion that the basket is spinning.

Matisse's abstract treatment of space in *Apples* is paradigmatic of his efforts to delineate the limits of two-dimensional painting. Like Paul Cézanne, whose still lifes of apples heralded an era of total abstraction, Matisse endeavored to capture the structural qualities of three-dimensional objects on a two-dimensional surface. Other of his still lifes painted around this time often feature an aquarium with goldfish, whose floating shapes and reflections effectively symbolize the shifting, back-and-forth quality of visual experience.

Given its focus on interacting bands of color, *Apples* may also represent Matisse's most direct response to Frantisek Kupka's and Robert and Sonia Delaunay's abstract paintings of suns, moons, and prism effects from the early teens, among the first totally abstract works of art. In *Apples* simple household items are swept up into a swirling interplanetary drama, involving both night and day. Bringing the subject back down to earth, Matisse, with typical informality, left accidental splatters of paint along the right edge of the canvas.

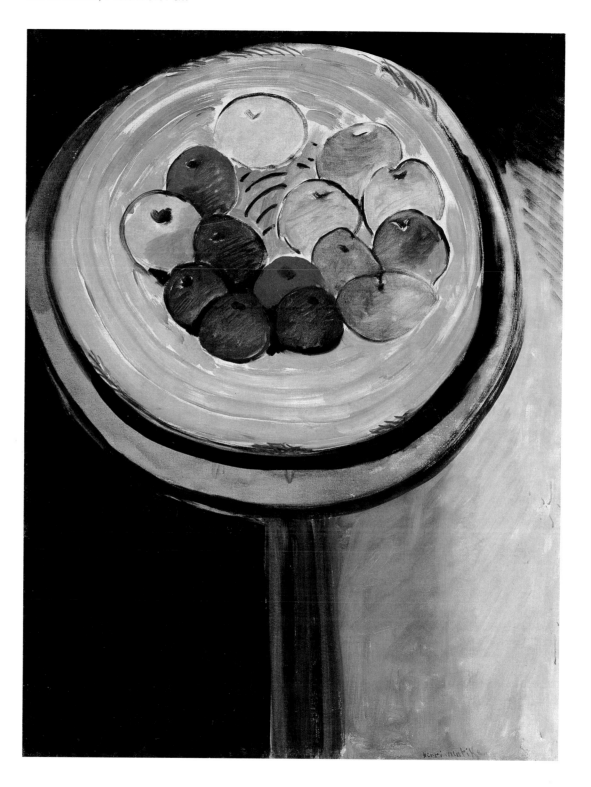

# Amedeo Modigliani

## *Jacques and Berthe Lipchitz, 1916*

Oil on canvas; 80.7 x 54 cm

After study in art academies in Italy, Amedeo Modigliani ventured to Paris in 1906, where he soon joined Pablo Picasso's circle in Montmartre. Three years later, he helped pioneer a general migration of artists to the left-bank neighborhood of Montparnasse. Home to scores of French and emigré artists from all over Europe, many of whom—most notably Modigliani, Jacques Lipchitz, and Chaim Soutine—shared a Jewish heritage, Montparnasse remained the center of avant-garde activity in Paris until World War II. Despite Modigliani's exceptional talent, his work, consisting mainly of portraits and frankly sensual nudes, only found a market after his death, in 1920, which was hastened by the artist's legendary bohemian conduct and a constitution weakened by tuberculosis.

In comparison, the life of the Lithuanian-born sculptor Jacques Lipchitz (1891–1973) was a model of industriousness and rectitude. Once his contract with the dealer Léonce Rosenberg assured him an income, he commissioned Modigliani to paint a portrait celebrating his recent marriage to the Russian poet Berthe Kitrosser. As Lipchitz recalled in his memoirs, Modigliani declared the work finished after only two days of work. However, at the modest price of "ten francs per sitting and a little alcohol," Lipchitz persuaded Modigliani to work on it for another two weeks.

In this nuptial portrait, Modigliani struck a careful balance between wry caricature and a deeply sensitive portrayal of the couple. Nothing in the picture is really plumb, from the features of Lipchitz's face to the painting in the background of the couple's home and the inscription written in clumsy, block letters. Despite the striking distance between the heads of the sitters, the way in which the figure of Lipchitz anchors himself to the back of his wife's chair and his upper torso protectively envelops her captures the sense of strong connection between the new husband and wife.

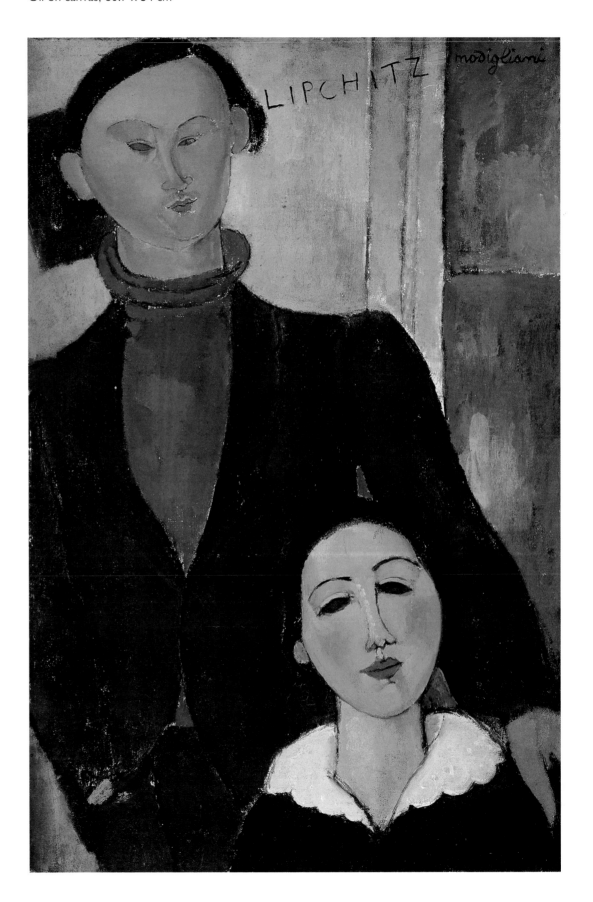

## Natalija Gontcharova

### *Spanish Dancer*, c. 1916

Oil on canvas; 200.7 x 88.9 cm

One of the leaders of the Russian avant-garde, Natalija Gontcharova was among the first artists to rediscover Russian folk art and icons, brilliantly combining their characteristic flatness, simplification, and decorativeness with the most daring aspects of the art of her time. With her lifelong companion, Mikhail Larionov, she pioneered in 1913 a form of painting known as Rayonism. This short-lived movement focused on the dynamic patterns created by rays of light bouncing off the surface of things, giving rise to works that at times achieved complete abstraction. The artist's prodigious output included theatrical designs for the ballets of famed impresario Sergei Diaghilev. *Spanish Dancer* is one of many works inspired by a 1916 visit to Spain and by designs the artist prepared for several ballets with Spanish themes that Diaghilev planned but never realized.

In this painting, Gontcharova gave a virtuoso performance like that of the highly trained dancer she portrayed; both artist and dancer convey a sense of complete control over the elements of their respective art forms. With consummate skill, Gontcharova combined a monumental conception of the figure, which occupies the entire canvas, with effects of great delicacy in the lacy expanses of the dancer's costume. Her palette is restricted to large areas of white animated by touches of gray, pink, and reddish brown and by heavily impastoed passages. The angular planes of the dancer's dress sweep diagonally upward, slicing the air and segmenting the canvas in a manner reminiscent of Cubist, Futurist, and the artist's own earlier Rayonist paintings. The action centers in the woman's dramatically foreshortened arms and in the swirling swaths of drapery, which are anchored by the strong vertical line of her body and the firm carriage of her head. These dynamic elements are combined with dazzlingly decorative areas created by the repetition of certain motifs—lace, fringes, scalloped edges, and zigzags of fan and shawl—in a manner that seems to evoke the vigorous rhythms of the dance itself.

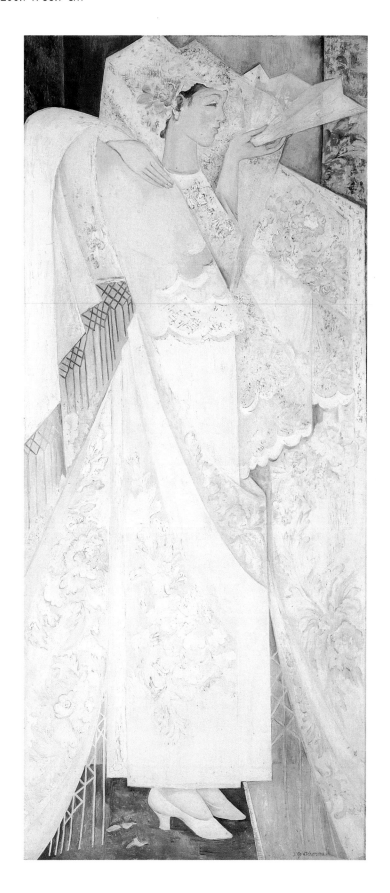

Oil on canvas; 259.7 x 389.9 cm

One of Matisse's most ambitious and moving paintings, *Bathers by a River* began in 1909 as a commission for the Russian collector Sergei Shchukin, who wanted an ensemble of mural-sized works for his Moscow residence. Of the three panels Matisse developed for his Russian patron, Shchukin purchased two, *Dance II* and *Music* (Hermitage, St. Petersburg). Like these paintings, the first version of *Bathers by a River* was a stylized rendering of a pastoral scene, in this instance showing five nude females near a waterfall.

When Matisse returned to the composition in 1913, he eliminated one figure and transformed the remaining ones into starkly hieratic forms, employing faceless ovals to define their heads and thick, black lines to indicate their limbs and torsos. This distinctive contouring, together with the limited palette, gave *Bathers by a River* its sketchlike quality, which the final version also displays. No other work by Matisse appears so close in spirit to the most ambitious figure paintings by his chief rival, Pablo Picasso.

Dissatisfied with the four-figure 1913 version, which is known through black-and-white photographs, Matisse in 1916 again revised *Bathers by a River*. He transformed the blue stream in the 1913 version into a black band, to which he added a white snake; and he isolated the columnar figures against vertical zones of green, black, white, and grayish blue, thereby creating the illusion of shifting space comparable to that made by a folding screen. The stiffly posed, predominantly gray figures resemble plaster sculptures more than they do real flesh. Silhouetted against the light and dark zones at right, these somber figures are now far removed from the graceful inhabitants of the original composition. Scholars have conjectured that the panel's ominous mood reflects Matisse's reaction to World War I, and the threat it posed to the values of art and life that the artist had set out to celebrate in 1909.

Oil on canvas; 130 x 160 cm

Following a period of producing lithographs, paintings, and posters of Parisian scenes in the style of Edouard Vuillard and Henri de Toulouse-Lautrec, Pierre Bonnard virtually reinvented his art, around 1905. The artist's new emphasis on large-scale, expansive compositions; bold forms; and, above all, brilliant colors shows his awareness of the work of modernist masters Henri Matisse and Pablo Picasso, as does his focus on a theme he had not previously explored, Arcadian landscapes.

Part of a series of four canvases painted for his dealers, Jos and Gaston Bernheim, between 1916 and 1920, *Earthly Paradise* exhibits Bon-

nard's new, daring investigations of light, color, and space. Here, foliage is used to enframe and create a prosceniumlike arch for a drama involving a rigid, brooding Adam and a recumbent, languorous Eve. While she recalls the reclining females portrayed in the bacchanals of Renaissance artist Titian, the figure of Adam is closer to Edvard Munch's anguished males. The contrast Bonnard set up here seems to follow a tradition according to which the female, who is essentially sensuous, is connected with nature, while the male, essentially intellectual, is able to transcend the earthly. His open mouth and the gesture of his right arm add a note of wonderment or questioning to the scene.

Heightening the ambiguity is an unusual panoply of animals, including a bird of paradise located near the head of each figure, a heron at the far left, a monkey, two rabbits, and a turkey—considered an exotic bird in France at the time. Only the serpent—here reduced to a garden snake—poised above the woman's hip refers directly to the biblical story. With this canvas, Bonnard presented a paradise that is less than Edenic. Too old to enlist in World War I, Bonnard may have been responding to the destruction of Europe and to his own powerlessness to act in its defense in this melancholic, yet hauntingly beautiful, landscape.

Oil on board; 53.3 x 40.6 cm

At the time he executed *Percolator,* Man Ray had been exposed to current trends in European art through his visits in New York to Alfred Stieglitz's "291" gallery and to the Armory Show of 1913 (p. 19). He had even experimented with Cubism (see p. 18). But in 1915, after the artist met Marcel Duchamp and Francis Picabia, his work took off in a new and radical direction. Expatriates who had immigrated to the United States at the onset of World War I, these French artists debunked Cubism for what they felt was its preoccupation with formal issues. They focused on machine design in their work, a subject they thought effectively captured the tenor of modern-day life.

Duchamp's meticulously rendered paintings of found objects initially inspired Man Ray to experiment with machinelike forms. Painted in an unprecedented slapdash fashion, *Percolator* heralded the antiheroic subject matter and "bad"-painting aesthetic of Dada (see p. 43). Further, this painting launched the artist into a famous series of sculptures incorporating such items as flatirons or metronomes; and it eventually led to his renowned photographs and rayograms of these objects.

Spotlighted in an unearthly way, the percolator filter basket almost seems to be some kind of totem, perhaps of the quotidian. It looks as if it were malfunctioning, the grains of coffee raining down, like Georges Seurat's dots, from the basket designed to contain them. Conceivably, Man Ray limited himself to a "mechanical" palette of grays, as well as utilized a styleless black frame, in an anti-art spirit. However, his choice of colors may represent a response to Duchamp's call for an art addressed to the gray matter of the brain, rather than to the mindless realm of retinal perception.

Perhaps twentieth-century art's greatest icono-clast, Marcel Duchamp became a leading expo-nent of Dada (derived from the most-common first word-sound of infants), a verbal and visual language challenging aesthetic standards and bourgeois values by expressing the nonsensical, accidental, and arbitrary aspects of life. This he and other Dadaists achieved through the intro-duction into their work of games, nonsense words, riddles; unconventional materials; irra-tional juxtapositions; and shocking content such as sexualized imagery. Although the body of Duchamp's work is relatively small (he publicly stopped making art around 1920), it has been enormously influential. Also contributing to

Duchamp's critical importance for subsequent art movements were his occasional, always un-conventional, activities and comments, as well as his extraordinary efforts through the years to support the avant-garde art of his time.

When Duchamp moved to New York from France in 1915, he left behind a bottlerack that he counted as his first Readymade. The term refers to commonplace objects that Duchamp chose for elevation to the status of art, thereby privileging the conception of a work over its execution. This and his subsequent Readymades, such as *Hat Rack,* epitomize Duchamp's belief that art should appeal to the intellect more than to the senses. Although wary of repeating an

idea, Duchamp subsequently singled out a few more objects for display, including a snow shovel and a urinal. All lost, the "originals" were docu-mented in studio snapshots; in 1964, however, a group of them, including *Hat Rack,* were repli-cated in editions of eight under Duchamp's supervision. In photographs the "original" *Hat Rack* is suspended from a ceiling, resembling a spider that hangs by a thread. It casts a web of shadows that Duchamp portrayed in his 1918 painting *Tu m'* (Yale University Art Gallery, New Haven), and points the way toward the mobiles invented some years later by Alexander Calder.

## Suzanne Duchamp

### *Broken and Restored Multiplication,* 1918–19

Oil and silver paper on canvas; 61 x 50 cm

Following in the footsteps of her three older brothers (Jacques Villon, Raymond Duchamp-Villon, and Marcel Duchamp), Suzanne Duchamp went to art school in 1905 and by 1912 began to exhibit Cubist works at the trend-setting Salon d'Automne in Paris. Later, she evolved into a preeminent Dada artist, a direction she took in part because of the seminal role her brother Marcel played in the movement. In 1916 Suzanne met a colleague of Marcel's, the Swiss modernist Jean Crotti. Together with Francis Picabia, the two joined to produce some of the most important paintings of the Dada movement. The dialogue between Suzanne Duchamp and Crotti led to their marriage in April 1919.

*Broken and Restored Multiplication,* with its flat, superimposed disks, refers to the work of Robert and Sonia Delaunay, whose pre-war, quasi-abstract canvases were extolled by the poet-critic Guillaume Apollinaire. His calligrammes (poems with words arranged pictorially) significantly informed Dada art. Reading from top to bottom and left to right, the text of Duchamp's painting, rendered in a variety of typeface styles, can be translated: "The mirror would shatter, the scaffolding would totter, the balloons would fly away, the stars would dim, etc. . . ." The composition's "balloon" disks allude to what Apollinaire designated as the Orphic, or musical, character of the Delaunays' works; and the "scaffolding" in the center refers to the Eiffel Tower, one of Robert Delaunay's hallmark images (see p. 26).

In Duchamp's painting, the tower, turned upside-down, appears enormous in relation to the blue, urban skyline as seen outside a window indicated at the bottom of the composition. The masterful interplay of word and image, color and shape, and of three overlapping, interrelated schemes (typography, disks, and dawn or early-evening sky), anticipated the whimsy of later, Surrealist compositions by Joan Miró and others.

**Fernand Léger**  *The Railway Crossing* (Preliminary Version), 1919

Oil on canvas; 54.1 x 65.7 cm

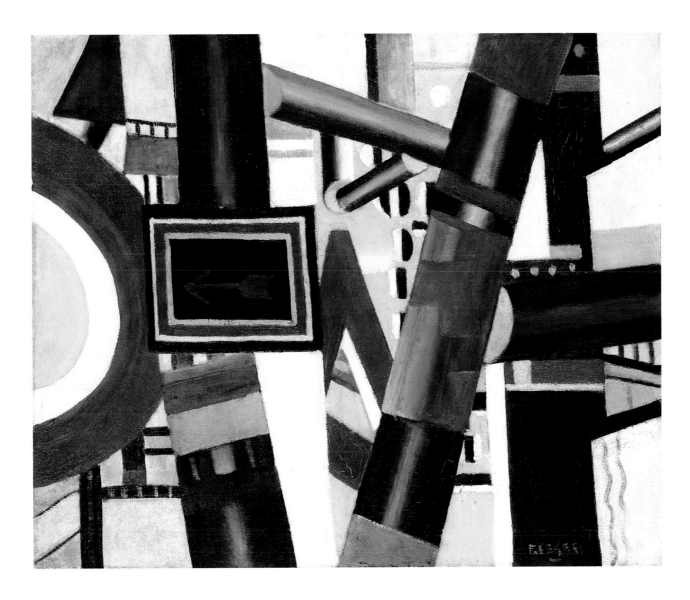

Like Robert Delaunay's *Champ de Mars: The Red Tower* of 1911 (see p. 26), Fernand Léger's *Railway Crossing* is a paean to modernity—its dynamism, energy, and movement. Unlike Delaunay's work, however, this painting contains no specifically recognizable objects, except the directional sign with the arrow. Inspired by a railroad crossing, Léger used the new visual language he had created with the fragments, colors, and shapes of his environment to evoke the rich sensations of modern industrialized life. Tubular beams appear to intersect the surface, evoking both the pistons of a machine and the open,

metal structures used in modern construction. Other forms, such as the circular, targetlike shape on the left, the stripes that proliferate throughout the painting, and most obviously the directional sign with the arrow, seem to have been inspired by the colorful, simplified geometry of railroad and street signs, and by the loud, attention-getting designs of billboards and posters. In this respect, Léger influenced a number of American painters, from Stuart Davis to the Pop artists (see pp. 116–17).

The railroad crossing, a subject epitomizing the noisy mechanical world that Léger loved, had first been painted by the artist as early as 1912.

In 1919 he took up the theme again, making a number of drawings and oil sketches, including the Art Institute canvas, in preparation for a much larger, finished painting of the same year (Raoul Laroche collection). The Chicago version already contains the major compositional elements found in the final work. There is, however, one dramatic difference: for the final painting, Léger decided to turn the entire composition upside down, in what amounts to a declaration of the painting's complete autonomy from literal representation.

# Georgia O'Keeffe

## Blue and Green Music, 1919

Oil on canvas; 58.4 x 48.3 cm

A 1917 review of Georgia O'Keeffe's first solo show emphasized the musical aspect of her art: "Of all things earthly, it is only in music that one finds any analogy to the emotional content of [her] drawings." That music should inform the artist's work was natural: O'Keeffe both played the violin and studied art at a time when students were asked to respond visually to music. While the invention of the phonograph made this activity possible, the idea that painting could aspire to the abstract expression of feeling found in music harkens back to the nineteenth century.

In his influential text, *Concerning the Spiritual in Art,* which O'Keeffe greatly admired, Vasily Kandinsky emphasized that artists should make music their guide when creating. "Color is the keyboard," he wrote, "The eye is the hammer [and] the soul is the piano, with its many strings." Kandinsky's writing and art loomed large for the artists of Alfred Stieglitz's "291" gallery in New York, where O'Keeffe first showed her work and encountered avant-garde art.

Three or four important abstract paintings by O'Keeffe, which were inspired by the landscape around Lake George, New York, explore the relationship between color and music. While specific natural objects are hard to discern, the landscape references are, nevertheless, pervasive. In *Blue and Green Music,* the triangular blue patch in the right-hand corner of the canvas evokes the sky, while the green and black wedges and fluid white forms in the middle suggest tree trunks or leaves animated by wind. The overlapping white scalloped forms in the lower left-hand corner also seem biomorphic. Together, these shapes powerfully express cosmic harmonies of rigid and fluid, light and dark, small and vast, near and far.

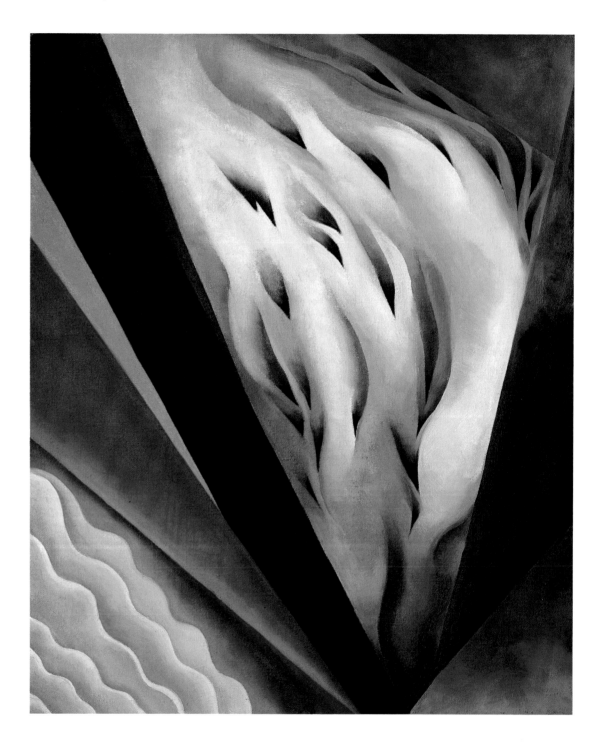

## Charles Demuth                    *Spring,* c. 1921

Oil on canvas; 56.2 x 61.3 cm

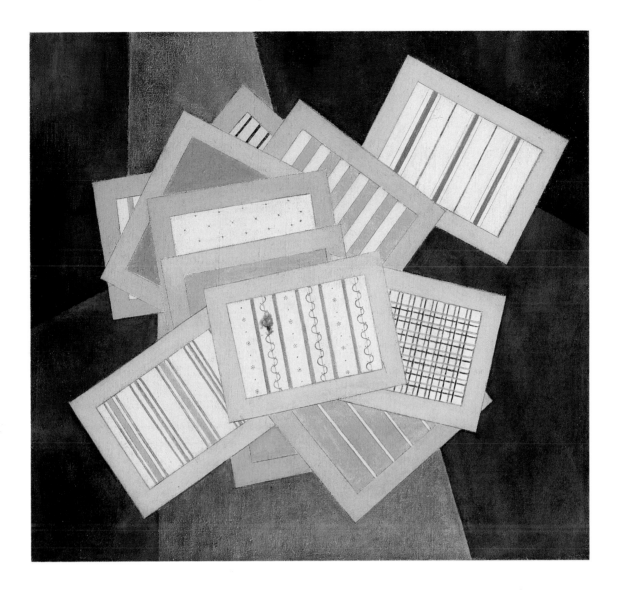

Although he had visited the Paris salon of the American expatriate writer Gertrude Stein, and was associated with the vanguard circles of collector Walter Arensberg and impresario Alfred Stieglitz in New York, Charles Demuth did not absorb the lessons of Cubism until late in 1916, when he worked with his friend Marsden Hartley. Inspired by Hartley, who had just returned from Europe, to experiment with the Cubist techniques of faceting and overlapping planes of color, Demuth went on to develop his best-known works: the images of vernacular-style churches and factories of his lifelong home, Lancaster, Pennsylvania.

With their crisply delineated forms and planar geometries, these paintings present a distinctive style that came to be known as Precisionism.

One of Demuth's most atypical compositions, *Spring* is both simple and delightfully sophisticated. The title refers to the twelve painted, overlapping samples of cotton fabric that are splayed across a faceted plane of molasses brown. Rendered in delicate shades of lavender, pistachio, and blue, the solid and patterned samples represent the swatches used to promote a new fashion line. Inspired by Marcel Duchamp's and Francis Picibia's use of machine imagery as metaphors for human behavior, Demuth here employed items of commerce to evoke nature.

*Spring* also represents a peculiarly Yankee type of Cubism in its fusion of the overlapping, flat planes of Pablo Picasso's Synthetic Cubist style (see p. 31) with the trompe-l'oeil still lifes of nineteenth-century American painters such as William M. Harnett and John Frederick Peto. Discovering the lyrical in the mundane, the work also parallels the clear, efficient poetry of Demuth's friend the poet William Carlos Williams, who dedicated his book *Spring and All* (1923) to the artist. Demuth in turn paid homage to the poet with the greatest of his so-called "poster portraits," *I Saw the Figure in 5 in Gold* (1928; The Metropolitan Museum of Art, New York), which was inspired by Williams's poem "The Great Figure."

Bronze, stone, and wood; h. 217.8 cm (with base)

Throughout his career, Constantin Brancusi focused on a small number of themes, such as the *Sleeping Muse* and the *Bird,* which he developed through a rich series of variations. Each version became a unique meditation on a primary form through subtle changes in proportions, material, and surface. Around 1910 Brancusi embarked on a series of close to thirty *Bird* sculptures. He called the earliest versions *Maiastra,* referring to a bird in Romanian folklore that leads Prince Charming to his princess. In several early *Maiastras,* Brancusi first used the highly polished bronze we see in *Golden Bird.* By mirroring the surrounding space, this reflective surface enabled the artist to integrate object and setting with unprecedented intensity.

Compared with preceding *Bird* sculptures, the Chicago version is more elongated and simplified. The sculptor suggested details such as feet, tail, and upturned crowing beak through elegant inflections of a single silhouette; and his streamlining of the *Bird's* form may have been prompted by his admiration for machine design. That Brancusi was challenged by new technology is revealed by an incident at the 1912 Paris Air Show. Reportedly, when he visited the exhibit with Fernand Léger and Marcel Duchamp, the latter turned to him and exclaimed, "Who could better the propeller? Tell me, can you do that?"

*Golden Bird* was purchased in 1920 by the New York lawyer John Quinn. Deeply concerned with the presentation of his sculptures, Brancusi in 1922 sold Quinn several new bases that he had designed, including the one now supporting *Golden Bird.* Brancusi himself placed *Golden Bird* on this base in 1926, when he went to New York to oversee an exhibition of his works. This show subsequently traveled to the Arts Club of Chicago, which acquired *Golden Bird* in a far-sighted gesture that has made this sculpture a symbol of the city's support for modern art.

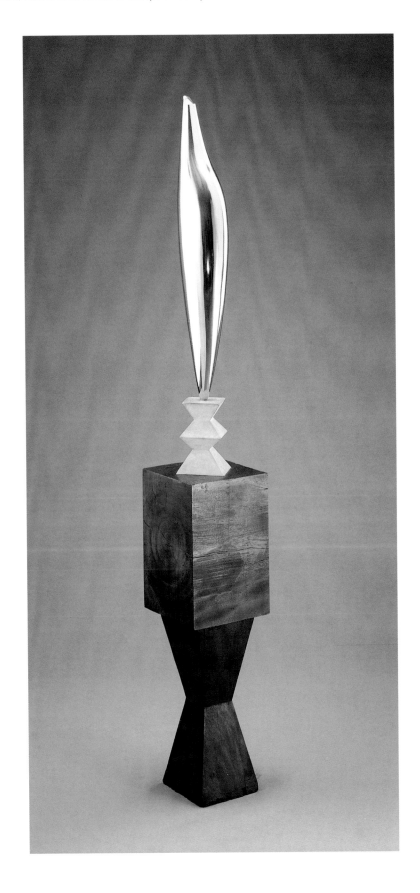

Oil on canvas; 60 x 60 cm

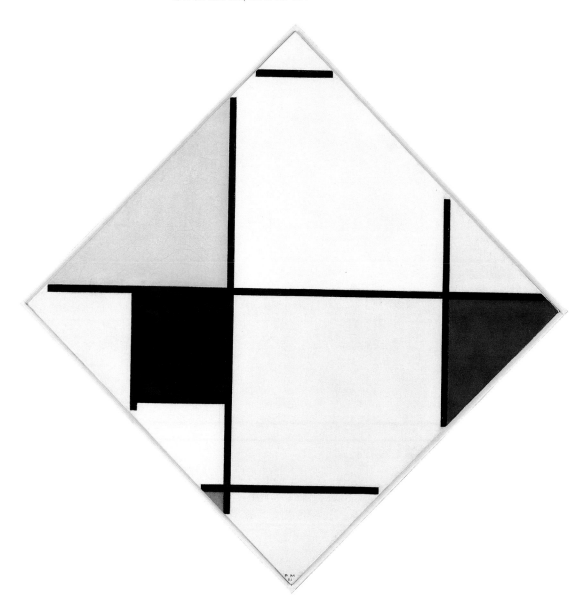

Among the first artists to paint in a wholly abstract style, Piet Mondrian sought to convey what he saw as the dualistic, but harmonious, energies of the natural world (such as male/female, aggressive/passive, light/dark) through his grids of horizontals, verticals, and primary colors. While his early paintings are moody, dark-toned landscapes, his renderings of trees, buildings, and water became increasingly fractured under the invigorating influence of Cubism, a style he encountered upon moving to Paris in 1911. Eventually Mondrian went beyond the

Cubists, eliminating all vestiges of naturalistic imagery from his work to create a visual language of extreme purity.

While he primarily produced rectilinear compositions, Mondrian began experimenting with the diamond in 1918–19, believing this shape to be more conducive to expressing the "expansion, rest, and unity" of nature than the square. *Diagonal Composition,* the fifth of his sixteen diamond-shaped works, plays upon a basic opposition between the diagonal edges of the canvas and the horizontal and vertical bars of the artist's customary grid. A single, blue trapezoid

on the right side of the composition audaciously counterbalances the three flatly painted and tightly clustered color areas on its left. These vivid color zones also highlight the clarity and spaciousnesss of the column of four white sections running from the top to the bottom of the diamond. That the black bars of the organizing grid do not extend fully to the edges of the canvas gives the whole an immaterial quality, as if to intimate that this grid represents only one of many designs that can be found in the dazzling white void of the universe.

# Henri Matisse

## Interior at Nice, 1919 or 1920

Oil on canvas; 132.1 x 88.9 cm

Henri Matisse was particularly drawn to the French Mediterranean coast, with its intense light and opulent colors, as well as to the mélange of civilizations that had inhabited or influenced the area, from the ancient world to Europe and North Africa. From 1917 on, he arranged to work part of most years in Nice. The Art Institute's *Interior at Nice* is a major example of his first phase there, when his room at the Hôtel Mediterranée was his main subject.

In the painting, Matisse meditated on a favorite theme—an interior with a window view to the outside. In such compositions, he could link internal and external space into a continuum structured by patterns and modulated by light. Here, daylight enters the room directly and indirectly; it is baffled by slotted shutters, reflected from the panes of the open window, and filtered through the fanlight and the white curtains. Repeated and displaced by the play of light, the linear shadow cast by the design of the fanlight on the curtain at the right introduces a sense of rhythm and fluidity that pervades Matisse's composition, most notably in the residue of lines at the bottom left that indicate where he initially placed the dressing table and chair before moving them to the right.

The apparently accidental rhyming of pictorial thought and afterthought is extended by the more overtly intentional harmony of pattern between the petaled fanlight and scalloped chair back, and between the upholstery pattern and the floor tiling. The floor and chair are observed from above, as if the artist were on a ladder, while the back of the room is seen from a seated position. Indeed, the vibrancy of this painting results in part from Matisse's portrayal of constantly shifting observations.

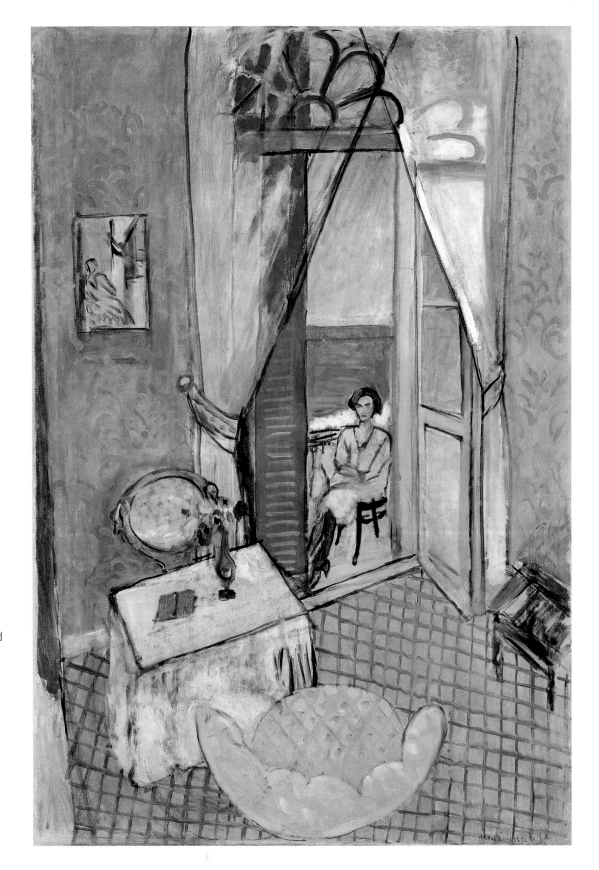

## *Mother and Child* (with fragment), 1921

Oil on canvas; 142.9 x 172.7 cm, fragment 143.4 x 44.3 cm

 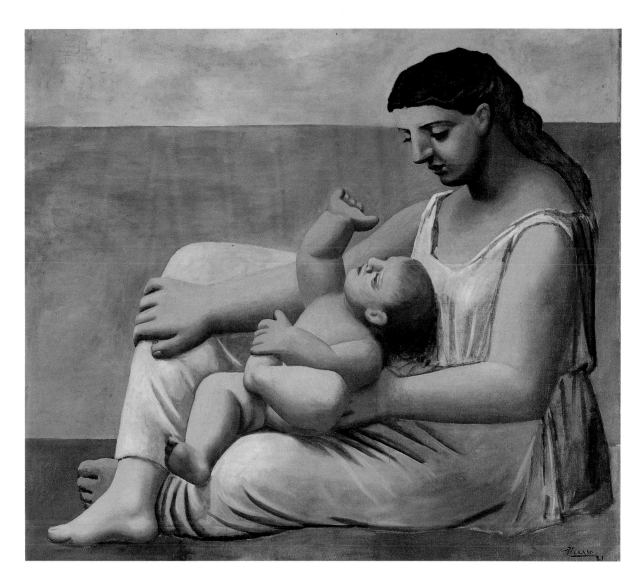

Contemporary art enthusiasts were stunned when Pablo Picasso abandoned Cubism for a traditional figurative style, around 1918. Inspired by the ancient and Renaissance art he saw while in Rome designing sets and costumes for a ballet troupe, the artist began painting heavy-set figures in a neoclassical mode. Equally galvanizing for Picasso were nineteenth-century artist Jean Auguste Dominique Ingres's exquisitely modeled odalisques and Pierre Auguste Renoir's late works of oddly proportioned nudes in Arcadian settings. The most important collector of Picasso's new canvases, New York lawyer John Quinn, purchased *Mother and Child* in 1922.

Having married Olga Koklova, a Russian dancer, in 1918, with whom he fathered his first child, Paolo, in 1921, Picasso was drawn over the next four years to images of mothers with children. The largest and stateliest work on this theme, the Art Institute's canvas portrays a mother, cloaked in a garment evocative of Grecian robes, gazing tenderly at her squirming infant. Behind them stretches a spare background of beach, sea, and sky, which, empty and still, accentuates the mother's calm expression. Picasso's graceful rendering of the boy—shown pulling his foot close and bending his hand backward—reflects the artist's careful observations of his young son's flexibility, as well as anticipates the languid,

gymnastic sexuality typical of works he did in the late 1920s and 1930s in a Surrealist vein.

When he was visited by the Chicago architect William E. Hartmann in 1968, Picasso explained that the Art Institute painting was initially larger. He gave Hartmann the fragment he had removed from the painting's left side, of a seated male nude, who, at one point, dangled a fish above the child. Although the reasons for the artist's decision to remove the figure are unknown, it is possible that Picasso felt it to be squeezed in and superfluous to the composition.

# Alexandra Exter  *Robot,* 1926

Cardboard, fabric, wood, glass, and string; h. 50.8 cm

Exter belongs to an unusually large group of women, including Natalija Gontcharova, Liubov Popova, Varvara Stepanova, and Nadezhda Udaltsova, who made major contributions to Russian avant-garde art. Like Gontcharova, Exter found a creative outlet for her multifaceted talent in stage, ballet, and even film design. *Robot* is in fact one of a series of marionettes the artist made in 1926 for a film that was never realized.

*Robot* is constructed of simple, geometric shapes, in strong, flat colors, inspired, like the works of Exter's close friend Fernand Léger, by the modern urban and industrial landscape. Particularly imaginative are her renderings of the marionette's head and torso. Exter chose a box-like shape for the head, placing a pane of clear glass where the face would normally appear. By using this transparent material, the artist indirectly and playfully alluded to the faculty of sight. The construction of the torso likewise humorously suggests its function. It is composed of a stepped sequence of cardboard cubes of different sizes, open at the sides. Capable of expanding and contracting like an accordion, these cubes simulate the chest's movement in breathing. On the front and back of the figure, Exter collaged, stenciled, or painted various numbers based on the bold typography found on modern billboards, directional signs, and posters. In this work, Exter drew, with great wit and ingenuity, upon many of the most revolutionary developments in early twentieth-century art: the widespread fascination with machines and mechanical beings; the use of unorthodox materials; the trend toward geometric abstraction; and an expanded definition of art to include previously neglected traditions—non-Western art, folk art, the applied arts, and, in this case, the puppet-theater.

**Francis Picabia**

*Woman with Matches,* **c. 1924**

Oil on canvas with wooden matchsticks, hairpins, coins, leather hair rollers, and string; 92.1 x 73 cm

This work and a closely related version of it (private collection, Paris) belong to a remarkable group of collage paintings that Francis Picabia made to satirize conventional taste. Rendered in house paint, these compositions incorporate such commonplace objects as combs, curtain rings, paper matches, toothpicks, and a toy monkey. This version of *Woman with Matches* is the only canvas in the group inscribed with a date. Apparently Picabia himself erroneously scribbled *1920* at the lower right when repairing the work after World War II.

Outlined in string, the figure's head recalls the simple, linear style of caricatures Picabia produced in New York during World War I, which were based on objects (such as cameras or sparkplugs) the artist associated with specific personalities. Used to define the figure's mouth and hair, the matches here may suggest a potentially flammable personality, while the earring and necklace, fashioned from French coins, may signal a mercenary nature. Organized into three zones, the background of *Woman with Matches* creates a remarkably abstract design, reminiscent of the biomorphic forms with which Jean Arp created chance compositions in his Dada wood reliefs of 1917 on. Evocative of sea or sky, the undulating blue-and-white shapes in Picabia's painting establish a mood of reverie and play.

As early as 1920, following experiments initiated by Marcel Duchamp around 1914, Picabia's close colleagues Jean Crotti, Suzanne Duchamp, and Man Ray all made works incorporating small, unorthodox objects. Among the closest parallels to Picabia's collage paintings, however, are a group of similarly witty pieces that the American artist Arthur Dove conceived, beginning in 1924 (see p. 54). The premises of *Woman with Matches* were further developed by the Surrealists, beginning with Joan Miró's collage paintings of 1928.

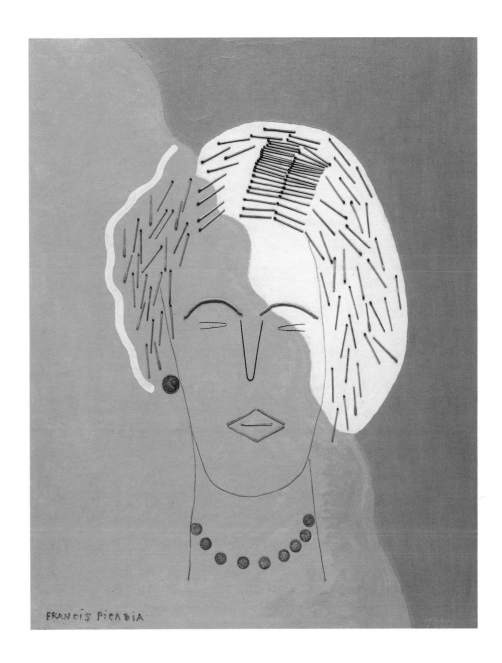

FRANCIS PICABIA

**Arthur Dove**  *Monkey Fur,* 1928

Corroded metal, monkey hide and fur, tin foil, and cloth on metal; 43 x 29.7 cm

One of the pioneers of abstract painting in America, Arthur Dove abandoned a promising career as a commercial illustrator to travel, from 1907 to 1909, in France, where he painted land-scapes and still lifes influenced by Post-Impressionism and Fauvism. By 1910, contemporaneous with such vanguard European masters as Vasily Kandinsky and Robert Delaunay, Dove had developed an abstract style, and, in early 1912, he showed a series of nonrepresentational works at Alfred Stieglitz's "291" gallery in New York, which subsequently traveled to Chicago. Dubbed (probably by Stieglitz) "The Ten Commandments," these lyrical and rhythmic compositions were the first abstractions exhibited in North America before the 1913 Armory Show (see p. 19).

Dove chiefly painted works whose luminous, organic forms were inspired by the natural world. In the mid-1920s, however, when his living arrangements—on a boat moored off Long Island—made painting difficult, Dove experimented with collage and assemblage, introducing a variety of at-hand materials into his compositions with, oftentimes, magical results. *Monkey Fur,* which features a bizarre and forelorn rusty figure encircled by a strip of hairy hide, is regarded as one of the most enigmatic collages and has obvious affinities with Surrealism (see p. 55). Its matter-of-fact construction and crude materials recall collages made by Pablo Picasso and Joan Miró in the late 1920s and early 1930s. *Monkey Fur* also brings to mind Francis Picabia's now-lost Dada assemblage, *Portrait of Cézanne* (1920), a corrosively funny work that presented a child's sock-monkey nailed to a board, thereby asserting that art based on the imitation of appearances was no longer valid. Dove's homely talisman, formed and probably selected utterly by chance, has a personal meaning that remains tantalizingly elusive.

# Joan Miró

## The Policeman, 1925

Oil on canvas; 248 x 194.9 cm

Joan Miró was both an avid follower of the Paris-based avant-garde—reading art and poetry journals and attending Cubist exhibitions in Barcelona—and an uncompromising individualist who cultivated his independent identity as a Catalan artist. In 1922, two years after he had moved to Paris, Miró was introduced to painters and poets such as André Breton by his studio neighbor André Masson, a young artist who had developed a method of automatic drawing paralleling the spontaneity achieved by Breton in his poetry. In 1924 Breton issued his first Surrealist manifesto, which advocated looking deep within the recesses of the mind to find a higher and truer reality—a sur-reality—than one visible to the naked eye. To penetrate the subconscious, the Surrealists, following newly developed psychoanalytic methods, favored the exploration of dreams and stream-of-consciousness associations, and the use of automatism, which involved relinquishing control over the pencil or brush in order to release subconscious images.

Miró's experiments in automatism between 1925 and 1927 led to a revolutionary series of works called the Dream Paintings. Straddling abstraction and representation as never before, these compositions are among the century's most influential works. *The Policeman* belongs to a subgenre of the series inspired by the circus—a form of entertainment that readily lent itself to Surrealist musings on the irrational and improbable. Here, two monumental figures, a policeman and his horse, are defined by scumbles of thinly applied paint, their closed contours separating them from a blotchy, ocher field. The policeman's red, budlike hand and blocky, mustachioed head spring from stems attached to his body. The sinuous horse rears up, his one visible leg terminating in a slipperlike, blue hoof. The reductive, almost childlike, pictorial means, which include the restriction to solid colors, belie the painterly finesse with which Miró coaxed this fugitive dream-vision into reality.

Oil on emory paper on scrap-wood panel covered with black paper; 116.5 x 39.4 cm

Like the sculptor Constantin Brancusi, Max Ernst was fascinated with birds and their forest nesting places. He even claimed that "he came out of [an] egg which his mother had laid in an eagle's nest and [upon] which the bird had brooded for seven years." Among his earliest essays on this motif are some two-dozen, small, unconventional pictures made around 1925. Using paint or plaster, Ernst printed bird forms on rough supports, such as emory paper, and often placed them in whimsical, cagelike frames. One of these works, printed on a leather support (which over time has shrunk slightly and its edges have curled), was incorporated as a picture within a picture into *Human Figure with Two Birds.* Here, a rudimentary figure, outlined in white, seems to be presenting the earlier work.

As early as 1923, Ernst experimented with painting white, linear images on black panels, evocative of night skies. In contrast to these earlier, elegant works, *Human Figure with Two Birds* is crudely rendered on black tar paper and then mounted on scrap wood. Used to parody conventional painting standards, these non-art materials revive the spirit of Dada (see p. 43), as well as recall a group of collages and assemblages that Ernst's friend Joan Miró executed around 1929.

Equally important, *Human Figure with Two Birds* set the stage for an extraordinary series of works Ernst began making in 1930, which features a large, fantastic bird figure that the artist spoke of as "Loplop, my private phantom attached to my person." In these works, Loplop generally holds up a picture for presentation. The starkly impressive and highly poetic *Human Figure with Two Birds* can thus be understood as an early manifestation of Ernst's playful Loplop concept of self-portraiture by proxy.

# Pablo Picasso

## *Head*, 1927

Oil and chalk on canvas; 100 x 81 cm

Picasso painted this demonic *Head* in the summer of 1927, at the beginning of a period of prolonged personal turmoil. Confronted with the deterioration of his first marriage and the onset of midlife uncertainties, he had initiated, in January of that year, a long-term sexual liaison with the seventeen-year-old Marie Thérèse Walter. Their relationship had a powerful, rejuvenating effect on the artist's work and spirit; yet concealing the union (which produced a child in 1935) from his wife came to dominate his life over the next several years.

Reflecting his personal affairs and the influence of friendships with the Surrealist painters and poets, Picasso's imagery of the late 1920s and 1930s was fantastical, erotic, and disturbing. He returned again and again, for instance, to the motif of the anguished or predatory female head. At once a headless body and a bodiless head, the spectral figure here projects an aura of menace and absurdity as it hovers before the abstract suggestion of a doorway. Schematically rendered features include a pair of nostrils, two eyes planted sideways, and a grinning corncob mouth. Its contours defined only by thinly applied black outlines, the figure lacks volume and looks flattened and insubstantial, held in place, it would appear, by the three spiked strands of hair.

The blasted and bubbling surface of the canvas was created by crushing chalk into and over an oily, liquid surface of paint. The nebulous and crude, all-over effect suggests the influence of Picasso's compatriot Joan Miró, whose Dream Paintings of the mid-1920s were at the forefront of Surrealist painting (see p. 55). At the same time, Picasso's *Head,* with its graphic armature and powdery, plasterlike materiality, anticipated the artist's renewed interest in sculpture, in both iron and plaster, over the next five years.

## Yves Tanguy

### *Title unknown*, 1928

Oil on wood, hinged folding screen in eight panels; each panel 200 x 59.7 cm, overall 200 x 477.6 cm

This nearly sixteen-foot-wide screen is Yves Tanguy's most ambitious work and among the most impressive achievements of early Surrealism; yet little is known about the circumstances of its creation. Conceivably, the screen was made to adorn a patron's home, since many artists living in Paris during the 1920s were intensely interested in the decorative arts, producing folding screens and other domestic furnishings.

The largely self-taught Tanguy decided to become an artist around 1923, when he saw a painting by Giorgio de Chirico in a shop window. Inspired by the metaphysical qualities of this composition and subsequently by works by Jean Arp, Max Ernst, Paul Klee, and Joan Miró that teemed with floating creatures, he developed "landscapes" in the science-fiction spirit of Jules Verne. The sole remnants of conventional landscapes in these paintings, which feature vast, arid plains and strange rock formations, are a horizon line and the presence of shadows. Given the horrors the world had recently experienced of trench warfare, these compositions might well invoke Tanguy's vision of a post-industrial civilization in ruins. But the barren landscapes, with their amoebalike inhabitants, suggest, to an even greater extent, primordial worlds.

Here, a tar-black expanse is pitched up toward a distant gray sky, with occasional mountains silhouetted along the horizon. Interspersed throughout the screen are thin, elevated poles that cast trembling shadows. A cloud-colored, caterpillarlike object spotted with fingerprints anchors the large structure in the screen's center. To its left, shapes resembling miniature chimneys emit smoke like just-extinguished matchsticks. Except for low-lying clouds and what look like two flying creatures and an exploding peanut, the plain is populated by drab, limbless beings that hover passively. These shapes, at once biomorphic and fantastic, anticipated the sculptural vocabulary of Henry Moore, and initiated a new phase in Surrealism, extended most notably by Salvador Dalí and Roberto Matta.

Thirty-two silver-alloy chess pieces with oxidized surfaces; h. 5.1 to 10.5 cm

The game of chess figured prominently in both the art and daily routine of Man Ray. It first emerged as a motif in the artist's 1911 assemblage *Tapestry* (estate of the artist, Paris), which features a checkerboard fabric, and subsequently reappears throughout his oeuvre. This obsession was fueled by his friend, colleague, and favorite chess opponent Marcel Duchamp, with whom he studied the game's subtleties at the Marshall Chess Club in New York. Unlike Duchamp, who ostensibly abandoned art for chess in 1923, Man Ray united his two passions. "[While] I remained," he wrote, "a third-rate player—a wood pusher, as [Duchamp] said: my interest

was directed toward designing new forms for chess pieces, of not much interest to players but to me a fertile field for invention."

Man Ray produced this chess set in 1926, which is based on a 1920 version that the artist made in wood. In 1945 he executed a second design in both wood and aluminum and, in 1962, fashioned an ebony-and-ivory set based on a third design. Originally fabricated from cast-off items in his studio such as draftsmen's tools, bottles, and broken violin parts, the geometrically shaped pieces shown here were intended as "symbolic

evocation[s]." A pyramidal shape represents the King; a cone structure suggestive of a medieval headdress, the Queen; a carafe-shaped piece, the Bishop; a violin scroll fragment evocative of a horse's head, the Knight; a cube, the Rook; and a sphere, the less-powerful pawn. Until exorbitant production costs squelched his dreams, Man Ray hoped to replace the standard set used in championship play with this one. In 1926 the Indian prince Maharaja of Indore commissioned the artist to execute the set in silver, and he produced three editions in that medium, including the Art Institute's *Chess Set*.

Iron and stone; 54.6 x 22.9 x 24.1 cm (with base)

Called "the father of iron sculpture of this century" by American sculptor David Smith, Julio González initiated the use of welded metal in 1926, when he was fifty years old. Prior to 1926, González worked in his native Barcelona as a metalsmith and pursued a career in painting in Paris. There, he came to know his compatriot Pablo Picasso, with whom he eventually embarked on a group of metal sculptures. Their collaboration, between 1928 and 1931, both deepened González's taste for humor in art and his interest in using space as an expressive sculptural element.

One of approximately thirty heads that González fabricated during this first, and most experimental, phase of his evolution as a sculptor, *Woman with Hair in a Bun* presents a traditional subject—the head of a woman—executed in a revolutionary manner. Rather than carving a block of stone or wood or modeling with clay or plaster, González welded several oval and rectangular pieces of iron together to indicate a woman's features. The sculpture's power derives from its combination of abstract shapes with pointed references to the human form, culminating in a thin, triangular nose and a semicircular chignon jutting out from her head. A rough, irregularly shaped stone base both enhances these crisp contours and imparts a solidity typical of more conventional sculpture.

Since 1945 numerous artists have chosen to express themselves with welded metal, thereby helping to realize González's deeply felt wish for this long-ignored material: "The age of iron began many centuries ago, . . . unhappily [with] arms. . . . Today, it provides, as well, bridges and railroads. It is time this metal ceased to be a murderer and the simple instrument of an overly mechanical science. Today the door is opened wide for [it] to be, at last, forged and hammered by the peaceful hands of artists."

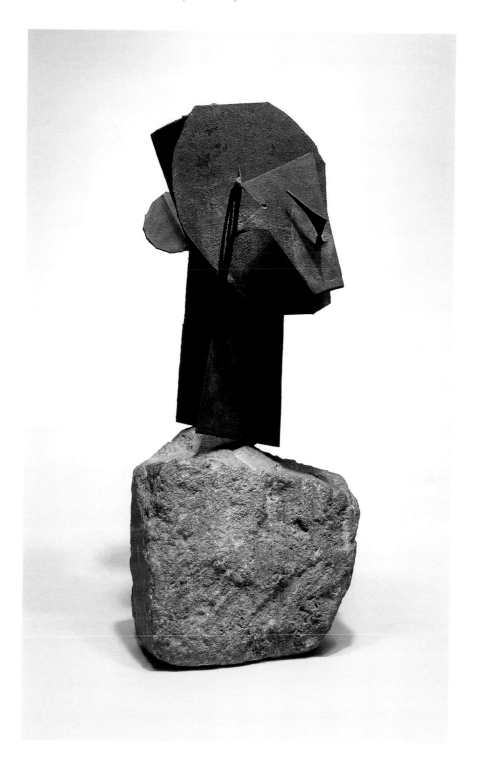

## Florine Stettheimer

### *Portrait of Virgil Thomson, 1930*

Oil on canvas; 96.8 x 51.1 cm

In the 1920s and 1930s, Florine Stettheimer painted imaginative portraits and representations of the life and world of celebrated members of the American avant-garde, including artists Marcel Duchamp and Elie Nadelman; novelist Carl van Vechten; and this fanciful painting of the composer Virgil Thomson (1896–1989), who is perhaps best known for his curiously titled opera *Four Saints in Three Acts*. First staged in 1934 with an all-black cast, the opera featured a libretto by Gertrude Stein (1874–1946) and striking cellophane sets and costumes by Stettheimer that achieved instant notoriety.

Stettheimer developed her unique blend of faux-naive art and avant-garde innovations during the teens. With little concern for proportion or perspective, the artist depicted fantastic scenes, combining past and present, real and imagined, near and far, which she populated with slim, stylized figures who seem to float or dance through space. In this painting, an ecstatic-looking Thomson, awash in a flood of supernatural light, gazes at a mask bearing Stein's features, which seems to represent a source of inspiration. Alluding to music's heavenly quality, this encounter between creative forces takes place on a bank of clouds, complete with a tiny stage and actors, lettered banners, and fluttering doves.

The chained lion to the right of Thomson might refer to the power of music to soothe even savage beasts, or to Saint Jerome and the evangelist Mark, who are frequently depicted in the company of lions. Reinforcing the link between creativity and spirituality are banners that combine the names of saints from the opera with those of Thomson and Stein. Stettheimer's own name, however, appears in reverse order to the others—Florine St.—perhaps a witty abbreviation of the artist's signature. The artist designed the scalloped frame that appropriately sets off her fanciful vision.

**Raoul Dufy**

*Open Window, Nice, 1928*

Oil on canvas; 65.1 x 53.7 cm

The work of the prolific artist Raoul Dufy often draws comparison with that of Henri Matisse, and the two indeed had a number of things in common: They both worked on the French Riviera, a circumstance that led them at times to treat very similar subjects; they both went through a Fauvist phase and continued to emphasize color in their subsequent work; and they both traveled to North Africa and were seduced by the lush, exotic patterns of that region. But in Dufy's work, the seeming ease and spontaneity of the brushwork often masks the traces of intellectual effort and intense experimentation so apparent in the art of Matisse. The unalloyed pleasure expressed in this canvas is a hallmark of Dufy's style; so unwaveringly did the artist sustain this mood in his art that it has been said that he "never painted a sad picture."

At his best, as in this superb example, Dufy displayed an unrivaled decorative sense, juggling with consummate skill broad areas of bold, saturated color (blue, red, green, yellow), a calligraphic line of great verve and fluidity, and an assured if carefree appreciation for the compositional liberties of modern painting. Dufy here brilliantly transformed the common modernist motif of the slanted, upturned tabletop (see pp. 37, 50, 80) into an abstract circular shape that hovers magically at the joyous center of his composition. Its undisturbed surface contrasts markedly with the active, richly patterned areas that surround it, while its perfectly self-contained shape becomes a symbol for the state of sensual fulfillment embodied in this picture.

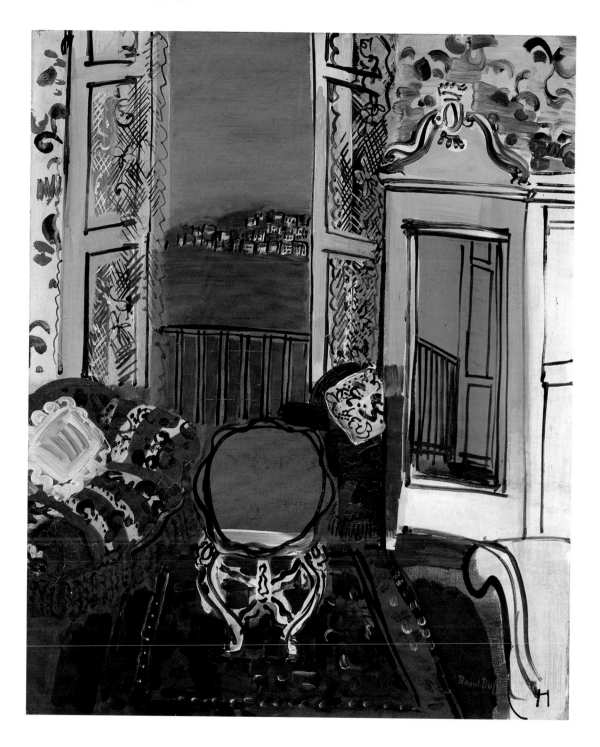

**Black Cross, New Mexico, 1929**

Oil on canvas; 99.2 x 76.3 cm

Georgia O'Keeffe first encountered the south-western United States when she went to Texas in 1912 to teach art. Many years later—in 1929—the now-successful painter visited Taos, New Mexico, where her forays into the country-side, with its breathtaking forms and colors, in-spired such works as *Black Cross*. Following years of extended visits, the artist left New York in 1949, settling outside of Santa Fe. O'Keeffe ex-plained the genesis of her black-cross composi-tions in her 1976 autobiography: "One evening . . . we walked back of the morada [chapel] to-ward a cross in the hills. I was told that it was a Penitent cross. . . . [L]arge enough to crucify a man. . . . the cross stood out—dark against the evening sky." Still active in northern New Mex-ico, which the Spanish settled as early as the sev-enteenth century, Penitentes, or secret lay broth-erhoods, may erect crosses for Passion week rites near remote *moradas*.

In *Black Cross, New Mexico*, O'Keeffe captured the otherworldly aura of the scenery she en-countered on her walk. The unnatural lighting—dark on the hilltops, aglow in the valleys—and stark contrast between the undulating contours of the hills and sharp angles of the cross trans-port the viewer into a spiritual realm. Slightly off center and pushed forward so that even its nail heads are visible, the somber cross seems as insistent and abstract as the grid lines com-prising Piet Mondrian's compositions (see p. 49). Since O'Keeffe often combined elements from different locales in her works, the original title of the painting—*Black Cross, Arizona*—suggests that she drew inspiration from Arizona hill country, as well as the New Mexico sanctuary with the cross. The present title was used in her first re-trospective exhibition, organized in 1943 by the Art Institute's noted director at the time, Daniel Catton Rich.

# José Clemente Orozco

## Zapata, 1930

Oil on canvas; 178.4 x 122.6 cm

Along with Pancho Villa (1877–1923), Emiliano Zapata (1879?–1919) was a powerful symbol of revolt and reform for liberal Mexicans such as José Clemente Orozco and his fellow muralists Diego Rivera and David Alfaro Siqueiros. Commanders of rebel armies that fought against their country's dictatorial government and wealthy, landowning classes during the Mexican Revolution (1911–20), both figures became legends after they were assassinated and continue to inspire Mexicans today.

Following the Revolution, the largely self-taught Orozco worked in Mexico on several fresco cycles depicting mass bloodshed and societal upheaval. Strongly attacked by conservative critics, he fled to the United States, where, between 1927 and 1934, he painted several murals and paintings, including the Art Institute's *Zapata*. In his autobiography, Orozco remarked that this canvas shows "Zapata entering a peasant's hut." Silhouetted against a pale sky, the head and shoulders of the revolutionary leader are, indeed, situated near the open doorway of a darkened hut. Given his heroic status, Zapata is curiously placed in the background of the composition. Instead, the people for whom he fought—frightened, oppressed peasants—and those with whom he fought—fierce, stalwart soldiers—dominate the picture and together form a strong pattern of intersecting diagonals in the foreground. The work's somber, earthy palette, in evoking the peasants' land, also unites them with their courageous leader.

In placing a sword point just under Zapata's eye, and thereby signaling his vulnerability to the opposition and eventual murder, Orozco further challenged the conventions of heroic characterization. Rather than glorifying a leader who sacrificed himself, the artist chose here to emphasize the cause and community to which Zapata dedicated his life.

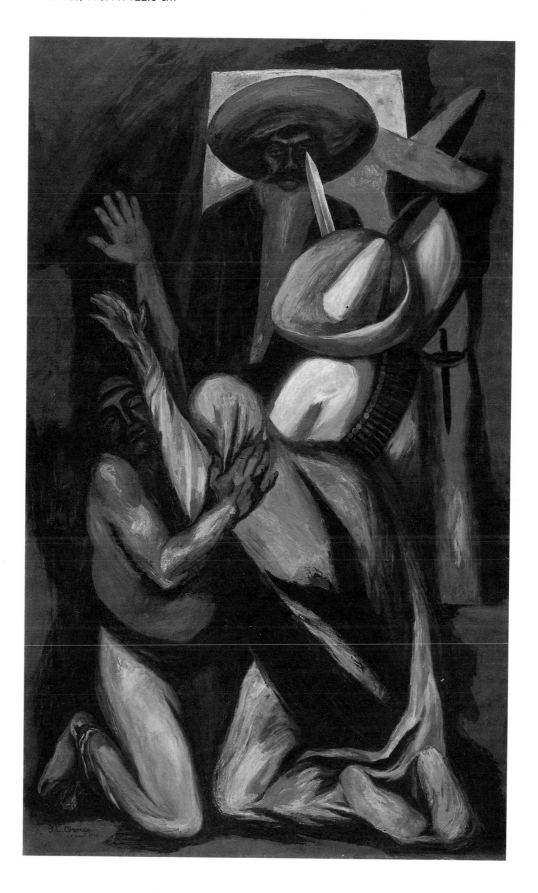

# Ivan Albright

## Into the World There Came a Soul Called Ida, 1929–30

Oil on canvas; 142.9 x 119.2 cm

While Ivan Albright's unique style has been called Magic Realism, it defies categorization. His painstaking creative process, driven by his need to meticulously record detail, involved designing sets, executing studies of models and props in his studio, even making diagrammatic plans for colors. Grounded in his love for the work of the German artist Albrecht Dürer and the Dutch painter Harmensz van Rijn Rembrandt, Albright's desire to present the minutest subtleties of human flesh or the tiniest elements of a still life often required that he spend years on a single painting. His experience as a medical illustrator during World War I is also cited as a determinant of his interest in rendering detail, and in capturing the processes of aging and decay.

*Into the World There Came a Soul Called Ida* was begun in 1929 after Ida Rogers, then about twenty years old, answered Albright's advertisement for a model. Ida was an attractive young wife and mother whom Albright transformed into a sorrowful older woman sitting in her dressing room, her flesh drooping and the objects surrounding her worn and bare. With characteristic precision, Albright delineated even the single hairs in the comb on the dressing table. The material lightness and precarious placement of the sitter's possessions on the dressing table and floor seem to symbolize her vulnerability. Ida gazes poignantly into the mirror and, with all the dignity she can muster, powders her aging flesh.

*Into the World There Came a Soul Called Ida*, which is widely regarded as one of Albright's greatest compositions, is among 125 works by the painter at the Art Institute. The museum, in fact, has the largest collection of this native Chicagoan's work in the world.

## Grant Wood

## *American Gothic*, 1930

Oil on beaverboard; 74.3 x 62.4 cm

Grant Wood's *American Gothic* caused a stir in 1930, when it was exhibited, for the first time, at The Art Institute of Chicago and awarded a prize of three hundred dollars. Newspapers across the country carried the story, and the picture of a farm couple posed with a pitchfork before a white house brought instant fame to the artist. The Iowa native, then in his late thirties, had been enchanted by a simple Gothic Revival cottage he had seen in the small southern Iowa town of Eldon. Wood envisioned a painting in which, as he put it, "American Gothic people . . . stand in front of a house of this type." He asked his dentist and his sister to pose as a farmer and his spinster daughter. The highly detailed, polished style and rigid, frontal arrangement of the two figures were inspired by Flemish Renaissance art, which Wood had studied during three trips to Europe between 1920 and 1926. After returning to Iowa, he became increasingly appreciative of the traditions and culture of the Midwest, which he chose to celebrate in such works as this.

One of the most famous American paintings, *American Gothic* has become part of our popular culture, with the pair having been the subject of endless parodies. Wood was accused of intending, in this painting, to satirize the intolerance and rigidity that the insular nature of rural life can engender, an accusation he denied. Instead, he created here an image that epitomizes the Puritan ethic and virtues that he believed dignified the midwestern character.

Oil on canvas; 50.5 x 59 cm

In the catalogue for a 1959 exhibition of his work, Victor Brauner described the figure in *Turning Point of Thirst* as a "personage in withered tatters [who] expresses unremitting solitude and [who] should pound the senses." With its eerie "brainscape," grimacing expression, and grotesque appendages, this specterlike figure evokes a life squeezed dry to the bone. The image's hallucinatory nature reflects Brauner's involvement with such Surrealist artists as Salvador Dalí, Max Ernst, and Yves Tanguy, who also explored the fears and fantasies of the unconscious mind.

In place of the brain is a depiction of a desert landscape that could allude to the sterility of the figure's life. Honeycomb shapes, which resemble the brain, appear above and below the mountains of sand. Also frightening is the head's scowling expression and the perforated, bony form that emerges from its forehead and chin. If examined sideways from the left, this shape resembles a four-legged animal whose mouth is open in a howl and who holds fast to its victim like one of the Furies. A pink, intestinelike tube emanating from the beast's hindquarters and merging with the pedestal below further establishes a connection to the animal world, perhaps to signify that a monster lurks in each of us.

As if to suggest the assaultive nature of despair, Brauner's vision spills over the edge of the frame and into the spectator's space. Shown against a black, isolating backdrop, this terrifying view of the demons of humankind does indeed "pound the senses."

Oil on canvas; 58.4 x 71.4 cm

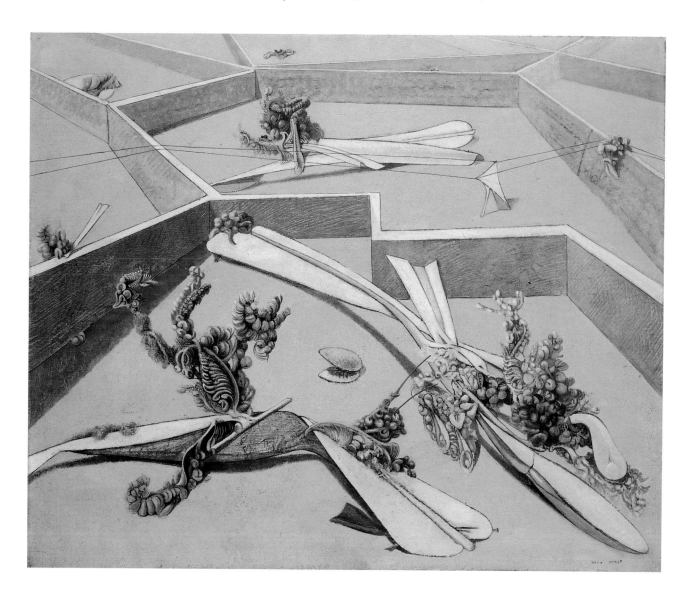

Reworking botanical diagrams for his influential Dada pieces, Ernst developed around 1920 a genre of fantasy creatures based on plant forms. The artist's 1928 paintings of odd-looking blossoms scattered on tilted planes expand on this idea, as do several of his 1930 Loplop (see p. 56) collages, which feature botanical illustrations that Ernst transformed into plant-bird-human creatures. By coincidence, the artist, in 1933, rented a studio in Paris at 26, rue des Plantes ("Plant Street").

Ernst began a series of roughly a dozen works, each entitled *Garden Airplane Trap,* following a visit to Switzerland in 1934, where he construct-ed a rock garden for the mother of sculptor Alberto Giacometti and painted a mural populated with plant creatures for a bar in Zurich. The Art Institute's example is one of the largest and most important of the series. Here, walls haphazardly partition a mountain or rooftop setting reminiscent of the desertscapes by Yves Tanguy and Salvador Dalí (see pp. 58–59, 75), as if to spoof contemporary urban planning or architecture. In the resulting subdivisions, flower clusters with antennae, jaws, and wings battle pale, streamlined creatures resembling leaves or paper airplanes.

The victorious flower beings, whose limbs sometimes seem to form subcreatures, cling to the "airplanes" or dance on their corpses. One purple flower creature appears to suck blood from the throat of a downed "airplane." Observing the carnage from behind a wall, another holds an "airplane" bit in its mouth, as a dog might hold a bone. Other peculiar elements are the opened, clamshell-like object at center and the two, long wires that traverse the walls like cables. While suggesting nature's power over technology, Ernst's *Garden Airplane Trap* paintings clearly have a Darwinian subtext in showing the destruction so integral to survival and may more specifically refer to the battle between the sexes.

*In the Magic Mirror, 1934*

Oil on canvas on board; 66 x 50 cm

*In the Magic Mirror* reflects the disillusionment that colored much of Paul Klee's art following the Nazi takeover of Germany in 1933 and the artist's subsequent removal from that country to his native Switzerland. Directly affected by the Nazis' ascent to power, Klee was dismissed in 1933 from the Düsseldorfer Akademie, where he had spent two years after teaching for a decade at the famed Bauhaus school of design. In addition to displaying the emotional qualities that prompted the German Expressionists (see p. 29) to claim Klee as one of their own, this characteristically childlike painting also exhibits the sense of the mystical present in the work of many Surrealists. Indeed, the magic mirror to which the work's title refers symbolized for these artists hidden truths and visions.

Illustrating what Klee called his method of "taking a line for a walk," a meandering red line twists and turns down the center of the canvas, delineating the forehead, nose, mouth, and chin of a face along the way. The tight curves on the brow suggest the figure is concentrating, while the tension between the nose and mouth, which pull in opposite directions, conveys anxiety. In contrast to the rather cheerful nature of the pink cheeks, the figure's tear-shaped eyes, misaligned and slanting downward, communicate distress. Resembling a ghostly apparition, the thinly painted, blurred outline of head and shoulders throws the sorrowful expression of the crisply rendered face into sharp relief. By coloring black the organ that he considered the body's true creative center—the heart—Klee indicated that a pall has settled over the figure and perhaps over his own creative powers as he contemplated the frightening developments around him.

Oil on copper; 35.6 x 49.8 cm

Joan Miró was one of many Spanish artists, including Salvador Dalí and Pablo Picasso, who addressed the horror and inhumanity of the Spanish Civil War (1936–39). This small, vividly hued painting belongs to a series of works that he produced in Barcelona and Montroig during the winter of 1935–36. Executed on copper and masonite, these Savage Paintings, as the artist called them, critique the kind of senseless human behavior that results in such catastrophes as war. Here, two agitated "philosophers" excitedly stamp their feet and fling out their arms rather than engaging in the calm, rational talk expected of intellectuals. Apparently to mock their irrational behavior, Miró likened them to animals, making the head of the philosopher on the right resemble that of a horse and showing green effluvia emerging from the nose of the figure on the left.

Lamentably, the two figures are so engrossed in their mutual animosity that neither notices the danger looming on the horizon. Under an ominous sky, which changes from yellow to green to a black blue, a stealthy, ground-hugging creature breasts the top of a hill. Directly below this mul-ticolored organism is a red, oval shape, which could represent a spreading pool of blood. In contrast to the vigorous brushwork establishing the foreground, this area is rendered in smooth strokes, perhaps to underscore the seductive nature of evil. Together with the expanding storm and approaching beast, this advancing form functions to emphasize that human self-centeredness, if unchecked, will engender such tragedies as the Spanish Civil War.

# Pablo Picasso

## *Figure,* 1935

Assemblage of wood, metal, plastic arms, nails, screws, paint, twine, paper, and concrete; 62.9 x 9.5 x 12.1 cm

Although he was never an official member of the Surrealist group, Pablo Picasso formed close relationships with several of its artists. Influenced by Picasso's friend Guillaume Apollinaire (who coined the term *surréalisme*), André Breton, the leader of the group, venerated the Spanish artist, declaring that, without his example, Surrealism would not have been possible. The young poet invited Picasso to exhibit with the group and reproduced the artist's landmark work *Les Demoiselles d'Avignon* (1907; The Museum of Modern Art, New York) in the first issue of the review *La Révolution surréaliste,* in 1925. Picasso, in turn, was deeply affected by the Surrealists' explorations of the desires and fears of the sub-conscious.

Made at the height of his involvement with Surrealism, Picasso's *Figure* exploits the unex-pected, expressive potential of everyday ma-terials. Renowned for his obsessive accumula-tion of studio clutter, Picasso began, in the early 1930s, to make sculpture from this beloved detritus. *Figure* is one of three surviving assem-blages from 1935, all of which were inspired by the birth of the artist's first daughter, Maya. Here, Picasso used the top of a tin of Ripolin enamel paint for the head, a toy boat for the torso, two plastic doll's arms for limbs, and three scraps of wood for the legs and for rounding out the back. A shallow wooden container, which once held tubes of umber paint, serves as a base. Filled with cement, it evokes both a child's sandbox and the beach. Whether toy doll or archetypal female bather, *Figure* descends from a long line of "bathing beauties" in Picasso's oeuvre, including the artist's noteworthy contri-bution to a 1933 edition of the Surrealist review *Minotaure.* Titled "An Anatomy," it included a series of thirty whimsical, yet disturbing, draw-ings of female figures made of furniture frag-ments, objects, and stuffed limbs.

# Mary Reynolds

## *The Free Hands, 1937*

Binding: full tan morocco (goatskin), kid glove slit open, pink sponge-rubber doublures (inside lining of covers), silk endpapers; 26.8 x 23 cm

Born in Minneapolis and educated at Vassar College, Mary Reynolds moved to Paris as a young war widow in 1920. There, she befriended such avant-garde artists as Alexander Calder and Fernand Léger, and the Surrealist painters and poets who were gathering around André Breton. In 1923 Reynolds began a love affair with Marcel Duchamp, often summering with him in Spain or southern France. Indeed, it was Duchamp who sorted through Reynolds's library after her death, sending the artist's many Surrealist books, journals, and rare pamphlets to her brother, Frank Hubachek, in Chicago. He, in turn, donated this important collection to the Art Institute.

Reynolds learned the art of bookbinding in Paris in the 1920s, a golden age in which design innovations flourished and an unprecedented number of women artists explored the medium. One of sixty-eight examples of her work in the collection, this unusual volume consists of drawings by Man Ray and poems by Paul Eluard, and it is bound in morocco, or tanned goatskin. On each cover, Reynolds placed a splayed kid glove, and on the spine, the title of the book and the artist's and poet's names in palladium leaf. The glove—an evocative motif featured in the work of Giorgio de Chirico and a number of Surrealists, including Breton—here refers metonymically to the hands of Man Ray, whose first name puns on the French word for hand, *main*. In typical Surrealist fashion, Man Ray claimed, "In these drawings, my hands are dreaming." Reversing the customary relationship of image to text, Eluard's fifty-four short poems loosely illustrate his friend's fantastic landscapes, figures, and portraits. On December 24, 1937, both artist and poet signed this copy of the book: "to Mary Reynolds affectionately."

# Salvador Dalí

## *Inventions of the Monsters, 1937*

Oil on canvas; 51.4 x 78.1 cm

While Surrealists such as Giorgio de Chirico and René Magritte generally focused on expressing the mystery of everyday objects, Salvador Dalí populated his visionary landscapes with the often monstrous creatures of his imagination. Dalí also favored dazzling displays of painterly skill, rather than the deadpan realism of de Chirico and Magritte, in giving his scenes a dramatic and hallucinatory intensity.

When this painting was acquired by the Art Institute in 1943, Dalí sent the following telegram commenting on the circumstances of the work's creation and its symbolism:

*Am pleased and honored by your acquisition. According to Nostradamus [sixteenth-century French physician and astrologer] the apparition of monsters presages the outbreak of war. This canvas was painted in the Semmering mountains near Vienna a few months before the Anschluss [the annexation of Austria by Nazi Germany in March 1938] and has a prophetic character. Horse women equal maternal river monsters. Flaming giraffe equals masculine apocalyptic monster. Cat angel equals divine heterosexual monster. Hourglass equals metaphysical monster. Gala [Dalí's wife] and Dalí equal sentimental monster. The little blue dog alone is not a true monster.*

As Dalí's comments suggest, there is an ominous mood to the painting. A hand mysteriously emerges from the lower left corner of the picture and points admonishingly to the scene before us. Here, a sibylline figure gazes from black sockets at the butterfly and hourglass she holds in her hands, both of which may be interpreted as memento mori, reminders of death. Behind her emerge the heads of Gala and Dalí, which are vividly caught in a happily shared moment, as they gaze with apparent amusement and fascination at the varied objects (a hand holding a ball, a long loaf of bread, and what seems to be a small portrait bust) on the long table before them. In the center of the picture, a kind of altar supports a female bust, her nakedness evoked with the lush eroticism that so appealed to the Surrealists. The woman's head merges with that of a horse, associating her with the horse-women shown bathing at left. What Dalí referred to as a "cat angel" leans against the altar, seemingly in conversation with the horse-woman. In what is now the empty right-hand corner of the picture, a dog was once visible (painted in a chemically unstable pigment, it has now faded almost completely). The populated areas of the picture in the foreground and middle ground seem to be threatened by some kind of conflagration in the far right corner, a danger epitomized by the "flaming giraffe." As Dalí's comments make clear, the artist understood this in retrospect to refer to the approaching threat of World War II.

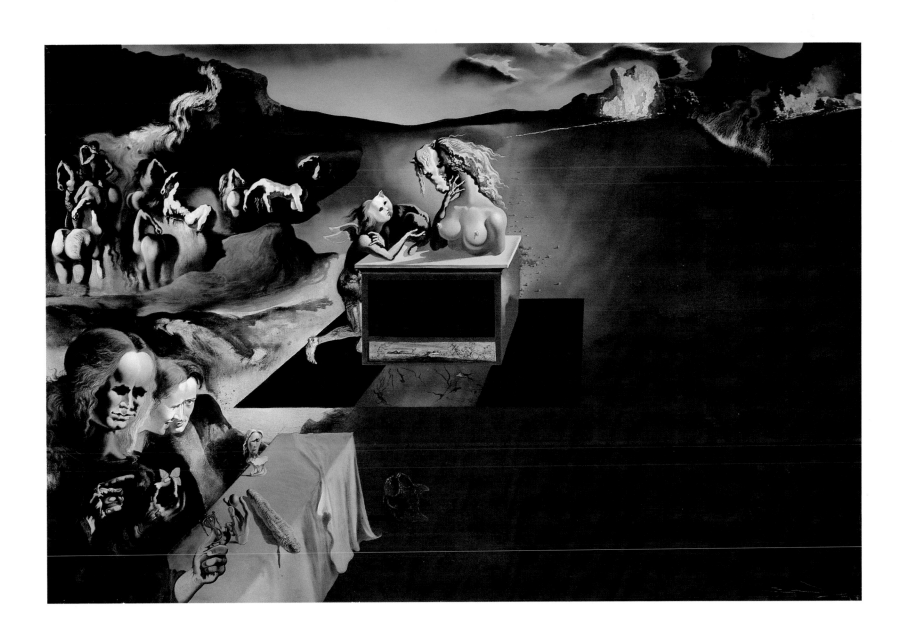

Oil on canvas; 147 x 98.7 cm

Inspired by Giorgio de Chirico's and Max Ernst's juxtapositions of disparate objects, René Magritte began taking in 1924 a leading role in the development of Surrealism in Belgium. His submissions to the 1936 International Surrealist Exhibition in London appealed greatly to the collector Edward James, who invited Magritte to paint three canvases (including *On the Threshold of Freedom,* also in the Art Institute) for the ballroom of his Wimpole Street home. In response, the Belgian artist conceived a bizarre portrait of James standing in front of his mantelpiece mirror. The following year, he painted *Time Transfixed*, his now-famous image of a smoking, model railroad engine exiting a fireplace tunnel.

Magritte, who took great pains with the titles of his works, later expressed dissatisfaction with the English translation of this painting's original French title, *La Durée poignardé,* which literally means "ongoing time stabbed by a dagger." When Magritte sent the picture to James, he expressed hope that it might be installed at the bottom of the collector's staircase so that it (presumably the outward-thrusting train) would "stab" his guests on their way up to the ballroom. James, however, installed the picture over the fireplace!

Viewing logic as restrictive, Magritte considered painting as a means to suggest impossible possibilities. Beginning in 1933, he conceived provocative images (such as an egg in a birdcage, or shoes shaped like feet) to demonstrate inherent relationships between mismatched objects. Analogous to the conduit pipe extending into a room from a fireplace heater, the speeding toy engine in *Time Transfixed* crashes from the outside world—on the other side of the looking glass—into an immaculate interior space. Suspended in snapshot fashion, the intrusion is fearsome, comic, or miraculous, depending on one's frame of mind—and altogether unforgettable.

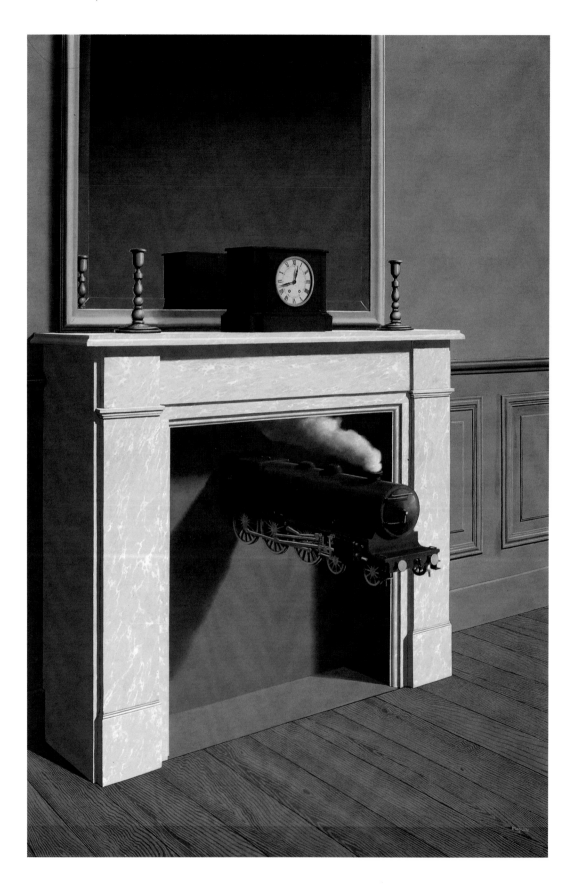

**Paul Delvaux**                    *The Awakening of the Forest, 1939*

Oil on canvas; 170.2 x 225.4 cm

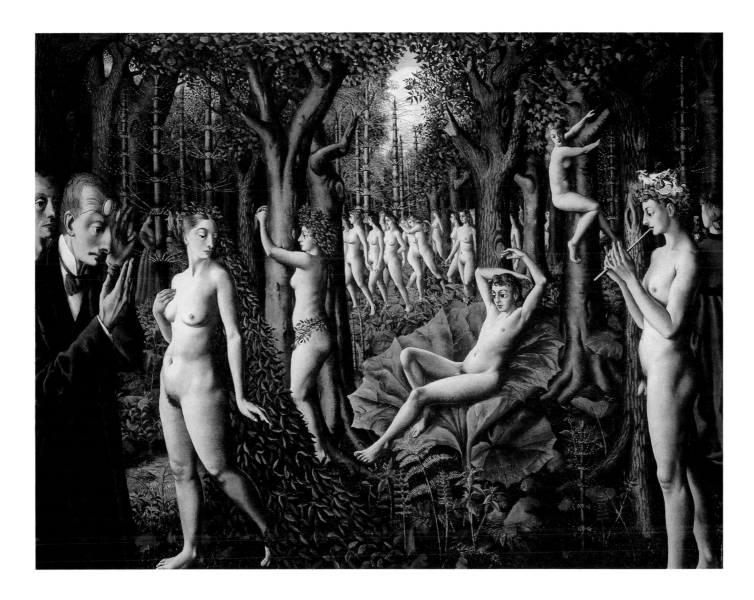

Paul Delvaux produced this ambitious painting during the late 1930s, when, under the influence of Surrealism, he changed his work dramatically. In the images of Giorgio de Chirico, Salvador Dalí, and René Magritte, Delvaux discovered new possibilities for giving visual form to his inner world, one populated with childhood memories and dominated by the obsessive recurrence of the same mysterious female.

In this work, the artist freely rendered and transformed in a hauntingly personal way an episode from a Jules Verne novel he had loved as a child, *Journey to the Center of the Earth* (1864). In it

Professor Otto Lidenbrock and his nephew Axel discover deep inside the earth a prehistoric forest. The professor is shown at left, examining a rock or fossil; behind him, the artist portrayed himself as Axel, gazing away from the scene with the same trancelike expression seen on the faces of the painting's other figures. Moving like automatons in the background, under a full moon, is a group of women, their nakedness as pristine as the forest is geologically. In the foreground, several figures combine elements from different realms: human and vegetal, in the case of the two women who have sprouted leaves instead of hair; and male and female, in the case of the

two hermaphrodites (the adolescent at center and the flutist at right). In their ambiguity, these figures seem to embody a primordial, as yet undifferentiated, state. A woman in the right foreground and another in the left middle ground, both in Victorian dress, advance holding lamps in a vain attempt to shed light on the unyielding mystery of the scene. There is, in fact, at the heart of this picture, an emotional estrangement, an oppressive silence that will not be denied, despite the languid eroticism of the many naked figures and the artist's obsessive preoccupation with detail.

# Marc Chagall

## White Crucifixion, 1938

Oil on canvas; 154.3 x 139.7 cm

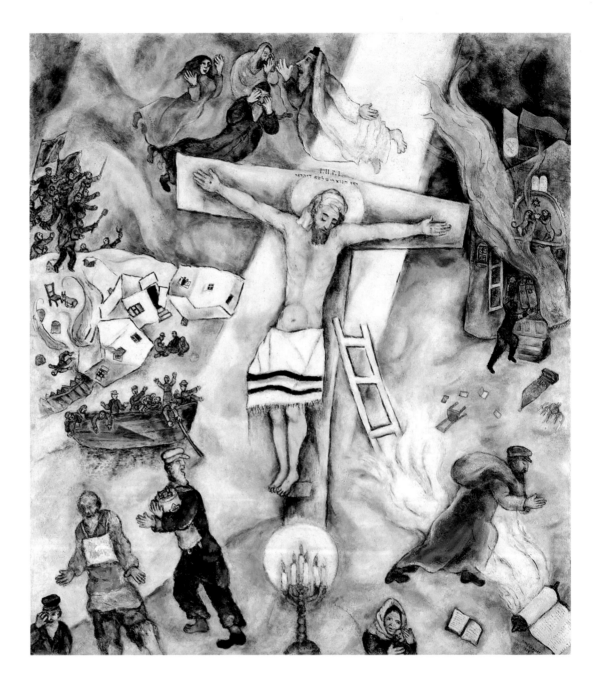

In paintings characterized by lyrical, dreamlike narratives, Marc Chagall explored such subjects as peasant life, mythology, and Jewish and Christian religious traditions. During the late 1930s, as the artist became increasingly aware of the dire plight of his fellow Jews in Europe, he painted a series on the theme of the Crucifixion. In these paintings, he altered the details traditionally associated with this familiar image to awaken the world to the perilous situation of Jewish people in the wake of Nazism.

In *White Crucifixion,* his first and largest work on the subject, Chagall stressed Jesus' Jewish identity in several ways: he replaced his traditional loincloth with a Jewish prayer shawl, his crown of thorns with a headcloth, and the mourning angels that customarily surround him with three biblical patriarchs and a matriarch, clad in traditional Jewish garments. At either side of the cross, Chagall dramatized the devastation of pogroms on Russian Jews such as his ancestors: on the left, a village is pillaged and burned, forcing a group of refugees to flee by boat and three bearded figures below them— one of whom clutches the Torah in his arms— to escape on foot. On the right, a synagogue and its Torah ark go up in flames, while below, a mother comforts her child. By linking the martyred Jesus with martyred Jews, and the Crucifixion with contemporary events, Chagall suggested that the Nazis were similarly engaged in persecution and murder.

Shortly after completing *White Crucifixion,* Chagall expunged some of its details. He eliminated the words "I am a Jew" from the sign worn on the chest of the bearded figure in the lower left-hand corner and a swastika originally worn by the figure outside the flaming synagogue. Chagall may have painted over these elements to protect himself, as well as the Parisian gallery where *White Crucifixion* was first shown, from Nazi persecution.

# Max Beckmann

## Self-Portrait, 1937

Oil on canvas; 192.5 x 89 cm

One of eighty self-portraits that Max Beckmann painted during his lifetime, this tall, arresting canvas is the last the artist executed in his native Germany. In July 1937, shortly after completing *Self-Portrait*, Beckmann moved to Amsterdam to escape the Nazis' intensifying attacks on modern art and artists. In 1933 Beckmann had been forced to resign his professorship from the Städelische Kunstinstitut in Frankfurt because of the so-called "degenerate" nature of his art. In 1947 the artist immigrated to the United States, where he taught at Washington University in St. Louis until 1949 and then at the Brooklyn Museum Art School until his death, in 1950.

Vilified because of his despairing view of human nature and stylistic distortions of figures and space, Beckmann had an undeniably harsh outlook on life. The artist was equally merciless in probing his own psyche, portraying himself in roles ranging from that of an informally dressed painter to a clown, medical orderly, musician, prisoner, sailor, and, as shown here, a gentleman in elegant formal attire.

Standing left of center on a grand, marble staircase, Beckmann casually rests his arm on a balustrade and his foot on a banister, while appraising us, himself, and the scene around him with a skeptical, sidelong glance. His wary expression and distance from the festive event occurring in the red room to his right, where guests mingle behind an exotic plant, suggest his ostracization from the social scene. The jarring mix of bright colors underscores his isolation from fellow party goers, and, by implication, from the events taking place in his native land. Indeed, Beckmann's exaggeratedly large hands, splayed and limp, emphasize his profession as a painter and imply the sense of futility that he experienced as a German artist at the time.

Oil on canvas; 114.3 x 145.5 cm

Inseparable partners from 1909 until the summer of 1914, Georges Braque and Pablo Picasso followed sharply divergent paths after World War I. Picasso, who developed a highly visible artistic persona, drew on his experience with Cubism to explore a multiplicity of styles. Braque, on the other hand, after recovering from grave wounds he received as a soldier, continued to refine the formal possibilities of Cubism. The optically dazzling and complex *Still Life with Fruit and Stringed Instrument* belongs to a series of magnificent compositions that the artist initiated in the mid-1930s.

Bristling with rhythmic movement and flickering light, Braque's still life resembles a rousing stage spectacular more than it does a routine arrangement of familiar objects on a flat surface. Restless pictorial activity bursts outward from a point of calm at the center, where pieces of fruit, nestled in linen, lie atop a constantly shifting surface. Draped in yellow at the right, and two shades of mauve at the rear and front, the plane of the table looks at once round and square. Defined by vibrant, white outlines, the objects on the table appear dematerialized by a strangely palpable light.

Jagged, ornamental forms, which descend from the wall onto the table, are transformed into gray shapes that look like birds or plants, while broad areas of color, liberated from the task of defining form, leap in all directions. To further activate the surface of the painting, Braque scattered sand granules throughout; some areas are embedded in thick layers of impasto, while others emerge through thin washes of tint. The varied and delicate surface, reminiscent of the smaller-scale works of the Swiss painter Paul Klee, adds yet another level of complexity and richness to this astonishing work.

# Fernand Léger                   *Divers on a Yellow Background,* 1941

Oil on canvas; 186.7 x 217.8 cm

Long committed to ideals of social equality, Fernand Léger sought, especially during the latter part of his career, to reconcile modernism in art with the demands of a mass audience. Beginning in the mid-1930s, the artist executed many mural-sized works, and, with increasing frequency, turned to the motif of the human figure, using organic forms inspired by the natural world rather than the geometric shapes of the man-made, machine-oriented world (see p. 45). The first of three mural-sized variations on a theme that Léger realized while residing in the United States during World War II, *Divers on a Yellow Background* successfully reconciles the abstract language of color, line, and form with the human figure.

Inspired by his memory of men diving off the docks in Marseilles, which was amplified by his experience of seeing hundreds of bathers in large public pools in the United States, Léger placed four monumental nudes with interlaced limbs at the center of his composition. Despite their epic proportions, the figures float effortlessly over the lively, broken-up areas of black, blue, red, and green, which resemble shadows that constantly shift over the larger, yellow background. The bold, flowing contours and interior modeling of the swimming nudes resonate with the globular shapes of these lesser color fields. Flanking the central knot of bathers are large, biomorphic black-and-white forms, placed over a field of solid blue at right, and red at left. Vaguely suggestive of either animal or vegetable forms, these areas not only frame the central cluster of swimmers but seem to undulate in harmony with it.

Oil on canvas; 109.4 x 83.8 cm

In reaction to the work of the leaders of the Mexican muralist movement—José Clemente Orozco, Diego Rivera, and David Alfaro Siqueiros—Rufino Tamayo developed a style that was distinctly his own. He eschewed the muralists' politically didactic approach, convinced that art should be concerned with color, form, and lyrical expression. In numerous murals, Tamayo depicted mythological, rather than sociopolitical, themes. Only later, in the early 1940s, did he produce works that comment on the dehumanizing impact of mass industrialization.

Feeling great affinity for his Zapotec Indian roots, Tamayo immersed himself in pre-Columbian art and, while residing in New York (1926 to 1928 and 1936 to 1950), in works by Georges Braque, Paul Cézanne, and Pablo Picasso. The resulting fusion of Mexican traditions and avant-garde innovations that characterize Tamayo's art is readily apparent here: the fragmenting of the face, upper torso, and arm into planes of color derives from Cubism; and the sculptural monumentality of the woman from West Mexican terracotta figurines. Her physiognomy—the elongated ear, large nose, hair pulled sharply back from the forehead, slanted eyes, and open mouth with menacing teeth—reflects figurines that the artist owned.

In the painting, the woman tends to a pet bird before an elegantly fashioned balcony. While she seems to enjoy the creature, her wistful expression and tender cradling of the cage with her hand might indicate her loneliness, as might the stucco building opposite, whose insistent, windowless expanse seems suffocatingly close. Executed in what Tamayo considered the real palette of Mexico—muted tans, olives, and grays—*Woman with a Bird Cage* illustrates his belief that "the secret of color lies not in the use of all possible hues but rather in [that] of a few from which one extracts all possible tones."

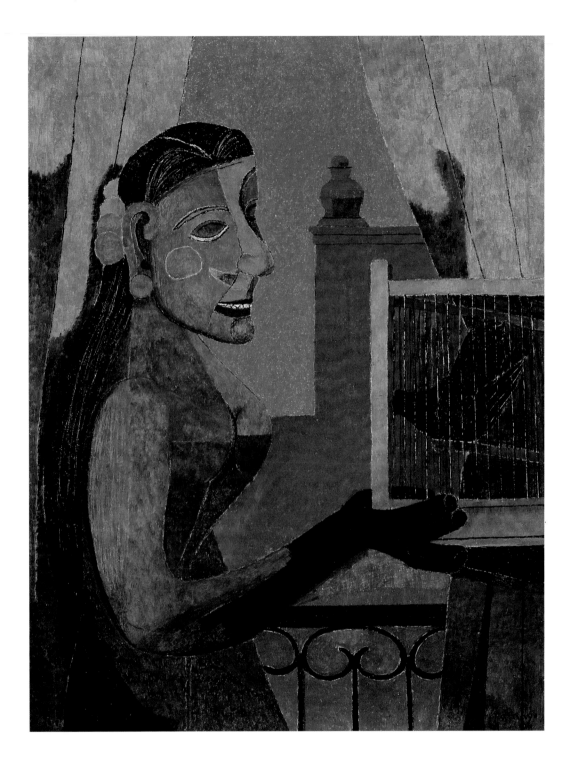

# Balthus

## Solitaire, 1943

Oil on canvas; 161.3 x 163.5 cm

Balthus is a master of vague menace and unease. As in many of his other paintings, the artist focused here on the unselfconsciously provocative pose of a pubescent girl, thereby injecting an unsettling element into an otherwise banal scene. The girl's taut, arching pose indicates a physical restlessness, an unrestrained quality, that seems to threaten the predictability of this bourgeois interior. Against the insistent regularity of the back wall, which is covered with striped wallpaper and is perfectly aligned with the picture's rectangular frame, the artist has placed every object slightly askew, as if to suggest the disruptive effect of the girl's presence. Many of these objects, especially the open book and box on the chair, seem to reflect, in their disordered state, the girl's distracted, bored handling of them. In her aimlessness, she seems to have carelessly moved many of the objects from their customary position: the cluster of containers and books stacked on the lower left, the open book and box dumped on the chair, the silver candlestick and cup pushed to the edge of the table. The activity in which the girl is engaged, a game of solitaire, seems insufficient to contain her pent-up energy. A sense of frustration, of a force and impulse vainly seeking an appropriate channel, pervades the picture.

Balthus's preference for muted colors and simplified volumes harks back to the figurative tradition of early Renaissance artists such as Piero della Francesca, whom he greatly admired. His tight execution and controlled contours confer to the scene a still, frozen quality that further heightens the feeling of repressed sexual energy expressed by the girl's pose. Painted in Switzerland, where Balthus took refuge during World War II, this picture has been interpreted, not surprisingly, as a metaphor for the restless waiting game of the refugee.

Oil on panel; 46 x 84 cm

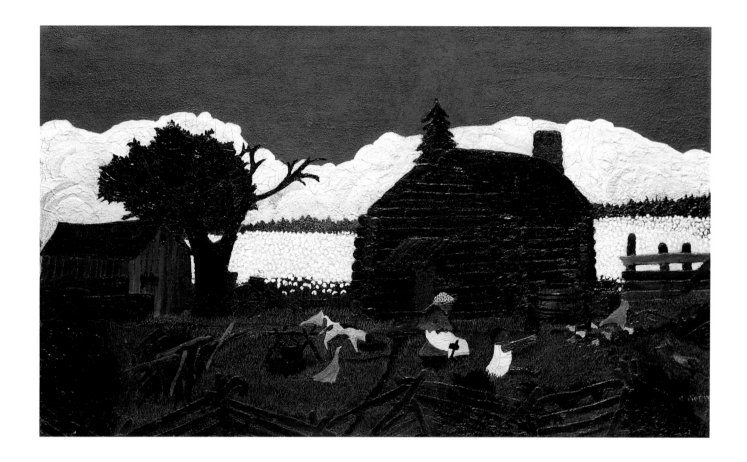

An artist of stark simplicity and quiet drama, Horace Pippin only discovered his métier as a painter after wounding his right shoulder while serving in France during World War I. Following the war, Pippin taught himself to paint by using his left arm to guide his right one. Although he produced numerous paintings during the 1920s and most of the 1930s, his activities as an artist were not known beyond his immediate circle of family and friends until the creation of *Cabin in the Cotton.*

In 1937 the artist N. C. Wyeth saw the panel in the window of a shoe-repair shop in West Chester, Pennsylvania. He encouraged Pippin to exhibit the work at the Chester County Art Association, where curators from The Museum of Modern Art, New York, then admired the painting and what they viewed as its genuinely naive qualities. They included *Cabin in the Cotton* in the museum's 1938 "Masters of Popular Painting" exhibition, which surveyed contemporary "primitive" artists, that is, artists largely untouched by conventional schooling. Soon, Pippin was represented by commercial galleries in both New York and Philadelphia. In 1940 the film actor Charles Laughton purchased *Cabin in the Cotton,* commencing the first of many sales of Pippin's work to Hollywood collectors.

Although Pippin may never have actually seen a cotton field himself (cotton hardly looks as it does, all opened, in the painting), he shared America's fascination with the South. Indeed, Southern culture pervaded American media during the Great Depression: the film *Showboat* appeared in 1929, the musical *Porgy and Bess* opened in 1935, and the novel *Gone with the Wind* was published in 1936. Scholars have recently suggested that the 1932 film *Cabin in the Cotton* directly inspired Pippin's work, as the opening and closing sequences of the film show a cabin at the edge of a cotton field.

# Edward Hopper

## *Nighthawks,* 1942

Oil on canvas; 84.1 x 152.4 cm

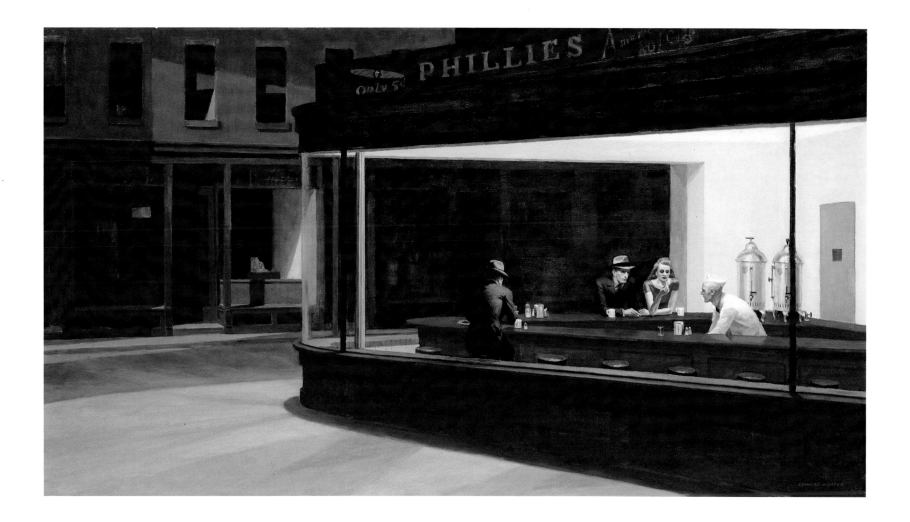

The glow of a lighted interior that beckons in the middle of the night is a motif that Edward Hopper explored in a number of paintings. While initially welcoming, these oases of humanity become, upon closer inspection, lonely outposts in an enveloping darkness, whether located in the country, a small town, or the big city. Suffused with a bright, seductive light, the Greenwich Village restaurant here both lures viewers toward it and unsettles us with its isolation from its surroundings. There is no apparent way to enter. Lost in their own thoughts, the four denizens of the restaurant seem as remote from one another as they are from us.

Even the couple sitting side by side appear, in their emphatic solitude, as if brought together solely by chance: The woman gazes idly at a matchbook, and the man stares off in space. While their hands seem to overlap, they do not touch.

Hopper accentuated the figures' estrangement by exaggerating the dimensions of the restaurant—it is twice as wide as high. In juxtaposing this streamlined wedge with a turn-of-the-century building across the street, he might also have been suggesting the dramatic contrasts and inconsistencies of urban, modern-day life. While his compositions often evoke an aura of

loneliness, Hopper emphasized that his goal was not to paint emotions, but rather "sunlight on the side of a house." When asked about his intentions in this painting, Hopper replied, "*Nighthawks* seems to be the way I think of a night street. I didn't see it as particularly lonely . . . . [But] unconsciously, probably, I was painting the loneliness of a big city." The artist himself led a solitary existence, remaining single until in his forties and, thereafter, using his wife, Jo, as his sole female model.

*The Earth Is a Man, 1942*

Oil on canvas; 182.9 x 243.8 cm

The artist Matta played an instrumental role in the development of post-World War II art in the United States by introducing the experimental techniques and theoretical principles of Surrealism to a group of young American painters who were seeking alternatives to the cold formalism of abstract art and to the narrow interests of regionalism—two styles that had dominated American art in the 1930s. As the youngest of the Surrealists to emigrate from Paris at the onset of the war, Matta was the most open to the artistic community in New York.

*The Earth Is a Man* was exhibited in New York shortly after its creation at the historic group show "First Papers of Surrealism." Organized by André Breton and designed by Marcel Duchamp, who strung a mile of crisscrossing twine throughout the gallery space, the exhibition included works by both Europeans and Americans working in a Surrealist vein. *The Earth Is a Man* reflects the influence of the fantastical and sometimes nightmarish imagery of Matta's Surrealist predecessors Salvador Dalí, Joan Miró, and Yves Tanguy. In turn, the visionary and abstract qualities of the mural-sized canvas enthralled a younger generation of American painters, such as Arshile Gorky and Jackson Pollock, who were searching for a new language of archetypal symbols.

Raised in South America and trained there as an architect, Matta settled in France in 1933, where he worked for the architect Le Corbusier. In 1934 he traveled to Spain, where he met and befriended Federico García Lorca, the poet who was assassinated by agents of the Fascist leader Francisco Franco in August of 1936. As a tribute to the fallen poet, Matta composed a screenplay entitled, "The Earth Is a Man." With its apocalyptic imagery, rapidly shifting perspectives, and emotionally charged language, the text became the principal source for his artistic work over the next five years, culminating in the Art Institute's painting of the same title.

*The Earth Is a Man* elaborates upon earlier works Matta called Inscapes or Psychological Morphologies, whose turbulent forms served as visual analogues for states of consciousness. The imagery of *The Earth Is a Man*, with its exploding solar eclipse and molten, primordial terrain, both symbolizes the turmoil of the mind and suggests the chaos of nature's creative and destructive forces. Indeed, the visionary intensity of the painting may owe to the artist's having witnessed the eruption of a volcano in Mexico in 1941. Suggestive of turbulent waves of energy set in motion by invisible forces, Matta's vaporous washes of paint are spilled, wiped, and brushed across the canvas, in varying degrees of weight and transparency.

# John Graham

## *Cave Canem*, 1944

Oil on canvas; 76.2 x 60.6 cm

*Cave Canem*, a Latin phrase that means "beware of the dog," is the witty title of this regal portrait by John Graham. The pint-sized canine seems to empower itself with its fierce, glowering stare, ready to protect his mistress, who restrains him, at least for the moment, with her hand. Calm and pensive, she seems oblivious of her pet. The smooth, rounded contours of her face; her strong, cylindrical neck; and her broad, bare shoulders are counterpointed by a fanciful, turn-of-the-century coiffure and the undulating neck-line of her gown. She is seated in front of a red-paneled wall that provides a striking contrast to her pink skin and black hair and dress.

Born Ivan Dabrowsky in Kiev, Graham studied law and served as a cavalry officer in the Russian army during World War I before fleeing to Warsaw following the 1917 Revolution. After briefly engaging in counterrevolutionary activities, the eccentric and magnetic Graham moved in 1920 to New York, where he first studied painting. During the 1920s and 1930s, he painted in a Cubist manner and, in 1937, published *System and Dialectics of Art,* a defense of modern art that influenced younger artists such as Arshile Gorky, Willem de Kooning, Jackson Pollock, and David Smith.

Despite Graham's advocacy of modernist ideas, in the early 1940s, he abandoned abstraction for a figurative style, first depicting Russian soldiers and then grave portraits of seated women such as *Cave Canem*. Made monumental and elegant through simplification and generalization, the portraits were often based on photographs of women close to Graham, including his mother and, in this instance, his first wife, Ebrenia Ignatevnia Makavelia, to whom he was married from 1912 to 1917/18.

**Peter Blume**　　　　　　　　　　*The Rock, 1944–48*

Oil on canvas; 146.4 x 188.9 cm

When it was exhibited at the Carnegie International in Pittsburgh in 1950, *The Rock* was voted the most popular painting in the show. Peter Blume's dramatic image of a shattered, but enduring, rock, with its implied message of hope, must have struck a responsive chord in many post-World War II viewers. Displaying a startling juxtaposition of images, the work evokes Surrealist dreamscapes (see, for example, pp. 58–59, 75) made even more vivid by meticulous brushwork that was inspired by fifteenth- and sixteenth-century northern European painting. Blume's fastidious approach can be seen as well in the numerous, detailed studies he made

for various parts of *The Rock*, beginning in 1944, many of which are in the Art Institute's collection.

The jagged, purple-red boulder rests atop an altarlike mound of dirt, on which lies an animal skeleton. The rock is flanked by two scenes, one symbolizing destruction, the other re-creation. On the right, smoke billows around the charred timbers of a house, an image that might allude to the bombing of London homes during World War II. The intact oval picture that clings to a shattered wall might symbolize the arbitrary nature of destruction. On the left, a new building, encased in scaffolding, rises as laborers in the

foreground cart slabs of stone up a hill to the partially completed structure. Other signs of life include green lichen on the rock and scarlet fungus on a tree trunk. Interestingly, the new structure represents Frank Lloyd Wright's famous Falling Water, Pennsylvania, residence of 1936, which the owners of *The Rock*, Liliane and Edgar Kaufmann, commissioned. Their son Edgar Kaufmann, Jr., donated the painting to the Art Institute in 1956, and Blume presented the museum with the accompanying studies in 1962.

# Charles Sheeler

## *The Artist Looks at Nature, 1943*

Oil on canvas; 53.3 x 45.7 cm

This small, but provocative, painting by Charles Sheeler depicts the artist working on a drawing outdoors. Instead of transcribing the view before him, the artist is shown painting a black-and-white interior in which ceiling beams converge toward a vanishing point, establishing the illusion of space as in traditional perspective. The scenery surrounding the artist, however, is less rationally structured than the interior. No horizon line establishes the sensation of space, the landscape tilts steeply upward rather than receding in the distance, a meadow at right drops off sharply at left, and a diagonal wall in back skews off the canvas.

The tension here between inner and outer views raises several questions: Is the outdoor scene meant to reflect a pre-Renaissance artist's rendering of a landscape, while the interior, in the hands of a modern artist, exhibits scientific advances introduced during the Renaissance? Or is Sheeler's apparent disregard of his surroundings intended to express his estrangement from a complex, war-torn world? Or did he wish to indicate his endorsement of the idea that artists do not merely copy, but rather transform, what they see? That he situated himself near a precipitous wall may suggest that the line between art and reality is perilously thin.

A painter, printmaker, and photographer, Sheeler began in 1916 using photographs he took as sources for his paintings. The stove in the interior view on the easel is based on a 1917 photograph, which later served as a model for a 1932 drawing. Sheeler had photographs taken of himself at work on this drawing, one of which (now in the Art Institute's collection) he referred to in creating *The Artist Looks at Nature*.

**Isamu Noguchi**    *Untitled,* 1945–46

Slate; 97.5 x 47.9 x 27.9 cm

Isamu Noguchi's dual roots in Japan and the United States—the son of a Japanese poet and an American writer, he lived in both countries—proved a rich source of creative tension throughout his career and often led him to infuse his work with elements from both cultures. This piece is one of an important series dating to the mid-1940s, in which the sculptor combined the sense of the fragile and ephemeral found in Japanese aesthetics with Surrealist-inspired forms (see, for example, the Art Institute's screen by Tanguy, pp. 58–59). Noguchi was in part motivated to use precariously thin sheets of slate or marble for these works

because such materials were cheaply and readily available as architectural facing. He cut the slabs with a power saw and then finished the components by hand, taking great pride in the fact that his sculptures were held together by gravity alone, without bolts, glue, or welding. He liked to compare this type of "honest" construction to that of traditional Japanese houses, which were built without nails by fitting together interlocking pieces.

In this example, three curved elements are slotted into and support a fourth, larger, rectangular slab, which presents six narrow perforations. These resemble wounds, teardrops, or inverted

teardrops, thus contributing to the sense of vulnerability already conveyed by the fragile sheets of stone. The mournful mood of this piece may be related to the difficult war years that directly preceded its creation. During this time, Noguchi's strong social conscience had sought expression in efforts to mitigate anti-Japanese hysteria in the United States. In 1942 he had even volunteered to live in a Japanese internment camp, in the hope of alleviating the lives of the internees through a variety of projects. None of these were realized, leading him to return to New York deeply disillusioned.

## *The Plow and the Song, 1946*

Oil on canvas; 128.9 x 153 cm

Sometimes described as the last of the Surrealists (see p. 55) and the first of the Abstract Expressionists (see p. 97), Arshile Gorky produced a body of biomorphic abstractions that convey a tender passion for the natural world. These works feature free-form, organic shapes resembling those of the Surrealists Jean Arp, Roberto Matta, and Joan Miró; and vigorous brushwork that evokes the dazzling surfaces of the Abstract Expressionists Jackson Pollock and Willem de Kooning.

Born Vosdanig Manoog Adoian in a small village in Armenia, Gorky immigrated to the United States in 1920. In the 1940s, he completed three drawings and three oil paintings entitled *The Plough and the Song* and three wood sculptures called *Armenian Plow #1–3*, all of which were initially inspired by the Virginia countryside. Evoking memories of the artist's homeland, this landscape prompted Gorky to write in 1944 to his sister: "You cannot imagine the fertility of forms that leap from our Armenian plows, the plows our ancestors used for thousands of years in toil and gaiety and hardship and poetry. . . . This I am painting and I am convinced you will appreciate it. So many shapes and ideas, happily

a secret treasure to which I have been entrusted the key."

In *The Plough and the Song,* delicately drawn forms resembling internal organs, bones, flowers, and plants populate an area between a blue-and-green "sky" and an energetically brushed, pale yellow-gray "earth." As the title of the painting suggests, these myriad shapes probably allude to the fecund organic life that a plow churns up when furrowing rich, loamy earth. The plow may be represented by the columnar form at left, which straddles both land and sky and seems poised to till the soil.

*The Key,* 1946

Oil on canvas; 149.9 x 215.9 cm

Despite the highly unique nature of his art, Jackson Pollock drew inspiration from a number of disparate artistic styles. He was as interested in the American Indian art of his native Southwest as he was in the heroic Renaissance and Baroque painting beloved by his teachers Thomas Hart Benton and David Alfaro Siqueiros. Pollock also responded profoundly to Surrealist art, particularly to works by Pablo Picasso, Joan Miró, André Masson, and Roberto Matta. He shared the Surrealists' desire to address primal and mythic subjects and to explore the unconscious.

For his first solo exhibition, in 1943, at the Art of This Century, Peggy Guggenheim's pioneering New York gallery, Pollock created a body of compelling totemic images defined by hieroglyphic marks. Subsequent shows of his work there prompted some critics to call him America's greatest painter. The popular press, however, disparaged his unconventional works; *Time* magazine, for instance, published a reproduction of *The Key* upside down, which it captioned, "The Best?"

Painted at his East Hampton, Long Island, home, *The Key* belongs to Pollock's Accabonac series, named for a nearby stream. The canvas presents what appears to be a ritual confrontation between two large, gesturing figures flanking a sacrificial beast under a dark sky. Displaying an extensive variety of paint application, *The Key* seems to be a demonstration piece. A jumble of triangles and arcs has been brushed onto the canvas, scraped with a putty knife, and dabbed and squeezed from tubes, leaving many areas of canvas exposed. The swirls of roughly applied paint that compose the "head" of the right-hand figure would lead to the completely nonfigurative "drip" paintings that the artist began to make later that year. The painting's technical virtuosity and many intense colors make it one of Pollock's most opulent and ambitious Surrealist works.

# Jean Dubuffet

## Supervielle, Large Banner Portrait, 1945

Oil on canvas; 130.2 x 97.2 cm

Jean Dubuffet came to painting late, only devoting himself exclusively to art at the age of forty-one. Despite his vast knowledge of classical art and culture, the artist quickly established himself as both a believer in and practitioner of an anti-aesthetic that he called *Art Brut* (raw art). For Dubuffet the "raw art" of untutored and compulsive creators (the insane, prisoners, children, derelicts), which he began collecting in 1945, was more exciting and beautiful than traditional Western art. In his own work, the artist developed a style that embodies the candor and immediacy of a child who sees without the preconceptions deriving from education and socialization.

In *Supervielle, Large Banner Portrait,* Dubuffet simply and crudely worked an enormous image of a head (two-and-a-half times life size) into a thick, tarlike surface. With its yellow, widely separated teeth, big ears, and narrow forehead, the face is strikingly ugly, even frightening. In contrast to its large, heavy head, the figure's skinny neck, bony shoulders, and sunken chest are disproportionately small and appear as if inadequate to the task of holding the head aloft.

This portrait of the Uraguayan poet Jules Supervielle (1884–1960) is part of a series of depictions the artist did in the 1940s of writers and intellectuals he knew. Their similarly unflattering portraits also display oversized heads with exaggerated features, due, in part, to the artist's desire to deflate the pretensions of learned individuals. That Dubuffet had little appreciation for Supervielle's poetry is apparent from a statement he made: "The work of this poet does not interest me very much. . . . However, I have to mention that his physical appearance (he is a tall, lean, stooping devil, whose head—tottering constantly—[has] the expression of a camel) seemed to lend itself to a portrait which might serve my intentions."

# Alberto Giacometti

## *Tall Figure,* 1947

Bronze; 201.9 x 22 x 41.6 cm (with base)

One of an edition of eight, this six-and-one-half-foot-tall bronze is paradigmatic of the haunting, elongated figures that Alberto Giacometti began making after World War II. In 1947 he developed his basic typology of human forms—standing woman, walking man, and pointing man—which appear equally emaciated and solitary, whether in an active or quiescent state. With their barely defined facial and body elements, these figures look like persons seen from a great distance. Albeit pencil-thin, they are endowed with large, broad feet that anchor them to the tall, narrow platforms on which they stand.

Following study at the Ecole des Arts et Métiers in Geneva and travel throughout Italy, Giacometti settled in 1923 in Paris. Under the influence of Surrealism, he produced a group of dream-inspired sculptures with such evocative titles as *Hands Holding the Void* and *Palace at 4 A.M.* (both at The Museum of Modern Art, New York). Eager to follow a new direction, the artist began to draw and sculpt from a model from 1935 on. In the early 1940s, he fashioned tiny plaster figures, ranging from one-half to five inches in height, making, in 1947, the electrifying transition to his hallmark, life-sized bronzes.

The skeletal appearance, blurred features, scabrous surface, and dark patina of *Tall Figure* reflect Giacometti's engagement with existentialist thought. Like Francis Bacon, Jean Dubuffet, and Jean Paul Sartre (who, in 1948, published an influential essay on Giacometti's new work), he sought to express the sense of isolation and anxiety that he thought permeated modern-day life. In addition to capturing the pervasive feelings of unease in the wake of World War II, *Tall Figure,* with its constricted, self-protective posture, embodies humankind's inherent fragility throughout time.

Tempera on board; 50.8 x 61 cm

Born in Atlantic City in 1917, Jacob Lawrence moved to Harlem in 1930, where, at age fifteen, he enrolled in the Harlem Art Workshop at the 135th Street branch of the New York Public Library (now the Schomberg Center for Research in Black Culture). A prodigy, Lawrence rapidly created a bold, unique style, which he applied to seldom-treated subjects from black history and life in Harlem. His early, multipart series on Toussaint L'Ouverture, Frederick Douglass, and Harriet Tubman (completed between 1937 and 1940) attracted the attention of artistic and cultural leaders of the Harlem Renaissance, as well as figures from New York's modern-art establishment. His masterpiece, the

*Migration* series (1940–41), which, in sixty panels, chronicles the historic wave of black migration to the industrial cities of the North, was shown at New York's prestigious Downtown Gallery and was then jointly purchased by The Museum of Modern Art, New York, and the Phillips Collection, Washington, D. C.

Executed in vibrant tempera colors on a white ground, *The Wedding* exemplifies Lawrence's expressive, trademark style. Befitting the solemnity of the event, the composition is arranged with symmetrical rigidity: a stern-faced minister addresses bride and groom, while two attendants stand nearby in profile. The contours of the figures and flower stands, a series of rhyming convex and concave lines, create a sense of

contained, nervous energy that finds release in the riotous profusion of intensely colored flowers and stained glass.

Lawrence's works are informed by a rich diversity of sources. Their narrative clarity is indebted to both comic strips and early Renaissance frescoes and panel painting, and their graphic economy, to the work of the Spanish artist Francisco Goya and the Mexican painter José Clemente Orozco. In addition, Lawrence's masterly handling of abstract form reveals a dialogue with Synthetic Cubism, in which his colleagues at New York's Downtown Gallery—Ralston Crawford, Stuart Davis, and Charles Sheeler—also participated.

## Mark Rothko

### *Number 19,* 1949

Oil on canvas; 172.4 x 101.9 cm

The largely self-taught painter Mark Rothko was one of a ground-breaking group of New York artists who at midcentury developed an emotional, nonrepresentational style of painting that came to be known as Abstract Expressionism. Two approaches to this style emerged: one, termed action painting, was based on the energetic handling of paint (see pp. 99, 102–103), and the other, called color-field painting, on the creation of vast zones of homogeneous color (see pp. 100–101), which Rothko's work exemplifies. While the artist's early figurative canvases were informed by Surrealism, he began, in the early 1940s, to paint flattened organic shapes floating in front of pale, thinly brushed backgrounds. In 1947–48 the artist initiated his Multiform series, or configurations of soft-edged rectangles; and, in 1949–50, his signature compositions of two or three vertically aligned rectangles (e.g., the Art Institute's *Purple, White, and Red*).

Hushed, elemental dramas of forms in flux characterize *Number 19* and Rothko's other Multiform compositions. Here, several variously sized, colored rectangles are suspended in a luminous, orange-pink atmosphere. These shapes hover near the perimeter of the canvas, leaving the center of the composition—traditionally the focus of a painting—virtually empty. A number of soft- and harder-edged rectangles seem to coalesce or dissolve, particularly the runny form, outlined in white, in the upper left-hand corner of the canvas.

Unlike many of his fellow Expressionists, who delighted in the strong rhythms and impact created by the opposition of primary colors, Rothko took a more understated, subtle approach. In *Number 19,* for instance, the artist achieved a delicate balance between orange-pink and blue-gray to realize his intention of "rais[ing] painting to the level of poignancy of music and poetry."

## Willem de Kooning

### Excavation, 1950

Oil on canvas; 206.2 x 257.3 cm

Willem de Kooning completed *Excavation* in June 1950, just in time for the work to be included in the Twenty-fifth Venice Biennial, where it generated great excitement. The following year, the painting won first prize at a major exhibition at The Museum of Modern Art, New York, after which the artist sent it to the Art Institute's prestigious American Exhibition. Despite the previous critical reception of *Excavation*, its subsequent purchase by the Art Institute provoked heated controversy among Chicagoans, who were not ready to accept such a bold and monumental abstract statement of art. Time has justified the museum's acquisition, for the painting is one of de Kooning's masterpieces.

The largest painting de Kooning had produced to date, *Excavation* exemplifies the Dutch-born artist's virtuoso style. Its rich, painterly surface is rendered by expressive and varied brushwork—the paint is swiped and dragged across the canvas, as well as scraped back. Punctuating the work are flashes of red, blue, yellow, and pink, whose impact has been diluted somewhat by the gradual yellowing, over the years, of the predominant white pigment. While it verges on the abstract, the all-over composition of loose, sliding planes with open contours is replete with shapes suggestive of birds and fish, eyes, human noses, jaws, necks, and teeth. As de Kooning explained in 1951, "I'm not interested in 'abstracting' or taking things out, or reducing painting to design, form, line, and color. I paint this way because I can keep putting more and more things in—drama, anger, pain, love, a figure, a horse, my ideas about space." *Excavation*'s irregular, oftentimes overlapping, shapes reflect the artist's idiosyncratic method of tracing parts of a painting as it evolved, cutting the tracings out, and copying them, oriented in new directions, onto other areas of the canvas. The resulting sudden shifts between adjacent forms activate pictorial space in an unprecedented way.

According to the artist, *Excavation* was initially inspired by a scene in the 1949 Italian Neorealist film *Bitter Rice,* showing women harvesting rice. While the painting's title might refer to the act of ploughing or manipulating the earth until it yields treasures, it also reflects de Kooning's painting process in these years, which involved the intensive building up of the surface and scraping down of its paint layers, often over months, until the desired effect was achieved.

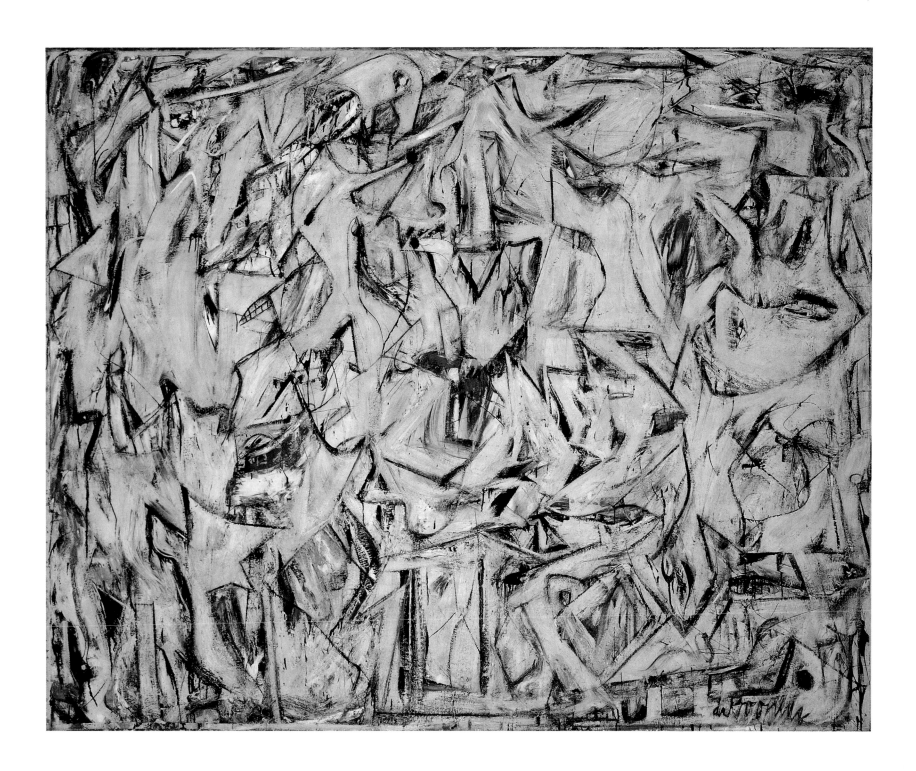

# Barnett Newman

## *Untitled (Number 3), 1950*

Oil on canvas; 142.2 x 7.6 cm

*Untitled (Number 3)* was one of six emphatically vertical paintings included in a 1951 exhibition of Barnett Newman's art at the Betty Parsons Gallery in New York. These enormously influential, slender-format works range from a mere 4.1 to 15.2 centimeters in width and 91.4 to 181 centimeters in height. The second most narrow work in the group, *Untitled (Number 3)* is just 7.6 centimeters wide and is limited to two colors—cadmium red and silver-gray—which meet right of center, cleaving the canvas in two along a wavy line.

With this series, Newman translated his signature compositions of monochromatic fields divided by thin, vertical bands called "zips" into three-dimensional objects. Painted on canvas over a frame that is twice the usual thickness of a stretcher, the strips of color here thrust outward toward the viewer, dismantling the boundary between painting and sculpture. Despite these experiments with shape, Newman emphasized that time, not space, was his primary interest. *Untitled (Number 3)*, like many of the artist's works, explores the moment of separation, of one element asserting itself against another, which for Newman embodied the act of creation. Indeed, in their struggle to diverge, the "zips" of vibrant red and subdued gray here evoke that initial moment of creation, when night was divided from day. Though only one of Newman's six, slim works bears a descriptive title—*The Wild*—the titles he gave to others made during this fertile period attest to his interest in metaphysical understanding: *Genetic Moment, The Word, The Beginning, The End of Silence,* and *Be.*

**Clyfford Still**          *Painting, 1952*

Oil on canvas; 301.8 x 396.2 cm

Clyfford Still emerged as one of the most powerful painters of the New York School in the late 1940s, even though he lived in the city only briefly before 1950. Along with Mark Rothko and Barnett Newman, he evolved a variant of Abstract Expressionism that relies for effect on monumental expanses of intense, homogeneous color. Such boundless vistas, these artists hoped, would overwhelm the viewer, sparking awareness of the elemental and transcendental aspects of life.

A native of Spokane, Washington, and Alberta, Canada, Still, early in his career, produced landscapes inspired by the scenery of the American West. Though banishing around 1944 identifiable imagery from his art, he continued to evoke mythic, dramatic terrain with his vertically oriented, flamelike forms. Eventually he enlarged these shapes into oceans of color, culminating in such works as the Art Institute canvas.

For stark simplicity of composition, only Barnett Newman's monochromatic paintings with their slim, vertical "zips" compare with *Painting*. However, whereas Newman's works reveal fairly uniform brushwork, *Painting* is a tour de force of texturing: Feathery black marks, applied with a wide brush or sponge, sweep over large areas of the canvas, while, at the center, thick paint has been pressed down as if to resemble patina on a sculpture. Providing the sole interruptions to this all-black field are a white, vertical line to the right of center and a thin zone of orange at the left. Together with the finish, which ranges from matte to glossy, the brushwork creates a shimmering field, evoking what the seventeenth-century poet John Milton termed "darkness visible." Such subtle modulations support Still's claim: "I do not oversimplify—in fact, I revel in the extra complex."

# Franz Kline

### *Painting*, 1952

Oil on canvas; 195 x 254 cm

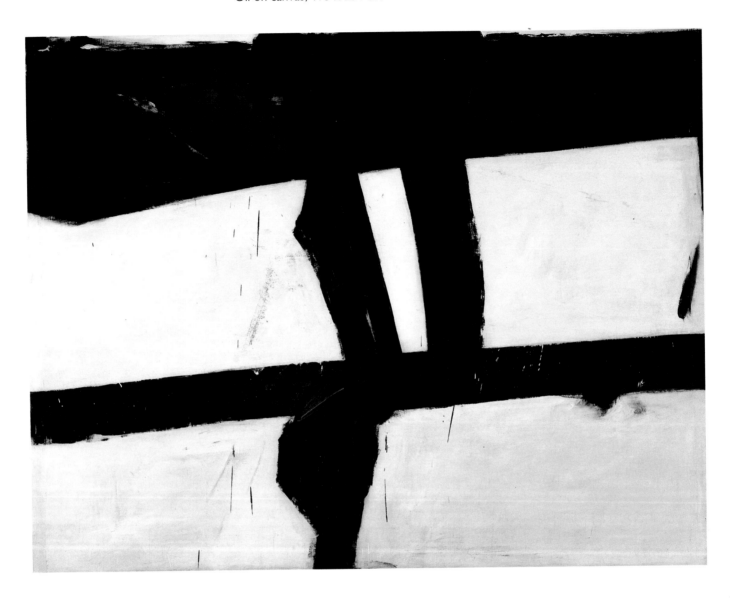

Along with Willem de Kooning and Jackson Pollock, Franz Kline originated a form of Abstract Expressionism known as action painting. Coined by the influential critic Harold Rosenberg, the term refers to the emotionally charged, deeply physical encounter between artist and canvas that is embodied in the work. This approach, which in Kline's case involved tacking canvas to a wood panel to obtain the hard surface needed for his vigorous use of housepainters' brushes, yielded spacious, emotion-laden canvases often rife with clashing forms and colors.

Like many of his abstractionist colleagues, Kline only gradually expunged representation from his compositions. Until the late 1940s, he painted realistic landscapes, portraits, and cityscapes that were inspired by the myriad textures and forms of New York City. Around 1949 he arrived at the black-and-white canvases such as *Painting* that rely for their effect on the interplay of black and white brush strokes. Though abstract, these forms, like many of the representational scenes that preceded them, continue to suggest the invigorating energy of urban street life.

In *Painting* two swaths of black rush across the canvas, their headlong movement barely slowed by three intersecting verticals and five white rectangles. These austere shapes effectively capture the sensibility of an artist who wanted to paint a world of eternally colliding forces. Though the many visible drip marks imply a quick, spontaneous execution, the artist returned to the canvas several times over a two-month period to refine and strengthen its rhythm and spacing. Fortunately for the Art Institute, the composition was the subject of an article—"Kline Paints a Picture"—in *Art News* (Dec. 1952), containing photographs that follow its genesis from exploratory drawings and sketches to the final compositional resolution.

# Jackson Pollock

## Greyed Rainbow, 1953

Oil on canvas; 182.9 x 244.2 cm

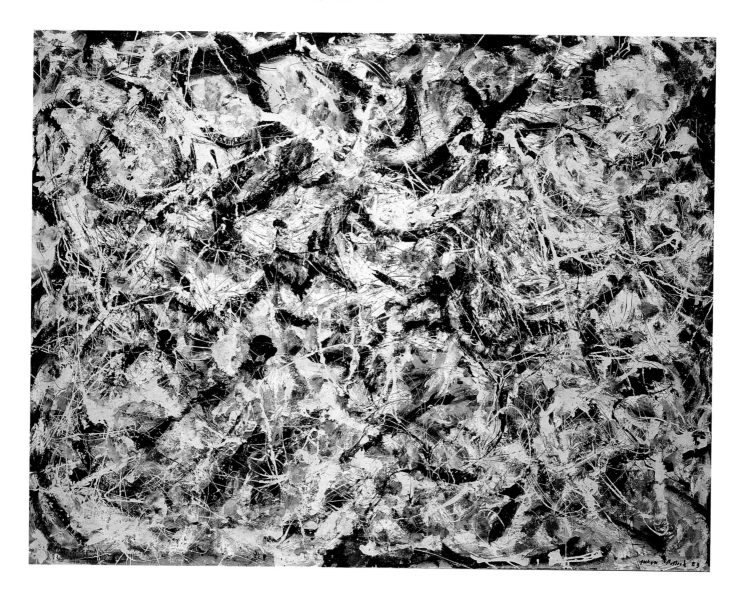

One of Jackson Pollock's last great abstractions made before his untimely death, in 1956, *Greyed Rainbow* is a quintessential example of action painting. Working on huge canvases spread across the floor of his Long Island studio, Pollock, in 1947, developed a revolutionary and highly energetic form of abstraction. He poured, dripped, and splashed paint, first on one side of the canvas, then on another, leaving parts of it exposed in the process.

In *Greyed Rainbow*, the paint application ranges from thick chunks squeezed directly from tubes to thin, meandering lines poured from a container with a hole or squirted from a baster. Partly the result of automatism (see p. 55), a modification of native American ritual sand painting, and an attempt to visually replicate jazz improvisations, the painting's marks evoke a landscape on the verge of cataclysm.

Two peculiarities of *Greyed Rainbow* stand out in view of Pollock's total oeuvre. Its title alludes to the most obvious—the addition of color to the bottom third of the black, white, and silver composition. Secondly, the canvas teems from one side to the other with bold, black arabesques, several of which end in what appear to be fishtails. Such imagery is even more explicit in earlier works by Pollock bearing such titles as *Full Fathom Five* (1947; The Museum of Modern Art, New York), *Ocean Grayness* (1953; Solomon R. Guggenheim Museum, New York), and *The Deep* (1953; Musée National d'Art Moderne, Centre Georges Pompidou, Paris). It reflects Pollock's fascination with Herman Melville's seminal novel *Moby Dick* and the author's view of the sea as a locus of primal conflict between opposing forces.

**Joseph Cornell**

## Soap Bubble Set, 1948

Mixed media; 22.5 x 33 x 9.5 cm

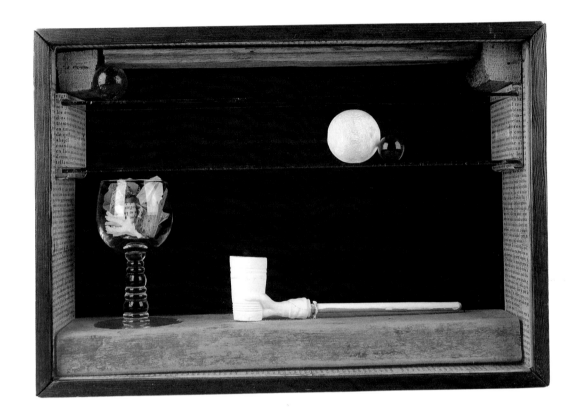

In 1929 the self-taught sculptor and collagist Joseph Cornell moved with his family to Flushing, New York, where he would remain the rest of his life. There, he lived a simple, routinized life, pursuing his interests in music, ballet, literature, theater, and art; and collecting vintage books, magazines, and objects that evoke earlier times and places laden with romance. Upon encountering the startling art of Surrealists Salvador Dalí, Max Ernst, Lee Miller, and Man Ray at a New York gallery, Cornell began, in 1931, to make collages from book illustrations and, shortly thereafter, intimately scaled shadow

boxes containing evocative combinations of images and objects. Explaining his affinity for these constructions, Cornell said in 1948: "Shadow boxes [are] poetic theaters or settings wherein are metamorphosed the elements of a childhood pastime."

In *Soap Bubble Set,* Cornell used a Spanish text to line the interior sides of a box, in which he arranged a Dutch clay pipe, a cordial glass stuffed with more of the text, a fragment of white coral, and a tiny piece of driftwood. Above these objects, he placed two glass shelves upon which rest two blue marbles and a white ball. Cornell made his first soap bubble set in

1936, and, in the many similarly titled assemblages that followed, he used the same types of items: balls, coral, cordial glasses, maps, marbles, pipes, and texts. These objects often owe their emotive power to childhood memories and pursuits, such as blowing bubbles, playing in the sea, and shooting marbles. Yet the formal reserve and deliberate arrangement of these elements (the rhyming of circular shapes, for example) give them a bracing rigor that allows their inherent poignancy to be expressed without undue sentimentality.

# Joseph Cornell

## Untitled (Crystal Cage), c. 1953

Mixed media; 48.6 x 27.9 x 10.5 cm

*Untitled* belongs to a type of construction by Joseph Cornell composed of numerous, tiny compartments that, when empty, resemble building facades. Chiefly made between 1943 and 1955, these boxes reflect their maker's fascination with plate-glass windows and the scintillating, elusive world of objects and personalities found behind them. In particular, Cornell relished investigating the souvenir and magazine shops of Times Square, where he discovered much of the material that animates his constructions and collages.

While Cornell's compartmentalized boxes often feature such found objects as balls, butterflies, cubes, illustrations, marbles, and stoppered glass vials filled with an assortment of things, in *Untitled*, no extraneous objects dispell the calm aura evoked by the barren grid. Composed of two lattices made of wood strips, a mirror at the back, and a transparent pane of glass at the front, the piece abounds in optical illusions. The mirror, for instance, accords the box a depth greater than its dimensions would allow. In peering into the box, the viewer's own fragmented image is reflected back, as if to invite him or her to fathom the mystery of self, as well as the enigmatic emptiness of the compartments. In contrast, the artist's object-filled boxes invite the viewer to mull over why certain and, oftentimes, incongruous articles have been brought together.

To evoke a sense of the fugitive moment, Cornell scrawled the word *wind* in white paint across the surface of the box. He also used white paint, cracked as with age, for the interior, in order to transport the viewer to the period of time that most captivated his imagination—the past.

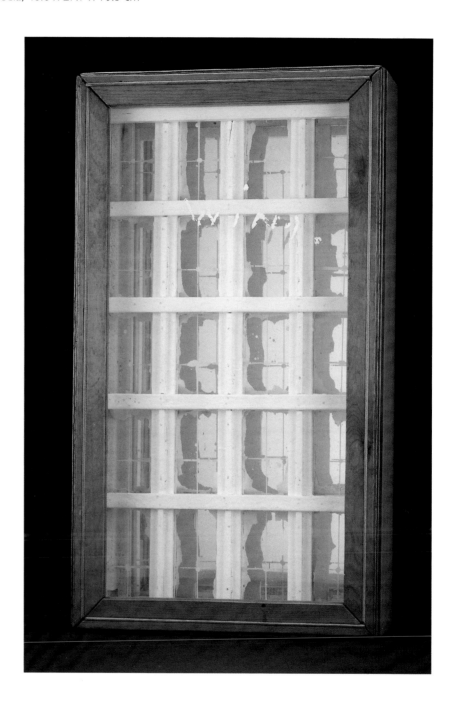

**Francis Bacon**

***Figure with Meat, 1954***

Oil on canvas; 129.9 x 121.9 cm

This painting belongs to a celebrated series of works, chiefly made between 1949 and 1965, that Francis Bacon based on Diego Velázquez's famous composition *Portrait of Pope Innocent X* (1650; Galleria Doria-Pamphili, Rome). Obsessed by the Spanish artist's stern image, Bacon owned several reproductions of the work and painted more than twenty-five versions of it; yet, despite his frequent trips to Rome, he remained, as he stated, "reluctant to look at" the original.

In *Figure with Meat,* Bacon placed Pope Innocent X in a small, dark cubicle outlined in white and, above the figure's head, inserted a small, black arrow that, in pointing at the prelate's face, underscores its anguished expression. Framing the seated figure are two sides of beef that create a grisly cloth-of-honor, as it were, in contrast to the luxurious drapery enveloping Velázquez's pope. By linking the pope and the carcasses, Bacon seems to have been suggesting that the former is either a depraved butcher or as much a victim as the slaughtered animals ranged behind him. During the same period, the artist painted a group of screaming figures wearing business suits in order to expose the anguish experienced, or evil perpetrated, by individuals with authoritarian roles.

Bacon's tormented visions of humankind, like the emaciated sculptures of Alberto Giacometti, the enigmatic scenarios of Balthus, and the coarse personages of Jean Dubuffet that began appearing after World War II, are permeated by the ethos of existentialism. As in the case of Albert Camus and Jean Paul Sartre, Bacon came to see "man [as] a completely futile being . . . [who] has to play out the game [of life] without reason."

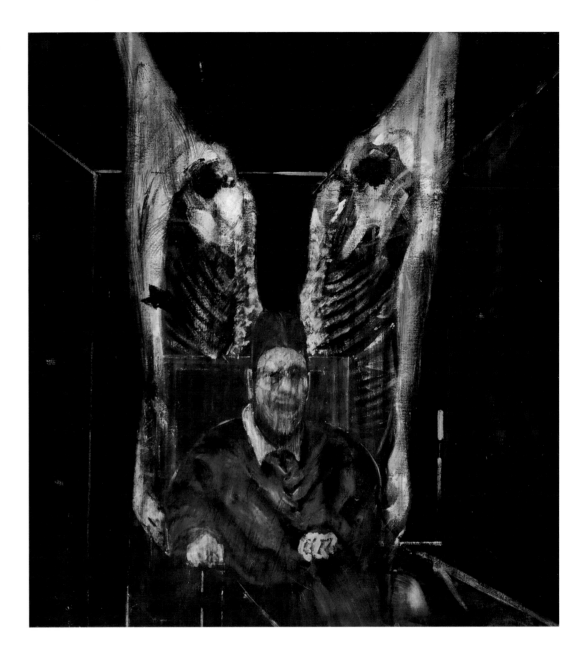

*City Landscape,* 1955

Oil on canvas; 201.9 x 201.9 cm

Early in life, Joan Mitchell developed a passionate interest in poetry and the natural world. Her mother was Marion Strobel, who, along with Harriet Monroe, coedited the pioneering *Poetry* magazine. From her family's apartment in Chicago, Mitchell could observe Lake Michigan, whose constantly changing appearance held her spellbound. "I paint," remarked the artist, "from remembered landscapes that I carry with me—and remembered feelings of them, which of course become transformed."

The Art Institute's *City Landscape,* produced in New York early in Mitchell's career, captures the pulsating energy of a metropolis. All the nerves of a vibrant city seem gathered here in a tangled ganglia of pale pink, scarlet, mustard, sienna, and black pigments, which thickens right of center. Composed of long, horizontal strokes, counterbalanced by vertical strokes and drips, this skein of color threatens to break out in pandemonium. A background of white, blocklike forms and the square shape of the canvas, however, stabilize the throbbing center. The effect is not unlike that of a city street, whose solid structures channel the activity surging between them.

Mitchell, who was influenced by the first generation of Abstract Expressionists, often worked, like Franz Kline and Jackson Pollock, in a very deliberate manner. As a painting evolved, she continually stopped to contemplate the relationships arising on the canvas. "The freedom in my work," she reflected, "is quite controlled. I don't close my eyes and hope for the best." Indeed, *City Landscape* achieves a remarkable balance between the exhilarating effects of chance and the solid virtues of stately, measured design.

## *Ready to Wear*, 1955

Oil on canvas; 142.6 x 106.7 cm

At fifteen, Stuart Davis moved to New York to study art, and, at nineteen, he exhibited five watercolors in the controversial 1913 Armory Show (see p. 19). The modernist works the young artist saw there represented, he later said, "the greatest shock and the greatest single influence" on his art. Also powerfully affecting him were the myriad sights and sounds of North America; Davis believed his pictures had "all [of] their originating impulse in the impact of the contemporary environment." Bursting with fragmented images of gasoline stations, jazz scores, kitchen utensils, neon signs, signboards, storefronts, and taxicabs, these works have been linked with the much-later Pop Art movement (see pp. 116–17).

Over the course of several decades, Davis's paintings became increasingly flattened and simplified, resembling billboards with their broad, vibrant areas of color and large scale. Exemplifying his compositions from the 1950s and 1960s, the Art Institute's canvas explores the uniquely American invention of ready-to-wear clothing, a term first employed in an 1895 Montgomery Ward catalogue. Here, what initially resembles a bewildering array of pieces cut from red, white, black, and blue construction paper may, in fact, represent leftover pieces of fabric, and the black shape that fills nearly two-thirds of the canvas may indicate a cutting-room table. Thinly layered, angular shapes play against curvilinear forms and the undulating contours that bracket the top and bottom of the "table." Animating the center of the composition is a free-form squiggle, which could indicate a curling scrap of material, and looming at the top-right corner is the tool that produced them, a pair of scissors. With its bright palette and contrasting shapes, the painting celebrates not only the vitality of the ready-to-wear industry itself, but also of its country of origin.

# Hans Hofmann                    *The Golden Wall*, 1961

Oil on canvas; 151 x 182 cm

As a young artist, Hans Hofmann witnessed the development of Fauvism and Cubism, associating with Georges Braque, Juan Gris, Henri Matisse, and Pablo Picasso during a decade-long residence in Paris. From 1915 to 1932, the artist disseminated his newly acquired theories of painting to students at an art school he founded in Munich, and, beginning in 1932, at another art school he opened in New York City and later in Cape Cod, Massachusetts. Despite his popularity and enormous influence as a teacher, particularly for the Abstract Expressionists, Hofmann chose in 1958 to devote himself exclusively to painting.

Hofmann considered movement "the expression of life." Advocating a "push-and-pull" theory of painting, he sought to orchestrate forms and colors in order to make them appear to simultaneously advance and recede. Such back-and-forth movement, the artist believed, combined with glowing, saturated hues, would infuse painting with the dynamism of life itself. *The Golden Wall* fairly vibrates with movement and opulent color. Cool blue and green rectangles counterpoise molten, red-orange tones that extend across the canvas. Though cool colors usually appear to recede, the blue rectangle at right, embedded in yellow, seems to push forward,

whereas the blue square at upper left, surrounded by orange-red, melts into the background. Expressionistic brushwork further activates *The Golden Wall*, making the passage of the artist's hand palpable to the viewer. These several techniques conspire to lead the eye around the canvas, rather than letting it rest on one area. In the end, then, Hofmann's romantic title, *The Golden Wall*, refers not to the barrier implied by the word *wall*, but to the resplendent colors and vigorous forms that animate this lyrical composition.

Although the artist Joan Miró divided his time between Paris and Spain from 1920 onward, he always maintained close ties with his native land, drawing inspiration from its variegated landscape. In Paris the artist became a founding member and leader of the Surrealist movement, exhibiting with, among others, Arp, de Chirico, Ernst, Klee, and Man Ray. At the outset of World War II, Miró returned permanently to Spain, where he lived until his death, in 1983.

Known principally as a painter, Miró nevertheless worked in a prodigious variety of other media, including bronze, ceramics, collage, and various printmaking techniques. Miró's first venture with ceramist José Llorenz Artigas occurred between 1944 and 1946, when they produced ten large vases and a number of decorative plaques. From 1954 to 1958, Miró worked almost exclusively in ceramics in collaboration with Artigas, once again intrigued by the possibilities of creating new forms. Together, they produced more than two hundred pieces.

Artigas's home and studio were located near Gallifa and Miró's family farm in the Catalan countryside. Their work, as Artigas later commented, "sprang directly from th[is] landscape." The barren, craggy surroundings of Gallifa seem to have informed *Stone*. Actually formed from clay, this piece has a roughened, stony texture that gives it a weathered and ancient appearance. Its roughly pyramidal shape and the pictographs it bears make it resemble a stele. Each side differs markedly from the other in imagery and overall coloration—one surface is light, the other dark. On the dark side are a blue crescent moon, stars, and a slithering night creature; and on the other, a sun disk and a teeming landscape.

Oil on canvas; 193 x 276.9 cm

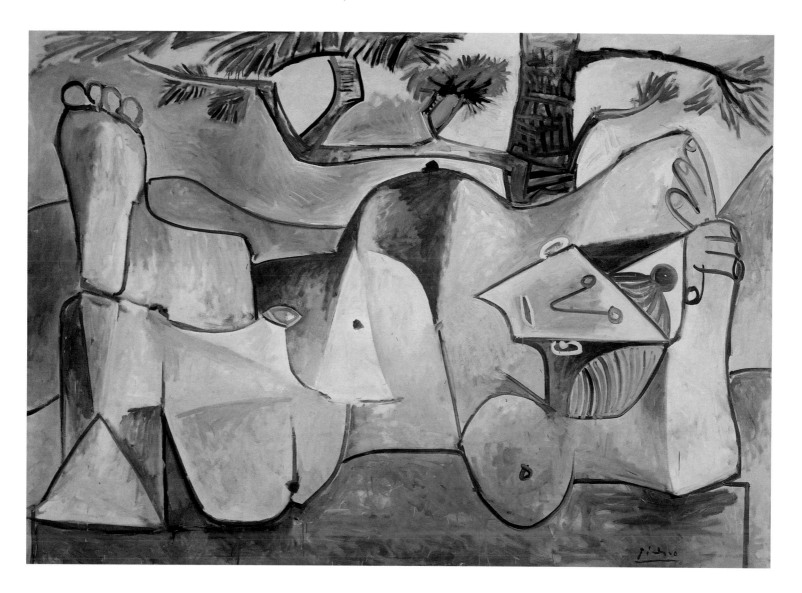

One of the most restlessly inventive artists of the twentieth century, Pablo Picasso took up traditional themes, such as the representation of reclining female nudes, revivifying them not through replication, but rather through free-wheeling quotations from historical precedents. In *Nude Under a Pine Tree,* he invoked the seductive female nude in Francisco Goya's *Naked Maja* (c. 1800; Museo del Prado, Madrid). Splayed out on a canvas extending over six by nine feet, Picasso's Amazonian figure, like the Maja, is depicted with upraised arms and breasts spread far apart. But Picasso radically transformed Goya's model by submitting the figure to bold, modernist distortions and by placing her on rocky terrain, rather than on a plush chaise longue.

Picasso's penchant for plagiarism extended to his own earlier periods of art: here, the flattening of the figure's face, bold segmentation of her legs and torso, and depiction of body parts that would be impossible to view simultaneously all derive from Cubism; while the pink, heather-green, and slate-gray palette evokes the artist's Rose and neoclassical periods. Tempering the contortions of the body, which are echoed in those of the pine branches, these pastel hues impart an air of serenity to the scene. Also counterpointing the blocky forms of the woman's body are crudely rendered anatomical details.

Picasso painted *Nude Under a Pine Tree* at Vauvenargues, a historic chateau located on the north slope of Mont Ste.-Victoire in the Provence region of southern France. This arid, rocky terrain, celebrated in the art of Paul Cézanne—a seminal figure for Picasso—is invoked not just in the sparse, barren background of *Nude Under a Pine Tree,* but also in the rises and falls of this woman's powerful body. Indeed, she seems to be the human equivalent of Mont Ste.-Victoire, as it appears in Cézanne's monumental canvases of that name.

Teak; h. 138.4 cm

Hepworth was one of the first artists to synthe-size, in her work, two broad trends in modern art: the urge toward geometric abstraction and structural rigor of Piet Mondrian and Naum Gabo, both of whom she knew personally in the 1930s; and the curving forms, rich in allusions to the human figure and to nature, of Jean Arp and Constantin Brancusi. This combination of ele-ments contributes, in sculptures such as *Two Figures (Menhirs),* to an exquisite balance be-tween anthropomorphic associations and purely formal clarity and poise.

*Two Figures (Menhirs)* belongs to a magnificent series of wood carvings dating to the mid-1950s that exemplify Hepworth's consummate skills as a carver. The openings in the two forms remind us of her pioneering role in piercing the tradi-tionally solid mass of sculpture. She was the first, in 1931, to cut a hole through a sculpture for purely formal purposes. This bold step led her to develop an unrivaled sensitivity for the unique qualities of inner, partially enclosed spaces—what she called the "withinness" of sculpture—qualities she expressed in the beautifully nuanced concavities that animate, as in this case, so many of her works. Hepworth was also an innovator in the use of color in sculpture, by often painting these concavities in ways that further enhanced their associative power. As she explained, "The color in the concavities plunges me into the depths of water, caves, of shadows deeper than the carved concavities themselves."

The subtitle of this work, *Menhirs,* alerts us to one of Hepworth's major sources of inspiration, the landscape and prehistoric stones of Corn-wall, where she made her home from 1939 onward. In sculptures such as this, the artist in-corporated the totemic dignity of these prehis-toric monuments, while also focusing on what she described as her search for "some absolute essence in sculptural terms giving the quality of human relationships."

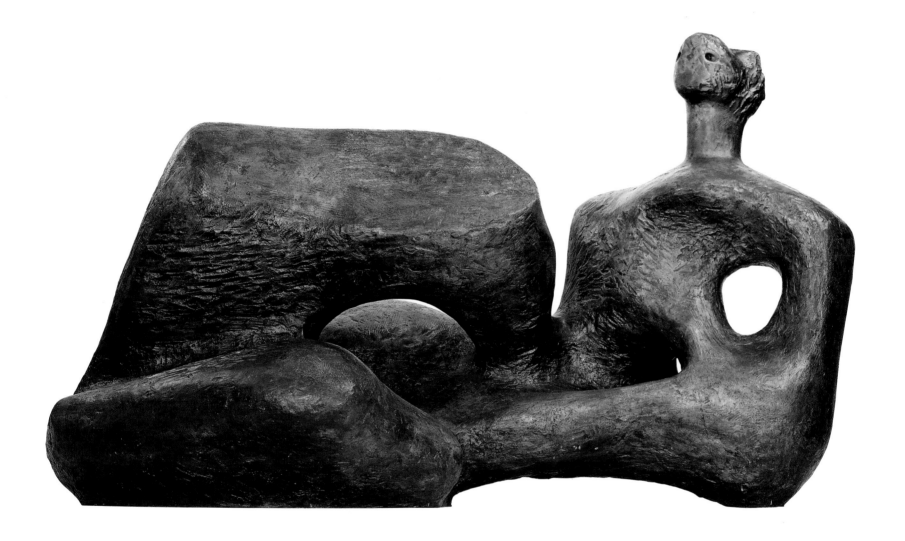

This monumental, recumbent nude by Great Britain's most prominent twentieth-century sculptor, Henry Moore, was originally conceived for the headquarters of the United Nations Educational, Scientific and Cultural Organization (UNESCO) in Paris. One of six bronze casts, the Art Institute work is roughly half the size of the unique, sixteen-and-one-half-foot-long marble figure that Moore installed at UNESCO in 1958. Though made of bronze, the rough, pitted surface of this version simulates that of the hammer- and chisel-worked sculpture.

Moore based the UNESCO bronze and numerous other reclining figures in part on an ancient figurine from the Yucatán region of Mexico, shown reposing on elbows with raised knees. Though supine, the figure here seems alert and powerful, reflecting the artist's desire to express the physical and mental strength of women. He invested the figure with pantheistic feeling, evoking the cliffs, caves, and valleys of the natural world through her rounded protuberances and voids. Explaining his revolutionary use of the latter, Moore noted, "A hole can have as much meaning as a solid mass—there is a mystery in a hole in a cliff or hillside, in its depth and shape. My idea [is] to make . . . sculpture [that is] as fully realized as nature."

The son of a Yorkshire miner, Moore drew inspiration from a wealth of sources, particularly non-Western traditions (such as African wood carving and pre-Columbian sculpture), which he thought most powerfully expressed the fundamental dignity of humankind. The artist produced his first pieces, executed between the world wars, primarily in stone or wood and, in 1945, began using bronze for his numerous, large-scale, commissioned works, striving at all times to remain true to the inherent nature of these materials. A second Art Institute sculpture by Moore, *Large Interior Form*, graces the museum's north outdoor garden, the Stanley McCormick Memorial Court.

Mixed media on canvas; 43.2 x 53 cm

"Painting relates to both art and life," Robert Rauschenberg has stated, ". . . [and] I try to act in that gap between the two." Along with such artists as Jasper Johns and Allan Kaprow, he attempted, in the 1950s, to bridge this gap by incorporating into his art images and objects culled from daily life. For Rauschenberg this meant combining photographs (of, for example, presidents, swimmers, or the Statue of Liberty), artifacts (such as clocks, Coke bottles, pieces of fabric, postcards, tires), and expressive brush-work in compositions that could be small or large, two- or three-dimensional, and wall-mounted or freestanding.

Here, Rauschenberg juxtaposed a photograph of the Lincoln Memorial in Washington, D. C., with several passages of paint, laid on both thick and thin, and a cluster of items, including a scrap of damask; a metal tag with the letters A, B, and C; a rectangle of brown wrapping paper with lists of numbers and letters; and an illustration, turned on its side, of an eroded cliff. In contrasting the image of Lincoln—a nineteenth-century American icon associated with freedom and wisdom—with more recent, albeit somewhat battered, artifacts, Rauschenberg here played off a lively and raw present against a somber, monumental past. While blurred in photo-screening and, thus, perhaps, meant to signify his diminishing importance in public conscious-ness, the very reference to Lincoln suggests that he persists as an important symbol. Indeed, Rauschenberg may have invoked the "Great Emancipator" because of the battle for integra-tion being played out in the southern United States during the late 1950s.

# Lee Bontecou

## Untitled, 1960

Steel and canvas; 182.9 x 182.9 x 45.7 cm

A Fulbright Fellowship in 1957 enabled Lee Bontecou to spend two years in Rome, where she learned to weld the steel frames that became the basis of her future three-dimensional work. To fill in the void created by these structures, she at first worked with such materials as terracotta and metal sheets. Beginning in 1959, she began to incorporate canvas she had salvaged from used conveyor belts discarded by a neighboring laundry, inaugurating an extraordinary body of monumental wall reliefs.

In the Art Institute's *Untitled,* pieces of canvas and burlap, left in their natural shades of brown, are tautly stretched and attached with wires to a skeletal armature and, at the work's outer perimeter, to a welded steel framework. At once support, medium, and subject, the canvas-and-burlap surface oscillates between abstraction and a compelling, but indeterminate, figuration. With its dusty coloration and raised surface, *Untitled* resembles a relief map of a barren topography as seen from a bird's-eye perspective. Every element in the work thrusts upward toward the deep, velvet-lined orifice that elicits references at once geographic and biological, from a volcanic terrain to the bodily cavity of an inchoate organism. The activity of war and its attendant destruction are also evoked through Bontecou's use of raw canvas material normally reserved for military operations, here redeemed and recycled while retaining an aggressive quality.

The Art Institute's piece was originally exhibited in 1960 as part of Bontecou's first one-person exhibition at the prominent Leo Castelli Gallery in New York, where she distinguished herself as one of only two women (Marisol being the other) given one-person exhibitions there during this period.

Oil and fluorescent paints on canvas; 183 x 198 cm

James Rosenquist has always been interested in the familiar, mass-produced items of modern industrial society. Between 1958 and 1965, he supported himself off and on as a billboard painter, which clearly influenced his later borrowings from the world of advertising of smooth surfaces, stylized forms, and commercial content. Rosenquist, along with a group of English artists and such Americans as Roy Lichtenstein, Claes Oldenburg, and Andy Warhol, originated a movement—Pop Art—that drew chiefly upon popular culture for style, technique, and content. While many examples of Pop freely embrace mass culture, others use it as parody and criticism.

With its incongruous juxtaposition of fragmented images that are tellingly spliced together, *Volunteer* functions to highlight idealized depictions of American life found on billboards and other forms of advertisement, as well as to critique glossed-over aspects of volunteerism. Dominating the painting's six seemingly unconnected images is a gigantic handprint of Rosenquist's own palm, which, according to the artist, represents the "hand that volunteers." Also depicted are a washing machine; a headless, suited man who sports a volunteer's red patch; a puzzle, representing a pistachio ice-cream cone, with a piece missing; and, finally, overlying these disparate images, a brown belt and oval yellow band, which unify all the elements.

Symbols of progress (the labor-saving washing machine), of personal appearance (the suited volunteer), and of gustatory pleasure (the ice-cream cone) conjure up an America that is efficient and innocent. In contrast, the headless volunteer, whose passive stance suggests that he simply "follows orders," and the overly emphatic hand allude to the darker, mindless side of American naïveté. During an interview, Rosenquist defined American volunteers as those who rotely raise a hand to help out regardless of whether they are capable of accomplishing a task. Striking a more positive note, he allowed that some volunteers were able "to rise to the occasion."

**Roy Lichtenstein**                    *Brushstroke with Spatter, 1966*

Oil and magna on canvas; 172.7 x 203.2 cm

Roy Lichtenstein, a major American Pop artist, received his earliest training from the Social Realist painter Reginald Marsh at the Art Students League in New York. By the 1950s, he was fully under the sway of Abstract Expressionism (see p. 97). His mature work, however, departs radically from these beginnings. In 1961 Lichtenstein began to lift motifs from sources such as newspapers and comic books, transforming them into paintings with the use of intermediary outline drawings and an opaque projector. He also adopted the Ben-Day dot (used in printing to create tonal areas) to mimic the depersonalized, mechanical reproduction of images outside the rarefied realm of easel painting.

*Brushstroke with Spatter* belongs to a series of paintings from the mid-1960s in which Lichtenstein turned from comics and advertising to fine art as subject matter. These lively pictures parody Abstract Expressionism, depicting, on a huge scale, its basic elements—the brush stroke and spatter or drip—in a crisp, deadpan manner that negates the very ideals of spontaneity and feeling associated with the style. Using a bright palette of primary colors, devoid of nuance, Lichtenstein rendered the thick, juicy impasto of action painting (see pp. 102–103) by means of its opposite—flat, dry, hard-edged forms painstakingly applied to commercially primed canvas with cut-out stencils. Similarly, the uniform field of red dots in the background evokes print media, thereby mocking the uniqueness and originality of the Expressionists' painterly gestures. Bold and upbeat, *Brushstroke with Spatter* epitomizes Pop Art's spirited critique of the triumphant American movement that it would upstage.

Oil on canvas; 228.6 x 304.5 cm

The neutral, straightforward title of Ellsworth Kelly's *Black and White* belies the elegance of the work's flaring white and emphatic black forms. Like the billowing of diaphanous fabric or the graceful glide of a dancer, the rightward swing of the slender, full-length white form at left is reprised at right by the incipient "entrance" of a related form. The gradual, subtle widening of the contours of the white shapes at the bottom of the canvas enhances the sense of light, balletic gesture, while the incomplete white form at right implies an endless succession of rhythmic movement.

The two-color palette and contrast of opposing shapes are distinctive traits of Kelly's art. Though born in New York State, Kelly spent his formative years, from 1948 to 1954, in France, where he saw the biomorphic configurations of Jean Arp and Joan Miró and the brilliantly colored, late, cut-paper works of Henri Matisse. He was impressed by the emphasis these artists placed on evocative contours and flat, contrasting areas of color.

After settling in New York, the artist was often linked with the color-field painters of the late 1950s and 1960s, such as Kenneth Noland and Frank Stella, who also employed crisp, hard-edged forms. Unlike some of these artists, Kelly often derives his spare abstractions from actual visual phenomena. The artist painted *Black and White,* for instance, the year after he had worked on sets and costumes for dancer and choreographer Paul Taylor. The lithe rhythms of this composition do, indeed, suggest the joie de vivre associated with spirited, unencumbered movement.

# David Smith

## Cubi VII, 1963

Welded stainless steel; h. 282.9 cm

Considered by many the most important American sculptor of his generation, David Smith pioneered the use of welded metal in sculpture in North America. After many years of working metal into evocative linear compositions, Smith helped forge a new, formal language for sculpture through increased focus on shape, volume, surface, and structure. He achieved this goal admirably in the twenty-eight pieces that compose his monumental, and highly influential, Cubi series, executed in the four years before his untimely death, in 1965. For the series, he chose to use stainless steel, a sensuous material rarely used in sculpture before the Cubis.

While the spare forms of the Cubis, as well as their almost industrial sleekness, relate them to Minimalist sculpture of the 1960s, they reflect the artist's connection to Abstract Expressionism in the gestural quality of their wire-brushed surfaces, their allusion to the human figure, and their attendant emotive power. Indeed, the large, central form and adjacent shapes of *Cubi VII* evoke a torso with limbs. Yet, when one walks around the sculpture, it becomes less a symbol of the human form than a vehicle for exploring the relationship between architectonic volumes and the space surrounding them. Despite its solidity, the piece appears to have no fixed center, and its elements seem precariously positioned, challenging accepted notions of balance.

The reflective, burnished surfaces of *Cubi VII* pick up the shifting light of the work's outdoor site—the Art Institute's north garden, the Stanley McCormick Memorial. On sunny days, the metal blocks catch and disperse light, dazzling all who happen to walk by.

**Untitled, 1964**

Oil and collage on canvas; 212.1 x 157 cm

With its expression of controlled agitation, *Untitled* effectively embodies its maker's goal of melding Eastern calligraphy and Western drawing. Tobey's interests in Old Master drawing developed through visiting The Art Institute of Chicago, whose school he attended briefly (1909–11), and in Eastern painting through befriending a young Chinese artist while teaching in Seattle, Washington (1922–25). Further stimulated by encounters in England with individuals who like himself wished to fuse Eastern and Western cultural traditions, Tobey studied calligraphy and brushwork in China and Japan, where he lived for a while in a Zen monastery.

Around 1935 Tobey arrived at his distinctive "white writing," or intricate networks of calligraphic marks that densely and evenly animate a surface. When viewed from a distance, these dabs and dashes of pigment, interspersed with short, overlapping lines, create a writhing, unified field of energy. In *Untitled* the subdued palette of lavender, white, gray, black, and burgundy functions similarly—the innumerable strokes and marks only become distinct from close-up. A smoothly painted border, which appears in much of Tobey's oeuvre, surrounds and offsets the vibrating center. The artist felt that the delicate, teeming webs of "living line" mirrored the connections between East and West, finite and infinite, humanity and the cosmos.

Tobey pasted several, small, irregular pieces of painted canvas over the original surface of the composition to "correct" areas that disrupted the work's overall effect. This "democratic" distribution of energy, the artist maintained, encourages the eye to sweep back and forth across the expanse of a canvas instead of focusing on a predetermined section of it and thereby affects the viewer's understanding of perspective. As Tobey once said, "I've tried to decentralize and interpenetrate so that all parts of a painting are of related value. Perhaps I've hoped even to penetrate perspective and bring the far near."

# Günther Uecker

## Vast Ocean, 1964

Painted nails and wood; 175.3 x 175.3 cm

In 1955 Günther Uecker emigrated from East to West Germany. In Düsseldorf he soon became involved with a collective of artists that evolved into Group Zero, which functioned less as a formal organization than as an association of colleagues in revolt against the gestural abstractions predominating in the 1950s. To advance their ideas, these artists wrote manifestos and sponsored exhibitions, happenings, and projects throughout Germany and other European countries, where sympathetic groups sprang up.

Explaining the essential mission of Group Zero, Uecker stated in 1965: "Zero has been, from the beginning, an open space in which artists have experimented with various possibilities of giving visionary form to the concepts of purity, beauty, and silence." Furthermore, Group Zero artists believed that these ideas could best be captured through focusing on such basics, or starting points, of art making as kinetics, light, and monochromy.

Initiated around 1957, Uecker's corpus of nail reliefs range from symmetrically patterned pieces to the fluid, organic rhythms of works such as *Vast Ocean*. Here, simple, elemental materials—nails, wood, white paint—are precisely organized and meticulously handled to stunning effect. Although the hundreds of nails are of uniform height, their varied angles and densities create the impression of perpetual motion, as in the ebb and flow of a restless sea. Painted white to connote, in the artist's words, "purity, beauty, and silence," the nail heads form a light surface floating above an underlying wood support, an effect intensified by the absence of an enclosing frame. Immersed in the hypnotic movement suggested in *Vast Ocean,* the viewer may enter a state of heightened consciousness and reverie.

**Frank Stella**

*De la nada vida a la nada muerte,* 1965

Emulsion with metallic paint on canvas; 214.2 x 744 cm

Rife with incident and complexity, *De la nada vida a la nada muerte* seems to belie Frank Stella's oft-quoted assertion that, in his art, "What you see is what you see." Streaking almost aerodynamically across the canvas' extravagant length of nearly twenty-five feet are twenty parallel lines, whose movement is tarried by zigzags on either side. The corresponding shape of the canvas reinforces this abrupt, but rhythmic, rise and fall of repeating lines. Complicating the viewer's experience is the illusion that the surface, though two-dimensional, either projects from or recedes into the wall. Though highly animated, the painting nevertheless lacks a narrative and thus appears to affirm the artist's statement.

The prodigiously inventive Stella always works in series in order to probe fully the multiple possibilities of shape and color inherent in a given form. The artist's methodical approach, which evolved partly in reaction to the often seemingly formless compositions and heroic grandeur of the Abstract Expressionists, led to his pioneering experiments with nonrectilinear canvases, beginning in 1960. Shaped like circle fragments, hexagons, parallelograms, and rhomboids, these works have helped sire a new genre of painting as object, and, thus, have significantly enlarged the parameters for late-twentieth-century art.

*De la nada vida a la nada muerte* is the largest of a series known as the Running V paintings, whose titles derive from colloquial Spanish expressions. The length and mellifluous sound of the title seem almost to coincide with the rising and falling cadences of the painting. Indeed, *De la nada vida* appears as if it might continue into infinity. Though Stella's rigorously calibrated surface, immaculate execution, and use of a monochromatic sheen of gold-metallic pigment temper this painting, they hardly constrain its kinetic exuberance.

# Louise Nevelson

## America-Dawn, 1959–67

Polychromed wood; h. variable, base 426.7 x 304.8 cm

Louise Nevelson, who immigrated with her family to the small town of Rockland, Maine, from Russia in 1905, struggled for many years to achieve recognition in the New York art world. Her signature works of the mid-1950s—the uniformly black, environmentally scaled sculpture created for evocatively titled gallery installations—evolved from a wide range of associations and experiences, beginning with instruction at the Art Students League in the late 1920s and then with Hans Hofmann in Europe in the early 1930s. Afterward, Nevelson studied voice and dance, worked briefly with the Mexican muralist Diego Rivera, and befriended the innovative architect Frederick Kiesler.

While Nevelson created *America-Dawn* for a 1967 retrospective exhibition at the Whitney Museum of American Art in New York, its origins can be traced back to *Dawn's Wedding Feast,* the artist's first all-white installation and her contribution to a 1959 show at The Museum of Modern Art, New York, entitled "Sixteen Americans." Despite her desire to keep the various parts of *Dawn's Wedding Feast* together, several groupings and individual elements were sold or reused in succeeding pieces, including *America-Dawn,* which shares many qualities of the original. With their strong sense of structure and uniform, all-over coloration, both achieved a pure, almost iconic beauty.

Composed of salvaged fragments of wooden objects and artifacts (furniture, crates, architectural ornaments, and driftwood), Nevelson's work epitomizes "assemblage," a sculptural movement of the 1950s incorporating found materials and urban detritus. Her installations, which are part-sculpture, part-theater, and part-environment, have a commanding and mysterious presence. Surpassing the scale and grandeur of the early-1950s work of her contemporaries Barnett Newman, Jackson Pollock, and Clyfford Still, these sculptures heralded art projects of the 1960s, in which artists explored even a broader range of media and a larger scale.

Yarn, stuffed birds, glass, plastic, beads, tape measure, crystal, and metal ore; 33 x 38.1 x 35.6 cm (closed)

Over a period of approximately thirty-five years, Lucas Samaras has created a diverse array of two- and three-dimensional works of art, including acrylic paintings, books, boxes, chairs, pastel drawings, photographs, rooms, and wall hangings. In the 1960s, the artist also participated in a number of "happenings," with Allan Kaprow, the originator of these artistic performances, and with Pop artist Claes Oldenburg. Often linked with the junk or assemblage artists of the late 1950s and early 1960s, such as Lee Bontecou and Robert Rauschenberg, Samaras employs unorthodox, nonart materials in his works.

At the beginning of his career, Samaras transformed a large number of found or purchased boxes into glittering, fantastic, and, oftentimes, menacing objects. *Box* belongs to a group of about fifteen of these boxes, all made in 1966, which frequently incorporate stuffed birds. As early as 1962, Samaras imagined creating a box totally covered with stuffed birds, but could not locate enough of them to realize his idea until 1966, when he executed *Box*. In this work, a bevy of multicolored birds of various shapes and sizes all but hide the top of a box. Stuffed but lifelike, these clustered creatures would seem to preclude raising the lid, lest they fly away or slide off. Equally colorful is the brightly hued yarn that Samaras meticulously glued to the box to form a richly patterned design of red, green, yellow, and blue.

When the lid is lifted, a mechanical tape measure audibly unreels as it neatly measures the height of the opening. Inside are four compartments, one of which features a crystal-encrusted rock. *Box* embodies a number of antitheses: between nature's brilliantly hued birds and man-made, colored yarn, between the container's relatively modest interior and flamboyant exterior, and between the muted rock and the noisy measuring device.

Mannequin hands and polyester resin; h. 92.1 cm

Like the American Pop artists (see pp. 116–17), the French artist Armand Fernandez has devoted his energies to the subject and vocabulary of everyday life, focusing, since the late 1950s, on a long series of works called Accumulations. In these assemblages, Arman arranges identical items (such as new or used clocks, combs, faucets, paintbrushes, and telephones) in piles or stacks, or places them in wood, glass, or Plexiglas frames or boxes.

Arman was a member of the Nouveaux Réalistes, a group of Europeans who, in the early 1960s, began incorporating familiar, mundane objects in their art partly in reaction to the thickly painted, rarefied abstractions predominating during the 1950s. These artists drew their inspiration from Marcel Duchamp, who initiated the use of artifacts as or within works of art early in the century. They were also inspired by Surrealists working in the 1930s, who conceived a new species of sculpture predicated on the unexpected and startling juxtaposition of nonart objects drawn from a multiplicity of sources (see, for example, p. 72).

In *Don't Touch*, Arman packed a polyester-resin female torso with a few dozen hands from old mannequins and titled the work with a familiar and irritating injunction. "Don't touch" is a warning uttered both in museums, to forbid the handling of artworks, and in society at large, to prohibit contact with the human nude. Significantly, Arman chose to seal hands—the primary agent of touch—within the transparent torso. Their chipped and cracked surfaces; faded red-, yellow-, and orange-hued fingernails; and severed wrists with dangling connectors call attention to the short life span of modern artifacts, which paradoxically are encased within a timeless, classically derived torso.

**Robert Irwin**  *Untitled,* **1969**

Acrylic lacquer on formed acrylic plastic; d. 137.2 cm

Robert Irwin's radiant disk paintings create a mesmerizing ambience of light and shadow. Exemplary of this series, *Untitled* comprises a spray-painted, convex plastic disk, cantilevered twelve inches from the wall. Four lights, beamed onto the disk, create multiple, overlapping shadows, which, in merging with the luminous core, blur distinctions between the material and immaterial and the two- and three-dimensional. A silver, horizontal bar, whose edges appear to trail off, anchors the diaphanous circles that seem to hover and expand in space. In the presence of these elusive effects, patient viewers may find themselves experiencing a sense of lightness, of being transported into a mystical realm.

Born in California, where he has always lived, Irwin studied at the Otis and Chouinard Art Institutes in Los Angeles, becoming a painter, first of Abstract Expressionist and then of Minimalist canvases. His increasingly spare abstractions were superseded by the disk paintings of 1966–69, which liberated Irwin from traditional definitions of what a painting can be. While the initial works in the series are made of aluminum, his later disk paintings are composed of acrylic disks in diameters of 116.8, 121.9, and 137.2 centimeters (the latter being the size of the Art Institute's piece).

*Untitled* is among the last permanent objects Irwin created. Since 1970, in an even more radical shift, the artist has focused on temporary installations that take the investigations of perceptual phenomena that he began in the disk paintings to their logical conclusion. Developed for a particular location and then subsequently dismantled, these environments, composed of scrims of fabric, look like fields of glowing light when illuminated.

Acrylic on canvas; 213.4 x 304.8 cm

Perhaps because of his outsider status, the English painter David Hockney has been able to cast a cool, objective eye on the life and mores of Southern California. A 1964 graduate of the Royal College of Art in London and part of the Pop scene there, Hockney first visited Los Angeles in that year and settled there permanently in 1978. Since that first visit, the artist has leveled his penetrating gaze on the region's ubiquitous swimming pools, lawn sprinklers, and modern architecture, as well as on its art collectors and dealers, designers, and writers.

Of the numerous double portraits Hockney executed in the late 1960s, this portrayal of Fred and Marcia Weisman has come, in particular, to epitomize the prototypical American art collectors. The artist expressed his amazement at the lifestyle of such a couple in 1976:

*I went to visit some collectors. I'd never seen houses like that. And the way they liked to show them off! They would show you the pictures, the garden, the house.... All had large comfortable chairs, fluffy carpets, striped paintings and pre-Colombian or primitive sculptures and recent three-dimensional work.*

Here, the husband and wife pose on opposite sides of a terrazzo patio deck on which some of their holdings are displayed. With his buttoned-up business suit, solemn expression, rigid pose, and clenched fist, Fred Weisman seems as intense and stony as the William Turnbull sculpture before him. Marcia Weisman faces the viewer frontally like the Henry Moore sculpture behind and to her left, whose contours she appears to share. Her toothy smile seems to mirror the grinning visages of the totem pole at the far right. Tellingly, it is the sharp, brilliant light of Southern California that binds the composition's many elements together, rather than any affinity between the two collectors, who seem oblivious of both each other and the art they have chosen to possess.

# Eva Hesse

## *Hang Up,* 1966

Acrylic on cord and cloth, wood, and steel; 182.9 x 213.4 x 198.1 cm

Eva Hesse's family escaped Hitler's Germany in 1939, relocating to Washington Heights, New York. The events of the war still haunted them, however, culminating in her mother's suicide when Eva was ten. For many years, Hesse chronicled her emotional pain and her creative growth in diaries and notebooks, revealing her fears but also the enormous strength that fueled her artistic achievement.

Though trained as a painter at Yale University, Hesse discovered her true medium in sculpture, in 1965. Considered by the artist to be her first significant work, *Hang Up* was fabricated by her friend the sculptor Sol LeWitt and her then-husband, Tom Doyle. They wrapped the wooden stretcher with bed sheets and attached the steel tubing sheathed in cord. Sealed with acrylic, the object is subtly shaded from pale to dark ash gray. It is an ironic sculpture about painting, privileging the medium's usually marginal feature, the frame, and overcoming by means of the extruding cord its inherent limitation to two-dimensional space.

The humorous title of the piece can be understood as a set of instructions for its display. From her diaries, we know that Hesse used "hang up" in reference to her marriage, which was disintegrating in 1966, and the term may also allude to her own "hang ups" or worries about her artistic abilities. These concerns were unfounded: Hesse produced an extraordinarily original and influential body of work, pioneering the use of eccentric materials such as latex and expressive, idiosyncratic sculptural forms in the four years that remained of her career before her tragically premature death.

# Richard Serra

## Close Pin Prop, 1969

Lead; pole h. 250.8 cm, d. 9.5 cm; cylinder h. 9.1 cm, d. 24.8 cm

In nearly one hundred sculptures conceived between 1968 and 1969, Richard Serra placed, or propped, lead or steel plates and tubes in various breathtaking configurations. Here, an eight-foot-tall lead pole leans in to support a hollow cylinder jutting out from the wall, which, in turn, braces the heavier pole. No welds, joins, or adhesives hold the cylinder in place. The result is an assaultive sculptural experience, since we feel a potential for danger despite the artist's precise calculation of thrusts and counterthrusts.

The studied informality of *Close Pin Prop* is characteristic of "antiform," an international style that Serra, along with Eva Hesse and others, pioneered in the late 1960s. Though Serra, among other antiformalists, challenged the formal severity and impersonality of Minimalist sculpture (see, for example, pp. 132–33), he nevertheless created works that incorporated the elementary, geometric forms favored by his Minimalist predecessors. Utilizing standard materials, as well as such unorthodox ones as chicken wire, felt, Fiberglas, latex, lead, neon, and rubber, the antiformalists advanced the liberating idea that sculpture can be made by the act of propping. Serra elaborated upon this concept with a list of additional alternative processes, such as "to roll, to crease, to droop, to spread, to swirl, to heap, and to stretch."

The artist entitled his sculpture *Close Pin Prop* both to invoke its structure and to allude to the painter Chuck Close, who visited Serra's studio during the genesis of the work. Playing off of the word *clothespin,* the title underscores the inherent simplicity of the piece and its supportive nature. Indeed, *Close Pin Prop* can be understood as an argument for the interdependence—albeit precarious—of all things and for the principle that no one ultimately stands alone.

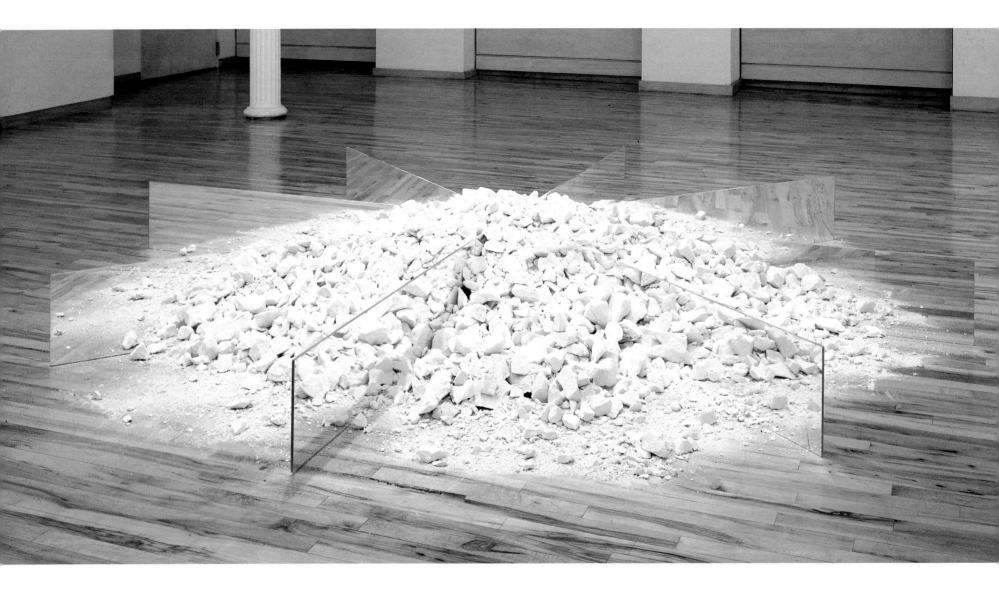

The painter, sculptor, theorist, filmmaker, and photographer Robert Smithson helped pioneer the Earthwork movement of the late 1960s and 1970s, which took as its subject the artistic reordering of the American landscape in its many varied forms, from the untouched to the industrially ravaged. During the 1960s, Smithson traveled throughout his native New Jersey, documenting the surroundings through maps, photographs, and samples of sediment, which he later installed in galleries. Out of this experience emerged his *Mirror Displacement* and *Site/Nonsite* pieces. Incorporating the earth itself into the gallery, these works extended the traditional confines of that space and created new parameters for contemporary sculpture.

*Chalk Mirror Displacement* belongs to a series of works, executed in 1968 and 1969, combining mirrors and organic materials. Eight double-sided mirrors radiate like spokes from the center of a chalk pile located on the gallery floor. As they slice through the pile, the mirrors separate the lumps of white chalk into almost identical wedge-shaped compartments. The double reflection in each compartment preserves the illusion of the whole pile, making the mirror dividers appear nearly invisible.

The Art Institute's piece was originally created for the seminal exhibition "When Attitudes Become Form," shown in 1969 at the Institute of Contemporary Art in London. Smithson and his wife, artist Nancy Holt, drove to a chalk quarry in Oxted, York, where they set up the *Site* piece, photo-graphed it, and then dismantled it. The materials were subsequently reinstalled in the gallery, or *Nonsite*. The *Site* piece, although destroyed, thus represented in its displaced and absolutely coequal reflection, the *Nonsite* piece. This process purposefully blurred the boundaries between art and its environment, within and without the gallery walls. After the London exhibition, the *Nonsite* piece was also destroyed. The work on view here is, therefore, not the original, but rather a posthumous re-creation of an ephemeral piece, constructed using the same materials and dimensions as the original, under the guidance of Holt, the executor of Smithson's estate, following his premature death, in 1973.

## Agnes Martin

## *Untitled #12,* 1977

Graphite and gesso on canvas; 182.9 x 182.9 cm

Early on in her career, Agnes Martin identified with the art of Abstract Expressionists such as Barnett Newman and Ad Reinhart, whose interest in monochromatic color schemes, geometric forms, all-over uniform composition, and expression of spiritual or emotional content she shared. Then, in the 1960s, her vocabulary of grids and graphs led critics to compare her work to that of a younger generation of Minimalists such as Carl Andre and Sol LeWitt.

In 1967, on the brink of critical success, Agnes Martin left New York and stopped making art. Retreating at first to her native Canada, she eventually settled in a remote area of New Mexico, where she built an adobe home and lived without electricity, telephone, and indoor plumbing. In this vast, sparsely populated place, she contemplated the nature of the universe and the place of humankind in it. Profoundly influenced by Daoism and Zen, she nurtured her spiritual growth and by 1974 felt able to again make art.

Beginning in 1975, Martin initiated each year a new series of works to explore the possibilities of a given color scheme and format. One of fifteen square canvases painted in 1977, *Untitled #12* reflects the subtle, yet distinct, changes that the artist made in her work after she ended her hiatus from art making. In the painting, the lines are more precise, texture more apparent (this due to the gessoing of the canvas), the colors more translucent, and the overall effect more austere than that of earlier work. *Untitled #12* quietly expresses the sense of absolute reality and suspended emotion the artist had sought to find in herself. Martin's unique ability to evoke transcendent realms led critic Hilton Kramer to remark that her art is "like a religious utterance, almost a form of prayer."

Steel and aluminum; 36 metal plates, each .95 x 30.5 x 30.5 cm, overall .95 x 182.9 x 182.9 cm

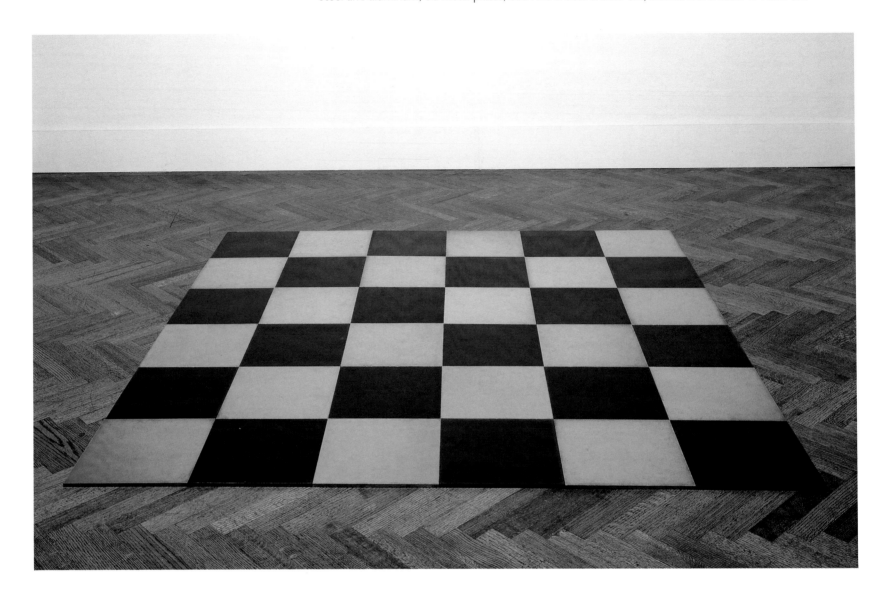

In 1966 Carl Andre revolutionized sculpture by creating works that hug the ground rather than rising up and occupying space. Clarifying his controversial innovation, the artist said, "All I'm doing is putting [Constantin] Brancusi's *Endless Column* on the ground instead of in the sky. In my work, Priapus is down on the floor. The engaged position is to run along the earth."

Prior to becoming an artist, Andre had a variety of jobs, ranging from publishing to factory and railroad work, which might have later informed his use of nontraditional materials. In 1957 the sculptor moved to New York, where he met

Frank Stella and other artists who, through experimenting with elementary, geometric forms, evolved a style that became known as Minimalism. Despite a lack of formal artistic training, Andre began, in the early 1960s, building stacked wood sculptures. Around 1965 he started to work with the products of anonymous laborers such as factory-made bricks and metal, as well as to create low-lying work that, like still water, would evoke a feeling of calm. In a further attempt to humanize his art, Andre invited viewers to walk upon his sculptures so that they could

experience the densities of different materials (such as steel versus aluminum) and the distinction between standing in the middle of a sculpture and remaining outside of its boundaries.

Characterized by simple patterns, the metal plates of Andre's flat "plains" are artlessly laid edge to edge on the floor/ground. In the Art Institute's *Steel-Aluminum Plain*, the alternating, identically sized steel and aluminum plates form a six-foot-square, checkerboard pattern of subdued visual restraint.

## *ABCD 5*, 1971–92

Baked enamel on steel; 21.9 x 80.6 x 273.1 cm

Often understood as a reaction to the emotive extravagance of Abstract Expressionism, the cool, cerebral products of Minimalism are simple, geometric forms composed of industrial materials. One of its chief practitioners, Sol LeWitt has explored, since the mid-1960s, the endless possibilities of the square, from which he derives grids, cubes, and rectangular prisms such as those comprising *ABCD 5*. A subset of one of his many serial projects to date, this elegant sculptural installation unfolds from a set of straightforward, logical propositions.

The variables in *ABCD 5* are two structures (a cube and the larger polyhedron containing it) and two conditions (open and closed). Four combinations of these variables are possible, all of which the artwork demonstrates: (1) closed cube/closed container, (2) open cube/closed container, (3) closed cube/open container, and (4) open cube/open container. Such uncompromising clarity is typical of Minimalism, as is the withdrawal of the artist's hand from the manufacture of the object. LeWitt eschews handicraft, along with personal taste, subjectivity, and expression as the bases for art.

LeWitt's famous aphorism, "the idea is the machine that makes the art," proclaims the primacy of the artist's intellect in the creative act. For him, the steel forms of *ABCD 5*, fabricated in 1992, are but the physical manifestation of the work of art. The real work is the idea itself, which dates to 1971. The Art Institute owns both the certificate for *ABCD 5*, signed by the artist and documenting its arrangement, and its sculptural manifestation. Sometimes, LeWitt provides no physical object at all, only a set of instructions to assemble the object, which may or may not be realized.

Ocean Park is the name of a section of Santa Monica, California, where, from 1967 to 1988, Richard Diebenkorn painted nearly four hundred canvases that celebrate the clear, even light and spatial configurations along the coast of Southern California. Determining at this time that he had "temperamentally always been a landscape painter," the artist chose to explore, in endless variations, a view over the streets and rooftops surrounding his studio that culminated in glimpses of the ocean. Diebenkorn's Ocean Park paintings can, however, also be read in terms of pure abstraction, since they only obliquely refer to an actual view.

In contrast to the horizontal orientation of traditional landscapes, Diebenkorn's Ocean Park compositions are generally vertical. Consisting of several wide and narrow vertical planes of color, with horizontal planes at the top, they subtly capture, as if seen aerially, the geometry of an urban landscape. A comparatively early example of his Ocean Park series, *No. 45* plays upon a basic opposition between the vertical bands of luminous blue and green dominating the canvas and the horizontal bar of golden yellow in the upper section. Together, these color fields may represent stretches of ocean and beach bathed in a radiant, glowing light, or a meditation on color and geometric forms.

Examination of the composition's linear armature and deployment of color reveals numerous corrections made by the artist. Like a writer who revises a manuscript by deleting and inserting new material, Diebenkorn similarly refined his compositions until he achieved a satisfactory arrangement of color zones. The traces we witness here of the artist's struggle to achieve his vision, reinforced by the sense of human touch in the brushwork and wavering, imperfectly drawn lines, humanize this stately, monumental painting.

# Helen Frankenthaler

## *Hommage à H. M.,* 1971

Acrylic on canvas; 203.2 x 160 cm

Helen Frankenthaler completed *Hommage à H. M.* after traveling to Morocco, where she was reminded of the impact this visually sumptuous locale had on Henri Matisse after his visit there in 1913. The bright, clear colors and simple, irregular shapes of Frankenthaler's tribute indeed evoke the French artist's color-saturated art, particularly his late paper cutouts. The expanses of color also reflect Frankenthaler's involvement with color-field painting (see pp. 97, 100–101), which for her involved pouring paint onto unprimed canvas. She and such artists as Morris Louis, Kenneth Noland, and Jules Olitski, who followed her lead, relied on the resultant broad areas (or "fields") of color to convey a sense of subject and mood.

Specific to Frankenthaler's paintings of 1971–73 is the use of thin, black lines to link and counterbalance zones of color. In *Hommage à H. M.,* a graceful network of wiry lines connect color areas that have been daringly pushed to the farthest reaches of the canvas. Adding to the work's acute sense of balance is the juxtaposition of green shapes on the left side of the composition with yellow, orange, and red shapes on its right. An assertive blue line at the top, however, provides a tantalizing alternative to the familial cords binding all the other elements in the painting. Swooping across and out of the picture, the line seems tethered to something beyond the spectator's view.

To achieve her lyrical union of color and line, Frankenthaler usually placed her canvas on the floor when pouring paint and on a wall when incorporating lines. This procedure, according to the artist, resulted in a "bird's eye, flying-carpet view [of the world]—as if [the viewer] were looking downward."

## Georg Baselitz

## *Woodman*, 1969

Oil on canvas; 250.2 x 200 cm

In the early 1960s, at a time when the art world was still propounding the virtues of abstraction and New York was its capital, a group of German artists turned their attention to the figure. Along with such artists as Anselm Kiefer and A. R. Penck, Georg Baselitz began producing representational works that drew inspiration not from New York, but from Germany's artistic and cultural heritage. These so-called Neo-Expressionist works are characterized by a return to figural representation, thickly painted surfaces, and oftentimes emotional and/or tragic themes.

After executing a series on mythic figures in the mid-1960s, Baselitz began in 1967 to paint severed animals, birds, and people. While belonging to this group, *Woodman* also clearly heralds Baselitz's work of the 1970s and 1980s, featuring figures turned upside down. Here, images of dismemberment abound: In front of a tree that is cut off by the picture frame float the severed halves of a woodman. Below him is a similarly violated tree trunk and two shoe prints that call attention to the absence of the figure's feet. With his furrowed brow, the woodman looks as if he is trying to fathom how he ended up in such dire circumstances. He tugs at an enormous ear, the size of which could signify a sensitivity to his surroundings.

Conjuring up a world gone mad, *Woodman* evokes the psychic and physical disorientation Germans experienced after their nation was partitioned in 1946. That a united Germany was important to Baselitz is evident in his decision to change his surname from Kern to Baselitz upon moving to West Berlin in 1956. In taking the name of his East German birthplace—Deutschbaselitz—the artist hoped to emphasize his connectedness to all of Germany.

**Gerhard Richter**                    *Two Candles,* 1982

Oil on canvas; 120 x 100 cm

Gerhard Richter has painted in several, often-times radically different modes, ranging from a blurry, photographic realism to complete abstraction, in order to question expectations of stylistic consistency. The use of various approaches enables Richter both to continually revitalize his art and to effectively embody different aspects of a reality that he feels cannot be fully expressed through any single manner of representation. These approaches include works based on preexisting color charts, colorful and gestural abstractions overflowing with paint applied with a spatulalike device, and the artist's photo paintings.

Based on media images and personal snapshots, Richter's photo paintings encompass cityscapes, portraits, seascapes, and, as in the case here, still lifes. While exhibiting the influence of Richter's training in trompe-l'oeil painting, the fluidly brushed surfaces of these works and their out-of-focus appearance recall the photographic medium. *Two Candles* belongs to a series of thirty-two works, executed between 1982 and 1983, featuring candles and skulls. Traditional still-life motifs, these objects have long symbolized the brevity of human life and, by implication, the folly of human vanity.

Departing from traditional *Vanitas* models, the lit candles—appearing singly or in groups of two or three—in this series have been pushed to the front of the picture plane. Here, two candles, one positioned slightly behind the other, irradiate the corner of a gray-green interior. The flame of the left-hand candle flickers as if blown by air, creating the illusion that time has momentarily been arrested. Analogous to the human condition, the two candles, while bravely dispelling the darkness that lurks in an empty corner, simultaneously consume their own substance.

**Joseph Beuys**

*Felt Suit*, 1970

Felt, wood, and wire; 170.2 x 99.1 cm

Acquired the year this famous German artist visited Chicago, *Felt Suit* embodies many of Joseph Beuys's central concerns about sculpture. Composed of a buttonless jacket and pants, the suit functions as a surrogate for the human figure, a typical sculptural subject. Unlike most traditional sculptors, Beuys insisted that his work involve the transformation of substances rather than the creation of beautiful appearances. Here, he converted humble gray material into a homely garment guaranteed to keep its wearer warm. Because felt is not woven but consists of compressed hair or fiber, the suit nicely illustrates the artist's belief that sculpture should entail a transmutation of chaotic movement (random strands) into ordered form (cut raiment).

Felt also had autobiographical significance for Beuys, whose personal mythology included a near-death experience during World War II: Flying for the German Luftwaffe over the Crimea in 1943, he was reportedly rescued by Tartars when his plane crashed in a snowstorm. They rubbed the young pilot with fat and wrapped him in felt blankets, nursing him back to consciousness. After the war, when Beuys found his métier as an artist, he employed these two life-saving substances as materials and symbols in his art. Noting the ability of fat to melt and permeate everything, and of felt to attract and absorb other substances, Beuys believed that *Felt Suit* could both insulate its wearer and make that person, in a sense, magnetic. Indeed, the charismatic artist-activist wore a felt suit during a Vietnam War protest in Düsseldorf in 1971. Beuys, moreover, thought it important to produce *Felt Suit* in an edition of one hundred, since he was committed to the idea of democracy in art as well as in political life.

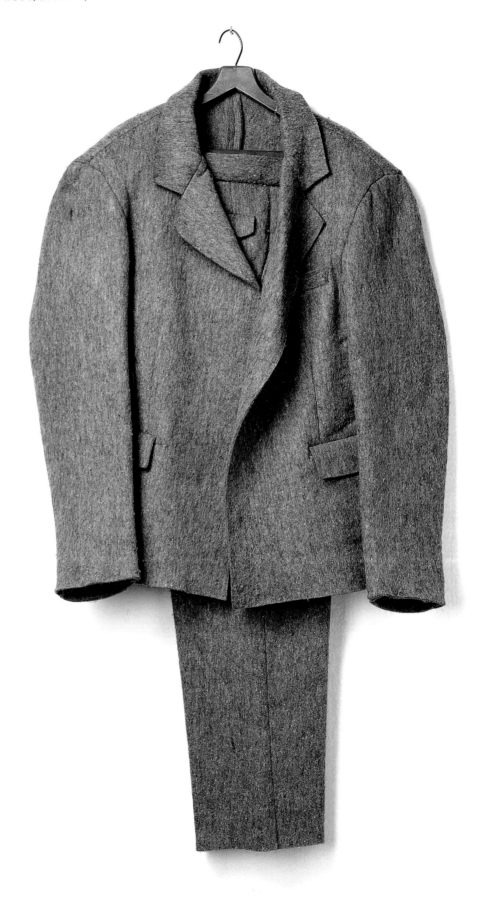

**Andy Warhol**

*Diamond Dust Joseph Beuys, 1980*

Silkscreen ink and diamond dust on synthetic polymer paint on canvas; 101.6 x 101.6 cm

Portraiture was extremely important to Andy Warhol, but not in a traditional sense. The customary aims of the genre—commemorating a person's achievements, honoring a noble character, penetrating an individual psychology—did not interest him, nor did he ever paint from life. Instead, Warhol chose fame itself as his theme and the photographic image (the means by which fame operates in this century) as the basis for all his portraits, whether of movie stars or political leaders, living or dead.

Warhol met the subject of this portrait in Düsseldorf in 1980 and snapped a Polaroid of him wearing his signature gray fedora. Through his political activism and public performances, Joseph Beuys had become the most notorious artist in Germany, his renown equivalent to Warhol's in the United States. From his snapshot, Warhol created several portraits, including *Diamond Dust Joseph Beuys,* using commercially produced photosilkscreens and printing inks to transfer the enlarged image onto canvas.

The sparkling surface of this picture has significance beyond its decorative allure. Warhol did not rue the commodity status of art. On the contrary, he celebrated it with his many paintings of dollar bills and, as shown here, by adding diamond dust to the surface of the work. In this way, he enhanced and emphasized the monetary value of the portrait. While Beuys coined the slogan "Kunst = Kapital" (art = capital), he did not interpret it literally, but rather meant that, through making art, the artist invests in creating a better society. Warhol, on the other hand, took the equation at face value, since he was convinced of the congruence of art, fame, and fortune in our contemporary world.

Acrylic on canvas; 155 x 226 cm

This large, austere painting is one of approximately two thousand "date paintings" that On Kawara has produced since 1966, each of which has a specific month, day, and year as its sole image. Though they vary in size from 20.3 x 25.4 to 155 x 226 centimeters (of which *Oct. 31, 1978* is an example), they share a similar format. The date, which is painted in white, occupies a central location on the canvas, and the monochromatic background is either black, red, or blue. Each canvas is completed on the day emblazoned on its surface or it is destroyed, and each utilizes the language of its country of origin. While usually not exhibited, a newspaper accompanies every work to document the date and location of its execution; the Art Institute painting came with two New York newspapers dated October 31, 1978.

Born in Japan, Kawara has lived primarily in the United States since 1965. His work is associated with Conceptual Art, a movement dating to the 1960s in which artists emphasized the expression of ideas over the creation of permanent physical objects or representational images, and used as their vehicle diagrams, language, photographs, and maps.

Deceptively simple, Kawara's date paintings, both singly and as a total oeuvre, represent an ambitious and complex undertaking. *Oct. 31, 1978* calls attention to the meaning of time: it reminds the viewer that, although October 31, 1978, refers to a specific day, it belongs, however infinitesimally, to the continuum of life; that each day, though seemingly insignificant, is precious; and that a particular day, which may or may not be meaningful to a viewer, has slipped away. Indeed, *Oct. 31, 1978* is an arresting and sobering reminder of the temporal nature of existence.

Steel and cast iron; 152.4 x 723.9 x 351.2 cm

Bruce Nauman has worked with such diverse materials as bronze, neon, plaster, steel, and wood; and such wide-ranging formats as dance, film, installation, performance, sculpture, and video. Initially a painter, he abandoned the medium in 1966, believing that it offered only "lush solutions" and that other media, rather than encouraging passive viewing, would invite physical interaction. In the 1980s, Nauman's art took an overtly political turn, embodied in *Diamond Africa with Chair Tuned, D. E. A. D.* and the several related versions that the artist fabricated in 1981.

Consisting of industrial steel beams, cable, and a cast-iron chair, the work's heavy components, may, despite Nauman's wishes, frighten an observer from walking under them. Suspended at the artist's specified height of sixty inches from the floor, the beams confront us at eye level, increasing our anxiety. Dangling in their middle, the overturned chair, like a hanging carcass, could be a surrogate for the human figure.

The work's title, and the beam's diamond-shaped configuration, evokes not just the form of the African continent but also one of its most coveted exports, which, centered in South Africa, has depended on black labor. Thus, by implication, this work addresses the economic oppression of racism and the brutal repression of opposition to apartheid. Indeed, the chair could represent those used to interrogate and torture political dissidents, by, among other practices, applying electrical shocks to their bodies. Significantly, the chair's metal legs have been tuned to the notes D, E, A, and D, transforming it into a musical chair. Suggesting a deadly version of the game "musical chairs," wherein the chair when struck would sound a death knell for its occupant, this work forces us to confront the inhumanity of South Africa's former political system and, perhaps, our own collusion with it.

**Philip Guston**                    *Couple in Bed,* 1977

Oil on canvas; 205.7 x 240 cm

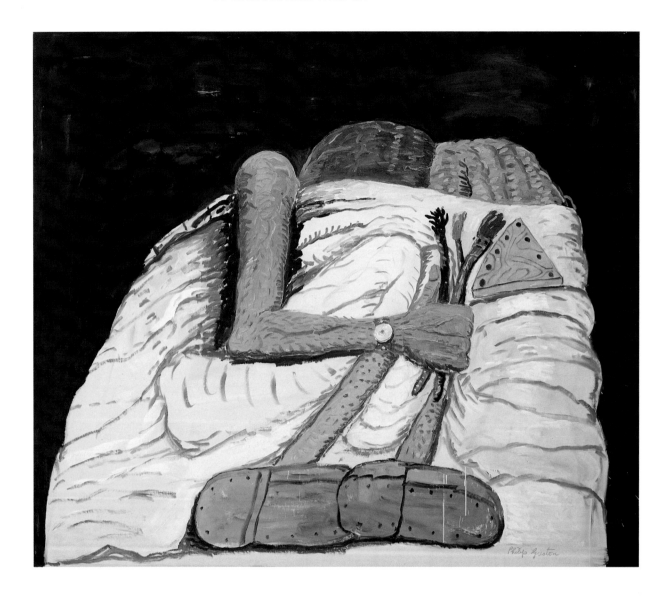

When Philip Guston exhibited paintings of Ku Klux Klansmen, cars, and cigars in 1970, they were greeted with bafflement and hostility. They seemed crude and awkward, in contrast to his lushly hued, sensuously painted abstractions from the 1950s and 1960s. Explaining his interest in figuration, Guston declared, "I got sick and tired of that purity! [I] wanted to tell stories." In an outpouring of drawings and paintings, he addressed critical sociopolitical issues such as American involvement in Vietnam, and his own artistic and personal conflicts.

For the artist, these new paintings represented a return to his creative beginnings. From 1934 to 1940, Guston worked on Works Progress Administration murals in Los Angeles and New York, bringing to bear upon these projects such wide-ranging interests as cartoons, Cubist innovations, Italian Renaissance painting, and leftist politics. By 1951 Guston, under the influence of the Abstract Expressionist painter Robert Motherwell, had abandoned figurative painting for pure abstraction.

The radical stylistic shift Guston made in the final decade of his life is fully evident in *Couple in Bed.* Here, the artist employed a gritty, cartoonlike imagery to explore the ongoing conflicts between his marriage and his all-consuming preoccupation with painting. In bed with his wife, he wears work shoes and grasps three paintbrushes that point to her tawny halo of hair. Missing its hands, and thus unable to track time, the artist's wristwatch symbolizes the enduring nature of his and his wife's love for one another, as well as their ongoing conflict over his priorities. Head to head, they huddle under a pale-gray blanket in an inky-black cosmos that surrounds but does not envelop them.

**Lucian Freud**                    *Two Japanese Wrestlers by a Sink,* 1983–87

Oil on canvas; 50.8 x 78.7 cm

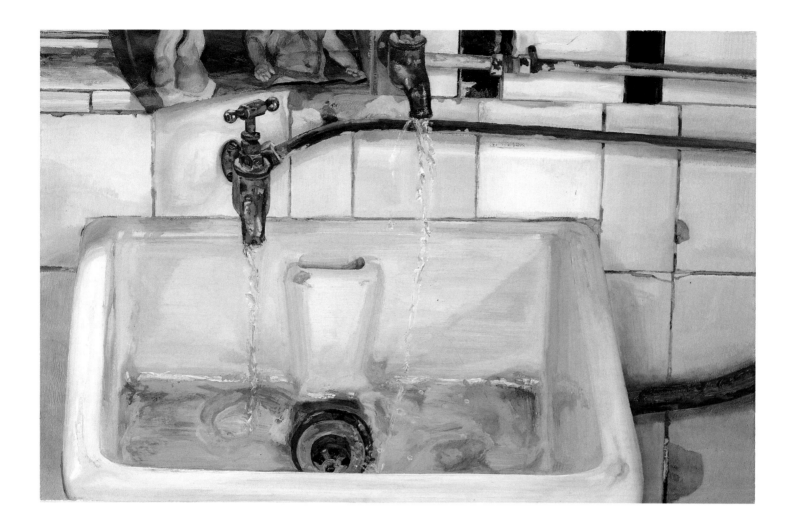

The grandson of Sigmund Freud, Lucian Freud has concentrated throughout his career on the human face and figure, producing paintings and graphic works that are intensely realized, penetrating studies of the human psyche. Because of his interest in the figure and in the alienating nature of modern-day society, Freud is often linked with such post-World War II artists as Francis Bacon, Jean Dubuffet, and Alberto Giacometti.

In the 1940s and 1950s, influenced by the nineteenth-century draftsman and painter Jean Auguste Dominique Ingres, Freud worked in a style based on meticulous drawing. Over the past three decades, he has replaced his earlier, smoothly rendered canvases with thick, sensuously painted surfaces that continue to be informed by superb craftsmanship. *Two Japanese Wrestlers by a Sink* displays richly textured pigment, whose density varies with particular objects and surface areas. Parallel vertical strokes are used for the aged, chipped tiles; long, horizontal sweeps for the sink; tight, circular movements for its stained bottom; and brisk, impastoed daubs for the sputtering water.

As shown in this composition, Freud's intense feeling for humankind infuses even the most mundane, inanimate objects. Painted with the same sensuous brush strokes and palette the artist lavishes on human figures, the sink conveys a long history of use and neglect. Its running spigot, deep bottom, and large drain hole; its rusted metal parts; and the chipped tiles that surround it express a sense of waste and loss. Propped on a ledge above the sink is a photograph of two wrestlers, who figure larger in the title of the painting than in the work itself. One appears in an upright position while the other is upside down. The close conjunction of the wrestlers and continuously running spigots could represent a rumination on the pointless squandering of human energy and resources.

**Elizabeth Murray**

*Back to Earth,* 1981

Oil on canvas; 306.1 x 342.9 cm

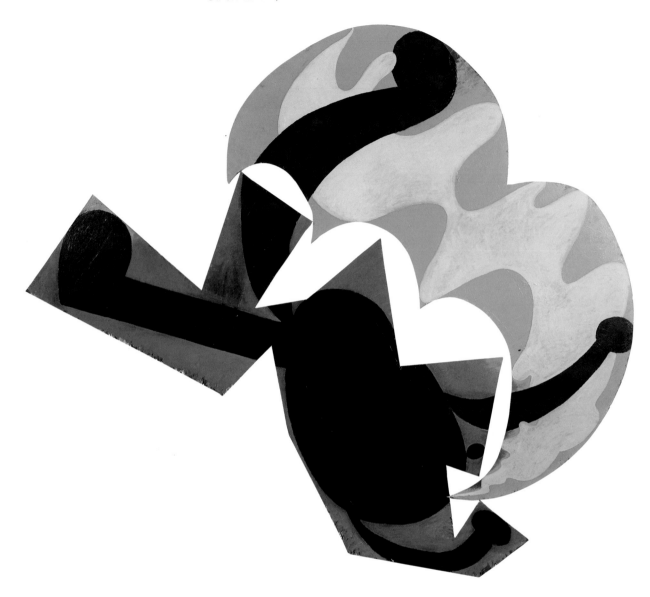

Elizabeth Murray's grandly scaled and eccentrically shaped double-canvas construction *Back to Earth* sprawls exuberantly across the wall. Here, the artist opposed the order and stability associated with earth to experiences of openness and liberation suggested by the sky. In the bottom canvas, a dark, ovoid shape, its appendages extended, returns, as the title implies, to earth. As this biomorph attempts to embrace a piece of turf, one of its arms/legs seems to rebelliously kick out at left, indicating a reluctance to leave the sky.

As the two realms collide, rifts emerge; the clasp of the biomorph's two uppermost appendages, for instance, is interrupted by seemingly unspannable gaps between the canvases; and their angular and curvaceous edges, meeting in the middle, create a pronounced opposition, as if to indicate that earth and sky are simultaneously embracing and rejecting each other. Although separate, the two canvases are linked by the artist's use of emphatic colors—black, blue, green—and of bold, simplified imagery. Illustrating her conviction that "all [her] work is involved with conflict—[with] trying to make something disparate whole," *Back to Earth* is at once unified and separate, continuous and discontinuous.

Following a period, in the 1970s, of painting abstract compositions with rectangular formats, Murray, in the late 1970s, began placing quasi-figurative images on idiosyncratically shaped canvases. Around 1980 she initiated a body of works composed of two or more individually shaped parts, which *Back to Earth* exemplifies. Poised between figuration and abstraction, Murray's distinctive and, at times, humorous imagery, with its dreamlike sensibility and appearance of constant motion, elicits multiple interpretations.

# Martin Puryear

## *Sanctuary, 1982*

Pine, maple, and cherry wood; 320 x 61 x 45.7 cm

In 1977 a fire ravaged Martin Puryear's Brooklyn studio and adjoining apartment, destroying a vast body of sculpture, as well as many of the artist's worldly possessions. Resulting in what he called "a period of grieving followed by an incredible lightness, freedom and mobility," the event proved pivotal in the direction of the artist's subsequent work. One year later, Puryear relocated to Chicago, where he began a series of works around the themes of movement and shelter.

First exhibited in the Art Institute's Seventy-fourth American Exhibition, *Sanctuary* embodies what Puryear described as "mobility with a kind of escapism, of survival through flight." Here, a finely crafted, cube-shaped enclosure perches upon a pair of craggy bark appendages, whose clawlike ends engage the axle of a wheel. Although the sculpture appears to be in a state of arrested motion, its "head" is secured to the wall, allowing the wheel to rest, however tenuously, on the floor, and thwarting any real possibility of movement. Both building and animal, refuge and escape vehicle, this whimsical and sophisticated work reconciles a longing for stability with a need for change.

Typical of Puryear's work, the thematic contradictions are echoed by a series of formal oppositions—architectural versus organic, geometric versus asymmetric, man-made versus natural. In pairing the wild tree saplings with a carefully fashioned shelter, Puryear celebrated the beauty of wood in both its natural and refined state. The artist's lifelong respect for natural materials, eloquent craftsmanship, and sensitivity to process derive from his immersion in various craft traditions, particularly native African carving and traditional Scandinavian carpentry. In its simplicity and directness, Puryear's work is also clearly informed by the Minimalist tradition. But, whereas Minimalist sculptors maintain an impersonal distance from their work, employing industrial materials and techniques, Puryear invests his sculpture with personal referents and metaphor.

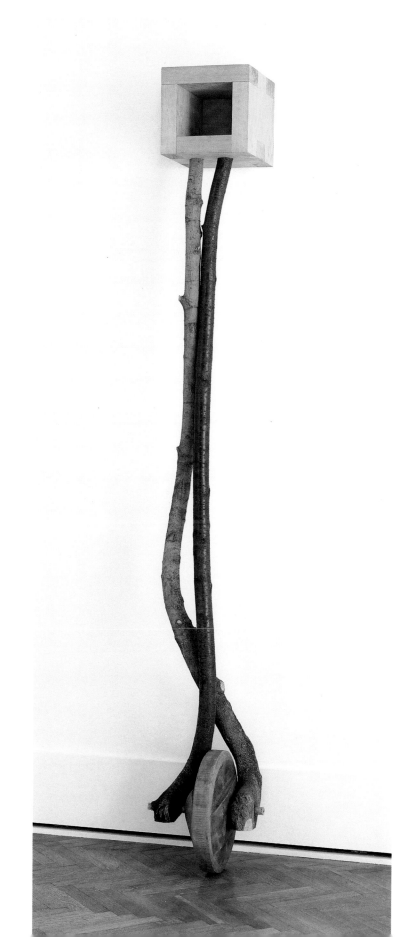

## *Ginny with the Yellow Hat,* 1971

Oil on canvas; 101.6 x 76.6 cm

Known for her unsparing, psychologically revealing portraits, Alice Neel succeeded, over and over again, in her goal of capturing essential aspects of the character of her sitters. In the 1940s and 1950s, working in relative obscurity, the artist discovered her subjects in the New York neighborhood where she lived and worked—Spanish Harlem. In the 1960s, she turned increasingly to her enlarging circle of art world acquaintances. "Discovered" in the late 1960s and early 1970s, during the rise of feminism, she was particularly praised for her sensitivity to her female subjects. While she painted accomplished still lifes and cityscapes, the artist's probing sensibility is most visible in her portraits of associates, friends, and family members.

Enveloped in heavy winter clothing, Neel's daughter-in-law Virginia ("Ginny") perches anxiously on the edge of a burgundy daybed in this striking portrait. Clearly influenced by the strong brushwork and emotive color palette of German Expressionism (see pp. 28–29), Neel used green, pink, purple, and red tones in modeling those features that she thought to be most expressive of the human psyche—the face and hands. Here, they emphasize the sitter's nervousness: the young woman's awkwardly dangling hands are spread uncomfortably apart, her eyes seem pinned open, and her lips are tightly pursed.

Ginny's helmetlike winter hat and fur coat protect her not just from the cold but from exposing too much of herself before Neel's searching gaze. She leans stiffly forward, as if to remain composed, or to stare her formidable portraitist—and mother-in-law—down. Twenty-five-years old at the time, Ginny Neel had recently married Neel's younger son, Hartley, and was just getting to know his family. Completed in three sittings, *Ginny with the Yellow Hat* is one of several portraits in which Neel emphasized—usually through a frontal pose—her daughter-in-law's unflinching directness.

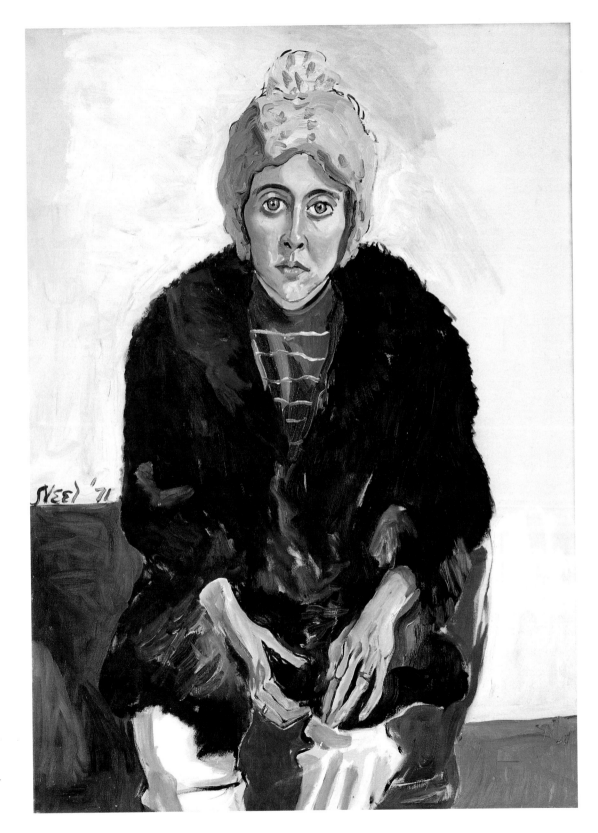

Along with her contemporaries Barbara Kruger and Richard Prince, Cindy Sherman is known for photographic investigations of the manipulative effect of mass-media imagery upon individual identity. Since 1977/78, Sherman has served as both photographer and model for a large cast of fictional personalities that she creates by wearing the appropriate clothing, hair (usually a wig), and makeup. The stereotypical looks and attitudes of her mostly female characters come from a number of sources, including such powerful purveyors of contemporary appearance, behavior, and values as film, television, and advertisements.

Sherman's first series of images, small black-and-white photographs called Untitled Film Stills, drew upon typical film-noir plots and characters. In 1981, when the magazine *Artforum* asked her to design a portfolio, Sherman began a series of large color photographs that includes *Untitled #88*. These works, which mimic the horizontal format of the centerfold, feature nearly life-sized figures primarily viewed from above, who often completely fill the picture frame and who are accompanied only by those props/costumes necessary for establishing the setting.

Unlike the exhibitionist female figures typical of magazine centerfolds, the awkward adolescents seen in this series convey anxiety, vulnerability,

and longing. In *Untitled #88*, a young woman with blonde, disheveled hair, and wearing a large, frayed sweater and knee socks, curls up before what, judging from the warm, flickering light, might be a fire. Darkness surrounds her, thereby accentuating her fragility and isolation. In addition to exposing the artificiality and debasement of females in "girlie" magazines, Sherman's work illuminates the widespread stereotyping of women as the weaker sex, which so many young girls, such as the one portrayed here, internalize and accept.

Video and sound installation with wooden chair, headphones, pedestal, and monitor; variable dimensions

Bill Viola is internationally recognized as a leading practitioner of video-installation art. In *Reasons for Knocking at an Empty House*, Viola's first major film and sound installation, the viewer enters a dimly lit, long, narrow room furnished with a monitor and a crudely built chair—resembling an electric chair or device of torture—to which earphones are attached. On the screen, a man (in fact the artist himself), looking tired and haggard, sits in a similar chair. The viewer, settling into the actual chair and putting on the headphones, hears both bodily sounds—breathing, gulping, swallowing, sniffling—and the sound of the mind at work—a steady, barely audible buzz of stream-of-consciousness whispers.

Periodically, another figure emerges from the darkness behind the artist, strikes him on the head with a rolled magazine, and walks away. Each blow is amplified to a deafening burst of sound that reverberates through the room. At the entrance to the installation, the artist provided a label (not pictured) discussing the astonishing medical history of a nineteenth-century laborer, Phineas Gage. His head severely wounded in a freak accident at work, Gage survived, but inalterably changed, his former amiability replaced by strident and uncontrolled behavior.

Above the label are photographs of Gage's skull, which are preserved at Harvard University. *Reasons for Knocking* seems to indicate that Gage's terrible fate could be shared not only by the on-screen persona but also by the viewer, who, over the video's forty-five-minute time span, conjoins with the artist's body and the inner recesses of his mind. Yet, while such a shock may produce a terrifying paralysis, it can also catapult the recipient out of unawareness and complacency. *Reasons for Knocking* encapsulates a terrible human predicament through a deceptively spare, elemental convergence of sound, setting, and film.

Oil on canvas; 203.2 x 254 cm

While based on a photograph of the English actor Sir Laurence Olivier (1907–1990), this colossal face hardly seems a portrait of a specific individual. Indeed, the title of the work refers not to Olivier but to the painting's color scheme—*caliente* means "hot" in Spanish—and the graffiti-like surname appearing under the eye to the right is Riviero. The arbitrary patterns of neonlike colors that play over the face and beyond; the bright yellow that shines from within, illuminating teeth and lips and eradicating the eyes' irises and pupils; and what looks like static electricity bouncing off of the nose and ears, make the subject not only virtually impossible to identify but also transform him into something no longer human. By simulating the appearance of a big-screen, television image, Paschke seems to have been suggesting that technology and the mass media have the power to dehumanize and to eradicate individuality.

A graduate of the School of the Art Institute, Paschke worked as a commerical artist in the 1960s. In the late 1960s and early 1970s, he participated in a number of group exhibitions with other Chicago-based artists who evolved a style that became known as "Imagism." Influenced in part by Pop Art (see pp. 116–17), Imagists such as Paschke, Roger Brown, Jim Nutt, and Christine Ramberg produced compositions characterized by meticulously worked surfaces, lurid colors, and imagery inspired by nontraditional sources, such as advertisements, carnival posters, cartoons, comic books, sport and entertainment magazines, tattoos, and toys.

In realizing his monumental portraits, Paschke projected an enlarged photograph onto a canvas and then applied several thin layers of paint to create glowing, lustrous color effects. While continuing to be informed by Imagism, *Caliente* and other of Paschke's subjects from the 1980s, such as his images of Elvis Presley, Mona Lisa, and Abraham Lincoln convey a more reflective, introspective mood than his earlier, more raucous compositions of circus freaks, hustlers, showgirls, and transvestites.

Oil, acrylic, emulsion, shellac, and straw on canvas with cardboard and lead; 330 x 555 cm

One of a generation of postwar German artists attempting to understand the horrors of its nation's recent past, Anselm Kiefer has chosen painting and sculpture as vehicles for expressing grief and achieving redemption. His thematic sources, which are often esoteric, include Teutonic mythology, German history, and Wagnerian operas. In representing the scorched landscapes of his childhood, Kiefer has developed a set of symbolic motifs to explore the implications of good and evil, and the power of art. A winged palette, for instance, sometimes soars over his images of the earth to suggest the angelic, liberating role the artist hopes art can play in what Germans call *Trauerarbeit,* the work of mourning.

In *The Order of the Angels,* the devastated land, made to seem vast by a high horizon, is visited by a miracle. A celestial hierarchy appears, based on the writings of Dionysius the Areopagite, a first-century, Athenian convert to the teachings of Saint Paul. Kiefer inscribed Dionysius's name at the upper left of the painting and, at the upper right, affixed labels to the canvas listing the nine heavenly ranks of angels: angels, archangels, principalities; virtues, dominations, powers; seraphim, cherubim, and thrones. A metal strip connects each label to a numbered rock below, thereby suggesting that the landscape itself is imbued with spirit. Lurking in the foreground is a giant snake, which may evoke the evil that continues to haunt German memory. Kiefer's use of this symbol, however, is ambiguous, for the serpent, which periodically sheds its skin, also stands for rebirth. In this way, the artist expressed hope here for a nation conscious of its past, but purged of its guilt and renewed through art.

## *Raised Chair with Geese, 1987–88*

Artificial resin and acrylic on various fabrics; 290 x 290 cm

The haunting central image of Sigmar Polke's *Raised Chair with Geese* is a menacing watchtower, an image rife with allusions to guards, guns, inmates, prisons, and concentration camps. Yet, Polke's choice of title refers to an elevated chair for hunting fowl (*Hochsitz mit Ganse*); and a gaggle of geese inhabit the right-hand corner of the composition. The parallel between slaying fowl and incarcerating and murdering prisoners suggests that the difference between a widely accepted sport and the slaughter of human beings may not be great.

The watchtower appears to float in space without anchor, like a ghostly apparition that reappears in our memories, perhaps triggered by a seemingly unrelated event or recollection. Polke's technique of superimposing disparate images similarly recalls the layering of events/images in memory. To signify its omnipresence in our late-twentieth-century psyches, the artist emblazoned the watchtower effigy on several contemporary fabrics, ranging from an awning stripe and pink, quilted material to a print spattered with sunglasses, folding chairs, and umbrellas. In including a fabric evocative of the beach and, hence, raised lifeguard chairs, Polke may have been implying that the watchtower image provokes associations both horrific and pleasurable.

*Raised Chair with Geese* is the last of five works commonly known as the Watchtower paintings that Polke completed between 1984 and 1988, at a time when a number of German artists, including Georg Baselitz and Anselm Kiefer, were exploring their generation's relationship to the horror and guilt emanating from past German atrocities.

# Leon Golub

## Interrogation II, 1981

Acrylic on canvas; 304.8 x 426.7 cm

The second of a series of three politically charged canvases, *Interrogation II* is based on reports of abuse, torture, and murder perpetrated by members of Central America's regimes. These paintings participate in a tradition of protest art that has attracted such artists as Francisco Goya and Honoré Daumier, and, in the twentieth century, Max Beckmann and José Clemente Orozco. Perhaps the most famous protest painting of our time is Picasso's *Guernica* (1937; Museo Nacional Centro de Arte Reina Sofia, Madrid), a powerful indictment of the Spanish Civil War that the young Leon Golub

saw exhibited in his native Chicago in 1939 and that proved pivotal to his subsequent artistic development.

In his early work, Golub depicted athletes, mythological figures, and philosophers, influenced by the Greek and Roman sculptures that he encountered while living in Paris and Rome (1959–64). His paintings from the 1960s feature mythic figures embroiled in struggle. By the early 1970s, Golub began to make his work more specific and contemporary, inspired by such calamitous events as the Vietnam War.

Golub works in series to explore subjects from multiple perspectives. In the series to which *Interrogation II* belongs, nude female or male

prisoners are shown at the mercy of uniformed officers or casually attired thugs. At left, an officer seems to bark out orders to three persecutors about to beat a stripped, hooded captive lashed to a wooden chair. The prisoner's nudity and the presence of a torture rack force viewers to contemplate the violent scenario about to unfold; indeed, the outward gaze of the two men on the right implicates us as participants in or voyeurs of the episode. Alternatively, the torturers may be gesturing to their next victim or to other torturers who look on. Painted in red-oxide, the "bloody" backdrop evokes the rust color of Roman wall paintings, thereby suggesting humankind's long history of inhumanity.

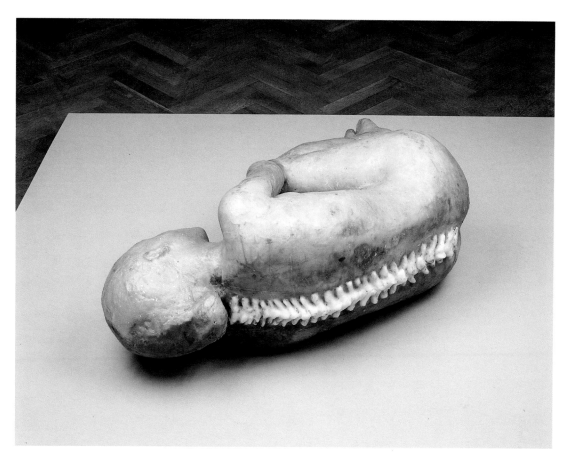

At once traditional and timely, the art of Kiki Smith is firmly rooted in humanist concerns and in recent artistic and sociopolitical currents. The daughter of sculptor Tony Smith, Kiki Smith seems to have drawn less on the work of her father than on some of his female contemporaries, such as Lee Bontecou, Louise Bourgeois, and Eva Hesse. Following a stint as her father's assistant, Smith moved in the late 1970s to New York, where she eventually joined Collaborative Projects (Colab), an artists' organization committed to political involvement and social change.

Initially, Smith's work explored the body's internal architecture. More recently, in sculptures such as *Blood Pool,* she has created discomfiting, life-sized figures that challenge and extend the tradition of human representation by treating the body as the site of biological, genetic, social, and political battles. Smith's passionate interest in the human form prompted her, in 1985, to train as an emergency medical technician, which deepened her knowledge of her subject.

Composed of wax, which Smith favors for its malleability and, thus, capacity to simulate human forms and textures, the figure exhibits a range of pink and buff tones evocative of real flesh. Also visible is the intimate imprint of Smith's touch, which the artist prefers to more realistic modeling. The poignancy of the work is further enhanced by its reference to such religiously inspired images as entombment scenes, *Vanitas* sculptures in which the brevity of life is symbolized by depictions of decay, or the arresting representations by Spanish Baroque artists of saints martyred by flaying. With its fetal-like pose and exposed spine, the figure becomes a primal emblem that engages us in issues of individual and collective health and disease, heroization and victimization, life and death. Given the life-sustaining and life-threatening potential of human blood in the era of AIDS, the meaning of *Blood Pool* becomes layered, complex, and open-ended.

# Kerry James Marshall

## *Many Mansions*, 1994

Acrylic and collage on canvas; 290 x 343 cm

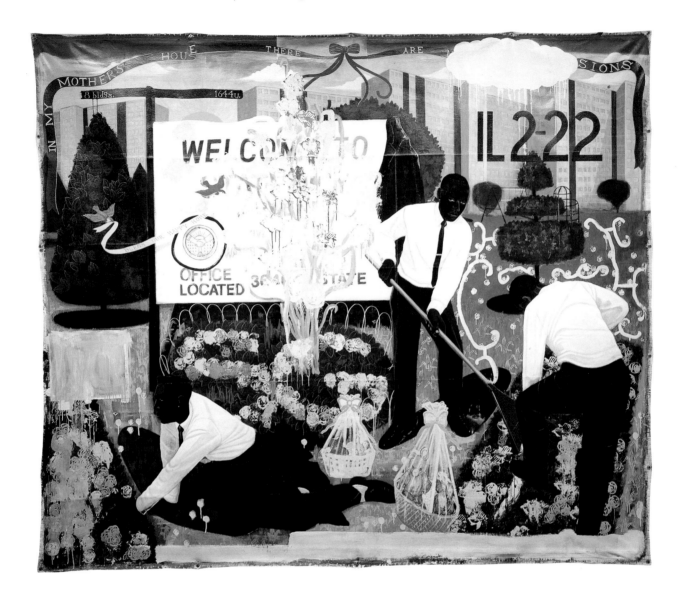

Intrigued by the frequent use of the word *garden* in the names of Chicago and Los Angeles housing projects, Kerry James Marshall set out to explore the triumphs and failures of these much maligned developments in a series titled Garden Project. With these works, the Chicago-based artist— who had himself lived in projects in Birmingham, Alabama, and Los Angeles—hoped to challenge stereotypes of public housing. "These pictures," Marshall remarked, "are meant to represent what is complicated about life in the projects. We think of projects as places of utter despair. All we hear of is the incredible poverty, abuse, violence, and misery that exists there, but [there] is also a great deal of hopefulness, joy, pleasure, and fun."

In the background of *Many Mansions* loom the angular, modernist towers of Chicago's Stateway Gardens, an immense development comprising eight high rises. In the foreground, three men tend an elaborate garden, which, with its profuse and curving forms, contrasts strikingly with the austere apartment buildings ranged behind it. Negating misperceptions of the black male, the dark-skinned trio—attired in white dress shirts and ties—enterprisingly beautify their harsh surroundings.

While full of images symbolizing the grim realities of urban existence, *Many Mansions* attests to the sense of community and humanity that Marshall believes defines life in public housing. At left, two

bluebirds support a banner proclaiming "Bless Our Happy Home," and at top a radiant sun seems on the verge of dispelling an ominous-looking cloud. Poised above the other images is a red ribbon, whose message—"In My Mothers House There Are Many Mansions" (a feminist gloss on a famous biblical phrase [John 14:2])— expresses an inclusive understanding of the idea of home. The unframed canvas is simply nailed to the wall, simulating a vividly hued billboard that, albeit somewhat tarnished over time, continues to offer a promise of happiness.

**Vija Celmins**

*Night Sky #2, 1991*

Oil on canvas mounted on aluminum; 45.7 x 54.6 cm

Since the early 1970s, Vija Celmins has challenged herself to produce exacting depictions of such expansive subjects as ocean waves, desert floors, the moon's surface, and, as in this canvas, star-studded night skies. Though the latter are derived from American and Russian satellite photographs of galaxies, they become, in Celmins's hands, meditations on some of the undifferentiated and uninhabited areas of the natural world. Indeed, the artist has described her paintings as "records of mindfulness." Far from panoramic, as might suit her immense themes, these easel-sized pictures invite intimacy while remaining overwhelmingly mysterious.

Born in the Baltic nation of Latvia, Celmins survived World War II to emigrate in 1948 to Indianapolis, where she resided until moving to Los Angeles in 1962 to study art. Following a period of painting household objects and images based on her memories of the war, the artist began drawing desert-, lunar-, and oceanscapes in graphite on paper, shifting in the early 1980s to oil on canvas. To create a smooth, velvety surface, Celmins often applies up to eighteen layers of pigment to her canvases, sanding each down before she adds the next. Every work is further modulated through the use of a wide range of black, white, and silvery-gray tones.

With its jewel-like imagery and suggestion of vastness, *Night Sky #2* is at once romantic and unsettling. Lacking the anchor of a horizon, a humanly scaled reference point, or a recognizable landmark, viewers cannot determine their relationship to the image. As a result, they may feel simultaneously awed and overwhelmed, swept up and distanced, stirred to speech and silenced, in the presence of this mesmerizing view.

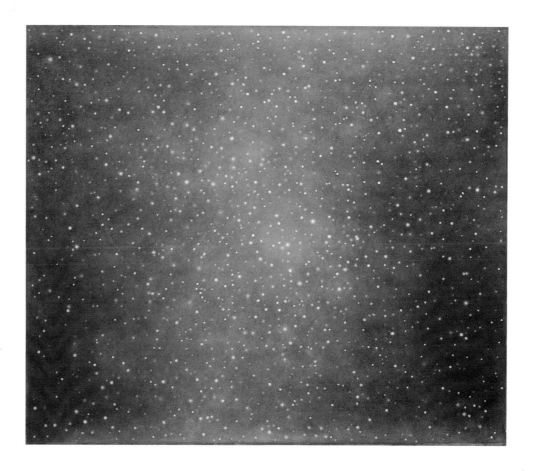

# Robert Ryman

## The Elliott Room: Charter, 1985–87

Oil, acrylic, fiberglass, and aluminum; *Charter,* 208.3 × 78.7 cm;
*Charter II–IV,* all varying between 183.8- and 242.6-cm square

For over three decades, Robert Ryman has focused on eliminating information and incident from his painting. He has intentionally restricted himself to the color white and to abstract and measured fields of carefully considered brush strokes. While white is usually considered a "non-color," it is actually the most subtle of hues. Beyond its sensual aspect, it enables Ryman to bring other painterly elements—particularly brushwork and support—to the fore as equal partners in his work.

The *Charter* series came about through a conversation between Ryman and the noted Chicago collector Gerald S. Elliott, who owned the artist's *Charter,* an emphatically vertical composition. Elliott suggested to Ryman that he create a series that could be exhibited in a single room, apart from other works of art. Ryman decided *Charter* should serve as the basis for four additional paintings that would compose the series. While each of the four is perfectly square in shape, and each displays a matte-painted surface divided by a horizontal band and accented by four small fasteners, these similarities mask subtle but distinct differences. By varying the size of each square, the area of the aluminum that is painted, the divisions of the surface, and the placement of the fasteners, the artist created shifts in impact and mood that become apparent upon sustained and even repeated examination.

Ryman's achievement in the *Charter* paintings lies in the range of impressions they express within a rigorously circumscribed set of possibilities. In establishing a compositional framework and then exploring it in all its permutations, he demonstrated the potential for freedom that self-imposed discipline holds and the idea that rigor can yield poetic calm. His clear, silent, and authentic surfaces induce a contemplative moment for weary urban eyes.

# Index of Artists' Names and Donors' Credits